photographing people

portraits fashion glamour

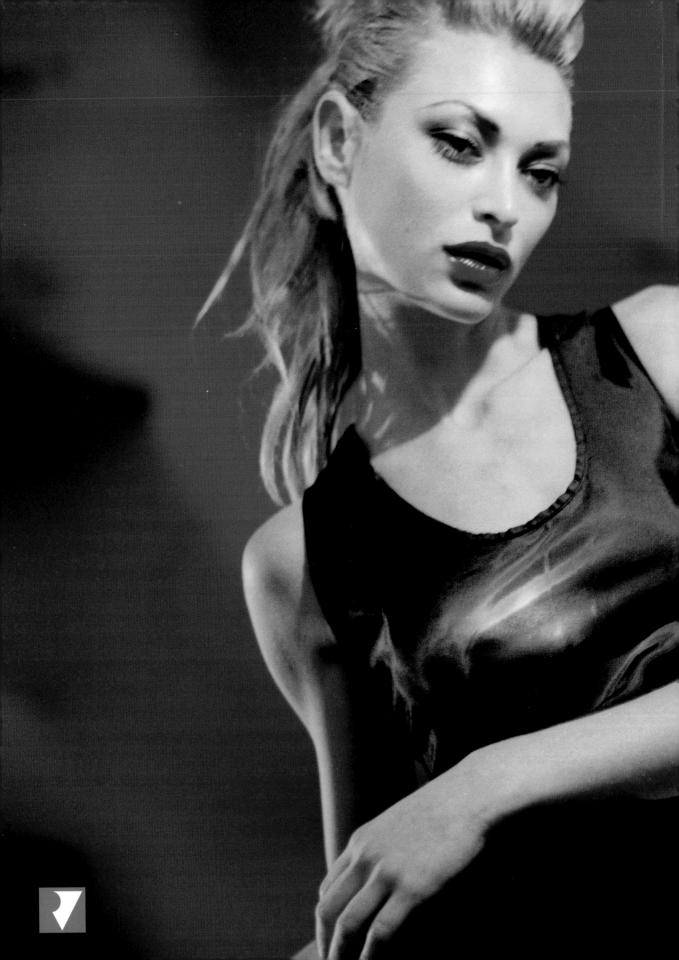

photographing people
portraits fashion glamour

Roger Hicks Frances Schultz Alex Larg Jane Wood

Published and distributed by RotoVision SA Route Suisse 9 CH-1295 Mies Switzerland

RotoVision SA Sales & Production office
Sheridan House
112/116A Western Road
Hove BN3 1DD, UK
Tel: +44 (0)1273 72 72 68
Fax: +44 (0)1273 72 72 69
e-mail: sales@rotovision.com

www.rotovision.com

Copyright © 2001 RotoVision SA.

All rights reserved. No part of this publication may be reproduced, stored in a retrieval system or transmitted in any form or by any means, electronic, mechanical, photocopying, recording or otherwise, without the permission of the copyright holder.

ISBN 2-88046-652-0

Designed for RotoVision
by Becky Willis
at
POD Design
Hastings, UK.

Project Editor: Nicola Hodgson

Printed in Singapore
Production and Separations by ProVision Pte. Ltd.
Tel +65 6334 7720
Fax +65 6334 7721

contents

Foreword	6
How to use this book	8
Diagram key	9
Glossary of lighting terms	10
Why we did this book	13
Portraits	14
Fashion	112
Glamour	212
Directory	292
Acknowledgments	304

foreword

People are easily the most popular subject for photography, with countless millions of pictures of individuals, couples and groups taken every year. The good news for professional photographers, and those aspiring to join their ranks, is that the market for images of people is enormous, and is growing every day. You need only look at the proliferation of periodicals of all kinds and the omnipresence of advertising and promotional material to know that that is the case. Photographs of people are an essential element for all but a few. Many product shots include a person to capture the interest of potential buyers, and even travel images often feature people enjoying the location.

Of course, there are many different approaches to photographing people, from the straight 'portrait', where the intention is to capture something of the character or personality of the person, through to more specialist areas such as fashion, where the emphasis is more on the clothes, and glamour, where creating sexy, erotic images is what is required.

Approaches to people

Whatever the approach or style of the photographer, interpersonal skills are every bit as important as photographic ability. You need to be able to get your subject to relax and co-operate with you. They may not be in the mood, or they might prefer to be somewhere else. And, sometimes with celebrities, you only get ten minutes in which to capture your shot!

Many people tense up in front of the camera, resulting in stiff body language and cheesy grins that ruin the shot. However, with the right approach, using skills to create a rapport and capturing the subject in a natural pose, the picture can be a true and lasting portrait that reveals something of the real person, and not just a superficial snapshot. Just chatting to the person about their life and interests is all it takes to break the ice and establish a good working relationship.

Of course, that doesn't mean you can dispense with the technical aspects of picture taking. You still need to light, expose and compose the shot correctly - but after a while that should be automatic, so well practised you don't even think about it, like driving a car.

Some decisions will inevitably be more consciously taken, such as how big the person is in the frame, where precisely you place them, and whether you want them looking at the camera or not.

Lighting and location matters

As with all areas of photography, lighting is one of the key factors to consider. Do you work with daylight, adapting it to your needs, or do you create your own lighting arrangements using tungsten or flash?

This will depend to some degree upon whether you are shooting in the studio or on location. Studios offer the ultimate in control, but their very nature imbues the results with a degree of artificiality unless great effort is made to create a convincing set. Working on location is more 'real', but considerably less controllable. You also have to take all your equipment with you, and that creates its own challenges.

The lighting you use will also depend upon the style of the image and where it will be used. With 'standard' portraiture the trend is towards a simple approach, using one or two heads, perhaps supplemented by reflector boards, to mimic daylight. One light, fired through a large umbrella or softbox, will produce soft, flattering illumination similar to that on a sunny day with thin cloud - and can be set up in a couple of minutes. Where there's more time, other heads can be added as required.

With glamour, more lights are often used, to accent or define different parts of the model's body. The more imaginative the lighting the better.

In practice, most photographers quickly establish a repertoire of lighting set-ups that work for them and their clients, to which they return time and again. 'Beauty' lighting, with a large softbox overhead and angled down with a reflector below providing fill is rightly popular, for instance. But it is essential not to get stuck in rut. You need to keep experimenting if your images are to remain fresh and contemporary. You might also like to investigate specialist lights such as a ringflash, which can be hired in for particular shoots.

Equipment matters

These days the most widely used cameras for pictures of people are roll-film models, which provide an ideal balance between convenience and quality. The 6x7cm format is favoured by many fashion and glamour photographers, because its aspect ratio approximates that of a magazine page, while the square 6x6cm format seems more common among portrait photographers. In all areas, though, 35mm is becoming more widely used on account of its responsiveness and speed of use. Large-format, sheet-film cameras are now rarely used for people pictures.

Lenses tend to be either standard focal lengths, giving a natural looking perspective, or slightly telephoto, producing a flattering perspective without crowding the subject.

The film stock used is often a matter of personal preference – with both transparency and print and colour and black and white widely used – as well as Polaroid emulsions. Accurate colour rendition is often important in fashion work, in order that potential buyers can see precisely what they will be getting, so film with a neutral tonality is essential. In glamour, a healthy glow to the skin is usually required, and warm toned emulsions preferred. Of course, skilled photographers can always manipulate the colour temperature through the use of filters and gels.

Steve Bavister

how to use this book

The lighting drawings in this book are intended as a guide to the lighting set-up rather than as absolutely accurate diagrams. Part of this is due to the variation in the photographers' own drawings, some of which were more complete (and more comprehensible) than others, but part of it is also due to the need to represent complex set-ups in a way that would not be needlessly confusing.

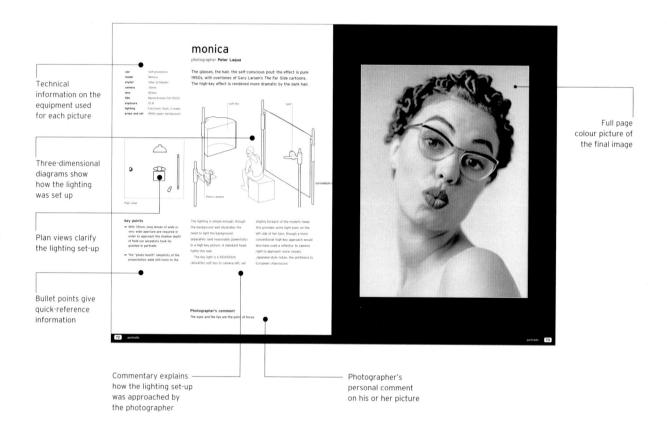

Distances and, occasionally, sizes have been compressed and expanded in these diagrams. In addition, because of the vast variety of sizes of soft boxes, reflectors, bounces and other equipment, we have settled on a limited range of conventionalized symbols. Sometimes, too, we have reduced the size of big bounces, in order to simplify the drawing.

None of this should matter very much, however. After all, no photographer works strictly according to rules and preconceptions. There is always room for improvisation and adjustment, to move this light a little to the left or right, to move that light closer or further away, and so forth, according to the needs of the shot. Likewise, the precise power of the individual lighting heads or (more important) the lighting ratios are not always given. Again, this is something that can be fine-tuned and played around with by any photographer wishing to reproduce the lighting set-ups demonstrated in this book.

We are confident, however, that there is more than enough information given about every single shot to merit its inclusion in the book. As well as discussing lighting techniques, the photographers reveal all kinds of hints and tips about commercial realities and photographic practicalities, and the way of the world in general, such as working with models and creating special effects.

The book can be used in a number of ways. The most basic, and perhaps the most useful for the beginner, is to study all the technical information concerning a photograph that he or she particularly admires, together with the lighting diagrams, and to try to duplicate that shot as far as possible with the equipment that they have available.

A more advanced use for the book is as a problem-solver for difficulties that have already been encountered during a photography session: creating a particular technique of back lighting, say, or of creating a feeling of light and space.

And, of course, the book could always be used, by beginner, advanced student or professional, simply as a source of inspiration and enjoyment.

The information for each picture follows the same plan, though some individual headings may be omitted if they were irrelevant or the information was unavailable. The photographer is credited first, then the client, together with the use for which the picture was taken. Next come the other members of the team who contributed to the session, including stylists, models, art directors, and anyone else involved. Camera and lens come next, followed by film. With film, we have named brands and types, because different films have very different ways of rendering colours and tonal values. Exposure is listed next: where the lighting is electronic flash, only the aperture is given, as illumination is of course independent of the shutter speed. Next, the lighting equipment is briefly summarized - whether it was tungsten or flash, and what sort of heads there were. Finally, there is a brief note on props and backgrounds. Often, these will be obvious from the picture, but in other cases you may be surprised at what has been pressed into service, and how different it looks from its normal role.

The most important part of the book is, however, the pictures themselves. By studying these, and referring to the lighting diagrams and the text as necessary, you can work out how they were created.

diagram key

The following is a key to the symbols used in the three-dimensional and plan view diagrams. All commonly used elements, such as standard heads and reflectors, are listed. Any special or unusual elements involved are shown on the relevant diagrams.

three-dimensional diagrams

plan view diagrams

glossary of lighting terms

Lighting, like any other craft, has its own jargon and slang. Unfortunately, the different terms are not very well standardized. Often the same object may be described in two or more ways or the same word used to mean two or more different things. For example, a sheet of black card, wood, metal or other material that is used to control reflections or shadows may be called a flag, a French flag, a donkey or a gobo – though some people would reserve the term "gobo" for a flag with holes in it, which is also known as a cookie. In this book, we have tried to standardize terms as far as possible. For clarity, a glossary is given below, and the preferred terms used in this book are asterisked (*).

Acetate

see Gel

Acrylic sheeting

Hard, shiny plastic sheeting, usually methyl methacrylate, used as a diffuser ("opal") or in a range of colours as a background.

*Barn doors

Adjustable flaps affixed to a lighting head that allow the light to be shaded from a particular part of the subject.

Barn doors

Boom

Extension arm allowing a light to be cantilevered out over a subject.

*Bounce

A passive reflector, typically white but also, (for example) silver or gold, from which light is bounced back onto the subject. Also used in the compound term "Black Bounce", meaning a flag used to absorb light rather than to cast a shadow.

Continuous lighting

What its name suggests: light that shines continuously instead of being a brief flash.

Contrast

see Lighting ratio

Cookie

see Gobo

*Diffuser

Translucent material used to diffuse light. Includes tracing paper, scrim, umbrellas and translucent plastics such as Perspex and Plexiglas.

Electronic flash: standard head with diffuser (Strobex)

Donkey

see Gobo

Effects light

Neither key nor fill; a small light, usually a spot, used to light a particular part of the subject. A hair light on a model is an example of an effects (or "FX") light.

*Fill

Extra lights, either from a separate head or from a reflector, which "fills" the shadows and lowers the lighting ratio.

Fish fryer

A small Soft Box.

*Flag

A rigid sheet of metal, board, foam-core or other material used to absorb light or to create a shadow. Many are painted black on one side and white (or brushed silver) on the other, so they can be used either as flags or as reflectors.

*Flat

A large Bounce, often made of a thick sheet of expanded polystyrene or foam-core (for lightness).

Foil

see Gel

French flag

see Flag

Frost

see Diffuser

*Ge

Transparent or (more rarely) translucent coloured material used to modify the colour of a light. It is an abbreviation of "gelatine (filter)", though most modern "gels" are acetate.

*Gobo

As used in this book, synonymous with "cookie": a flag with cut-outs in it, to cast interestingly-shaped shadows. Also used in projection spots.

"Cookies" or "gobos" for projection spotlight (Photon Beard)

*Head

A light source, whether continuous or flash. A "standard head" comes fitted with a plain reflector.

*HMI

Rapidly-pulsed and effectively continuous light source approximating to daylight and running at far cooler temperatures than tungsten lights. They are most commonly used in studios that use digital scanning backs.

Honeycomb (Hensel)

*Honeycomb

Grid of open-ended hexagonal cells, so called because it closely resembles a honeycomb. This increases the directionality of light from any head.

Incandescent lighting

see Tungsten

Inky dinky

Small tungsten spot.

*Key or key light

The dominant or principal light, the light which casts the shadows.

Kill Spill

A large flat that is used to block spill.

Electronic Flash: light brush "pencil"

Electronic Flash: light brush "hose" (Hensel)

brush

Light source "piped" through fibre-optic lead. Can be used to add highlights, delete shadows and modify lighting, literally by "painting with light".

Lighting ratio

The ratio of the key to the fill, as measured with an incident light meter. A high lighting ratio (8:1 or above) is very contrasty, especially in colour, a low lighting ratio (4:1 or less) is flatter or softer. A 1:1 lighting ratio is completely even, all over the subject.

*Mirror

Reflectors are rarely mirrors, because mirrors create "hot spots" while reflectors diffuse light. Mirrors (especially small shaving mirrors) are widely used, almost in the same way as effects lights.

Northlight

see Soft Box

Perspex

A brand name for acrylic sheeting.

Plexiglas

A brand name for acrylic sheeting.

*Projection spot

Flash or tungsten head with projection optics for

casting a clear image of a gobo or cookie. Used to create textured lighting.

Electronic Flash: projection spotlight (Strobex)

Tungsten Projection spotlight (Photon Beard)

*Reflector

Either a dish-shaped surround to a light, or a bounce.

*Scrim

*Snoot

Conical restrictor, fitting over a lighting head. The light can

Tungsten spot with conical snoot (Photon Beard)

Electronic Flash: standard head with parallel snoot (Strobex)

only escape from the small hole in the end, and is therefore very directional.

*Soft box

Large, diffuse light source made by shining a light through one or two lavers of diffuser. Soft boxes come in all kinds of shapes and sizes, from about 30x30cm to 120x180cm and larger. Some are rigid; others are made of fabric stiffened with poles resembling fibreglass fishing rods. Also known as a northlight or a windowlight, though these can also be created by shining standard heads through large diffusers.

*Spill

Light that ends up other than on the subject at which it is pointed. Spill may be used to provide fill or light backgrounds. It may be controlled with flags, barn doors or gobos.

manufacturer: Strobex.

Swimming pool

A very large Soft Box.

*Tungsten

name of a leading

Incandescent lighting. Photographic tungsten Umbrellas may be used as reflectors (light shining into the umbrella) or as diffusers (light shining through the umbrella). An umbrella is the cheapest way of creating a large, soft light source.

Apart from the obvious meaning of light through a window, or of light shone through a diffuser to look as if it is coming through a window, this is an alternative name for a soft box.

Electronic flash: standard head with standard reflector (Strobex)

lighting runs at 3200°K or 3400°K, as compared with domestic lamps which run at 2400°K to 2800°K.

system with reflectors or

lenses or both, a "focusing

spot". Also used as a

reflector head rendered

more directional with a

honeycomb.

Electronic flash: strip light with removable barn doors (Strobex)

*Strip or strip light

Lighting head, usually flash, that is longer than it is wide.

Strobe

Electronic flash. Strictly, a "strobe" is a stroboscope or rapidly repeating light source, though it is also the

Tungsten spot with safety mesh (behind) and wire half diffuser scrim (Photon Beard)

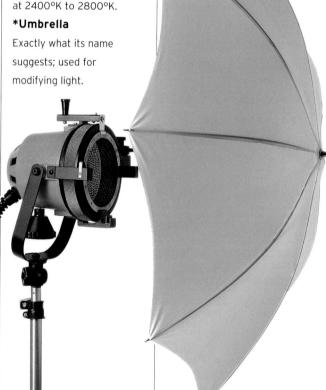

Tungsten spot with shoot-

through umbrella (Photon Beard)

why we did this book

The most common response from the photographers who contributed to this book, when the concept was explained to them, was "I'd buy that". Our aim was simple: to create a book illustrated with first-class photography from all around the world, which showed exactly how each individual photograph featured in the book was lit.

Who will find it useful? Professional photographers, obviously, who are either working in a given field or want to move into a new field. Students, too, who will find that it gives them access to a very much greater range of ideas and inspiration than even the best college can hope to present. Art directors and others in the visual arts will find it a useful reference book. both for ideas and as a means of explaining to photographers exactly what they want done. It will also help them to understand what the photographers are saying to them. And, of course, "pro/am" photographers who are on the cusp between amateur photography and earning money with their cameras will find it invaluable: it shows both the standards that are required, and the means of achieving them.

The lighting set-ups in the book vary widely, and embrace many different types of light source: electronic flash, tungsten, HMIs, and light brushes, sometimes mixed with daylight and flames and all kinds of other things. Some are very complex; others are very simple. This variety is important, both as a source of ideas and inspiration and because the book as a whole has no editorial bias towards one kind of lighting or another.

The pictures were chosen on the basis of impact and (occasionally) on the basis of technical difficulty. Certain subjects are, after all, notoriously difficult to light and can present a challenge even to experienced photographers. Only after the picture selection had been finalized was there any attempt made to understand the lighting set-up.

This book covers the diverse genres of portrait, fashion and glamour photography. The intriguing thing in all of them is to see the degree of underlying similarity, and the degree of diversity, which can be found in a single discipline or genre. In portraiture, for example, there is remarkable preference for monochrome and for medium formats. though the styles of lighting are very varied. Glamour shots concentrate on models, often nudes, and soft lighting tends to be used, though having said that, many of the bold new-style shots are deliberately stark and provocative and the choice of harsher lighting can be used to good effect in these cases. Fashion changes with each passing year and each trend changes the images being sold, as the collection of photographs in this book shows.

portraits

This section explains the techniques behind a successful portrait shot. The photograph must capture the subject's significance, whether it is the naivety of a child, the importance of a self-made man or the well-known personality of a celebrity. In each case, the lighting set-up is fundamental to achieving the right effects.

Until the invention of photography, the "likeness" was the preserve of the very rich. Skilled painters and sculptors have always been a rare commodity, and their work takes a long time, which translates into high costs.

Traditionally, portraits were intended to be as flattering as possible. We do not really know what (say) Queen Elizabeth I looked like. We may assume that her famous portraits were passing likenesses, but it is less certain that we would recognize her from them if we were to see her in the street, dressed perhaps in jeans and a T-shirt instead of the magnificent court dresses, stiff with jewels, in which she was usually represented.

The tradition of flattery and aggrandisement lasted well beyond the invention of photography. Think of pictures of Lenin. The style in which his portraits and statues were created makes him look far more heroic than his photographs; but we remember him from his iconic representations, not from his "likenesses."

Even where realistic portraits are readily available, there is still a tendency to accept the iconic over the homely or naturalistic: think, for example, of the countless portraits of Churchill that exist, and of the relatively few that appear again and again in the press and that have achieved iconic status partly as a result of their inherent qualities, and partly through sheer repetition.

To this day, therefore, the portrait lends itself remarkably well to deconstruction. For example, it may be a symbol of The Business Leader, The Family Man, The Professor, The Affluent Consumer, The Sex Goddess. In this sense, it is to some extent independent of its subject. He or she is merely a tool that is used to illustrate a theme or to sell a product (an airline ticket, a brand

of beer) or a concept (the American way of life, success in academia, European café society).

In another context a portrait may be a "likeness" of a particular person but the camera always lies. Through one photographer's lens, the subject is relaxed, cheerful. Through another's he or she is stern, cold, harsh. In yet a third context the image may transcend both personality and symbol: we see an arrangement of curves and textures and lines that is in itself beautiful.

This leads us to the question of why photographers take portraits. Some do it just for money, of course. But even the most commercial of portrait photographers must have a reason to photograph people instead of something else. And many photographers sincerely want to capture a likeness that is more than skin deep; they want to "get under the skin" of their subject, to make a psychological interpretation.

The circularity of the process then becomes apparent: the portrait is as much a psychological interpretation of the photographer as of the subject. There are cruel photographers and there are kind ones, gentle photographers and harsh photographers, light-hearted photographers and very serious photographers. The photographer takes portraits for one set of reasons, and the subject may sit for them for an entirely different set of reasons, and the picture is the only place where they meet.

Studios and contexts

The choice between a studio portrait and a portrait of the subject in a wider context - the so-called "environmental" or location portrait - is a matter of personal styles; and besides, there are no real distinctions between the two. Some traditionally minded portrait photographers maintain built sets in

which to photograph their sitters: the book-lined library is a well-established favourite, and the boudoir has apparently done well for some. Equally, a location may be so bare that it supplies little more context than a roll of background paper.

Even so, the photographer must consider which approach to take. Some take their lead from Richard Avedon and photograph their subjects against a featureless white background; others like to show people in settings that are crowded almost to the point of surrealism. There are also many options in between. Arguably, though, the photographer must rely more on psychological interpretation when the background is minimal; in a more complex environment, whether a built set or a location, he or she is more concerned with the gestalt, the whole.

Remember, too, that few people are one-dimensional and consistent: they exist in different milieus, and by learning a little more about them, you may be able to place them in a setting with which they, or you, or both, are more at ease. The lawyer, for example, may also be a windsurfer; the accountant may ride a motorcycle. However, remember that there can be a gap between how people want to see themselves, and how they are going to look convincing. Some accountants are never going to look like bad-ass bikers, and some Hell's Angels are never going to look like accountants.

Clothes, props and make-up

As with the choice between the bare background and the crowded environment, so the photographer (and the sitter) must also choose between the casual picture, taken in everyday clothes, and the more formal portrait picture.

If the photographer leans towards the formal or the pseudo-informal, or if the portrait is to be used for advertising or some other public purpose, then it may be worth calling on professional make-up artists and hairdressers and even professional clothing advisers and prop-finders.

Working on a more modest scale, the photographer must at least be aware of what make-up, hair, and careful choice of clothes and props can do, and it is a good idea to talk through a portrait with the subject before they come to the studio. Ask them what they intend to wear, what sort of image they want to project - and advise them to bring a favourite and characteristic personal possession. Everyone has personal foibles; it is the job of the paid portraitist to capture them.

Cameras and film for portraits

Most portraitists use a medium-format reflex, typically with a longer-thanstandard lens; in fact, 150mm and 180mm lenses on medium-format cameras are often known as "portrait" lenses. Medium formats allow better sharpness, smoother gradation and less grain than 35mm, but are still sufficiently rapid-handling to allow a degree of spontaneity. They are also significantly cheaper to run than largeformat cameras. The modern tendency is in any case to shoot a number of similar portraits - typically a roll or two of 120, between 10 and 30 images and then to select the best.

Another reason why rollfilm is so popular among High Street portrait photographers is that special colour negative portrait films in this format are offered by a number of manufacturers. They are optimized for skin tones, and typically have a lower contrast than standard colour print films.

There is also a place for 35mm in portraiture, often with very long lenses, and surprisingly often with Polaroid materials, which give effects quite unlike those obtainable with anything else.

Lighting equipment for portraits

The first and most important generalization about portrait photography, which immediately distinguishes the skilled portrait photographer from the unskilled, is that the background is separately lit from the subject. This allows the background to be lightened or darkened (or graded) independently of the subject. In order to do this, there must be a fair amount of space between the subject and the background: at the least 1.5m (5ft) and preferably 2 or even 3m (6½ or 10ft).

After this, it is surprising how many photographers use a single light to one side of the camera plus a reflector on the other side to provide a fill. If more than one light is used, it should be used with good reason. Hair lights are a familiar example, but they are only one of many kinds of effects lights that are used to draw attention to a particular feature.

Another reason to use extra lights (or complex multiple reflectors) is to create a very even overall light. As a general rule, highly directional lighting is more widely used for men, and more diffuse and even lighting for women and children.

The team

Many portrait photographers work alone, though it is often useful to have an assistant to move the lights so that the photographer can judge the effects without having to leave the camera position. It is also good to have remote controls for the lights so that they can

be switched on or off, or turned up or down, from the camera position.

In advertising and publicity photography, and in the higher reaches of corporate portraiture, at least one assistant is all but essential and there is likely to be a need for specialist make-up artists, etc, as mentioned above.

The portrait session

Sometimes a portrait session goes as if by magic. There is an immediate rapport between the photographer and the subject and they spark ideas off one another.

At the other extreme, the sitter is in a hurry and does not particularly want to be photographed in any case. As quickly as possible, the portraitist has to put the sitter at ease, get the picture, and get out.

Either way, the preparation is the same. The photographer must have a clear idea of how to set up the session: where the lights are going, what the pose and props will be, and how the picture will be framed. Setting up should be as fast as possible, and there should be little fiddling about with equipment or exposure readings.

The photographer should know something about the sitter in advance: easy conversation can make all the difference between establishing a rapport with the subject and a formal, lifeless portrait. Some photographers have a natural gift for this; others do not. Beyond this, it is down to you. Portraits are perhaps the most idiosyncratic branch of photography and the personality of the photographer can be paramount.

justine

photographer Marc Joye

This portrait owes as much to the soft, flary, grainy nature of Kodak's High Speed infrared film as to the lighting, which is a straightforward double back light with a bounce to camera right.

use Self-promotional

model Justine camera 35mm

lens 150mm, light amber filter film Kodak High Speed infrared

exposure f/11

lightingElectronic flash: 2 headsprops and setWhite background

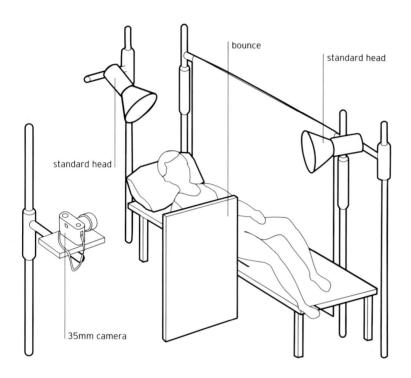

The same thing - choice of film - explains the very high-key effect: over-exposure, together with the IR sensitization of the film, lightens the hair and the eyes. It is interesting that the photographer has chosen weak filtration, so as to retain the normal sensitization of the film as well as the IR sensitization. With the more usual deep red filtration, an unpleasantly dead and corpse-like appearance often

results: this is periodically exploited for its shock value by rock photographers, who imagine that they are being innovative and daring rather than tired and hackneyed.

It is worth noting that the IR output of flash tubes varies widely, so any attempt to use flash with IR should be preceded with a check of the emission spectrum of the flash equipment in use.

Photographer's comment

I like to photograph on infrared film, where the warmth of the body contributes to the image. Justine has very dark eyes, but in this way they become light and she looks very different from usual.

key points

- ► The sensitization of IR films varies widely, from Kodak's High Speed infrared (sensitized beyond 900nm) to Konica and Ilford materials sensitized to 750nm and 740nm respectively
- ► Full (deep red) IR filtration creates effects very different from weaker or no filtration

Plan View

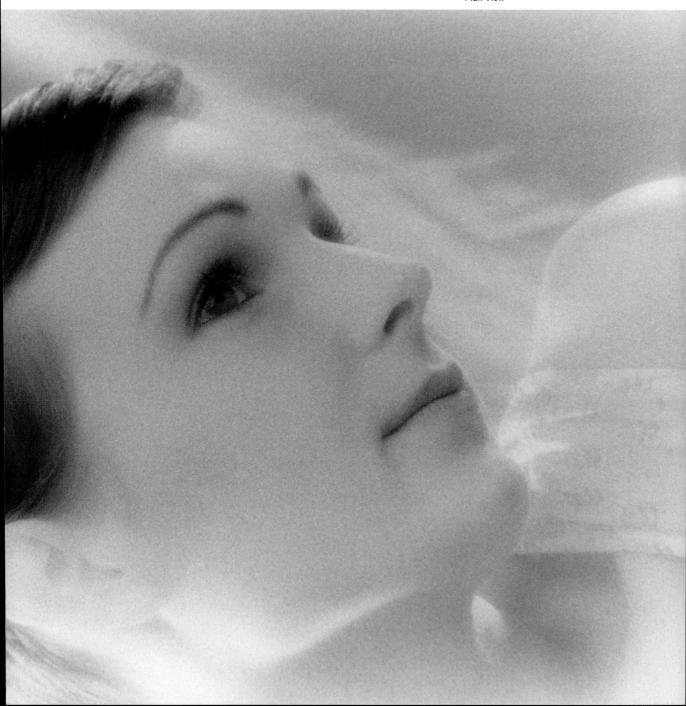

michaela

enough diffuser.

photographer Rudi Mühlbauer

Diffused but directional light can be extremely effective and

getting enough light in the first place, and in making a big

natural-looking. The main problems for the photographer lie in

use

Self-promotional

model camera Michaela 35mm

lens film

50mm

exposure

Kodak TMZ at EI 3200

1/60 second at f/2.8

lighting Tungsten: single diffused lamp

props and set

White wall as background

Plan View

35mm camera

3200, EI 6400, EI 12,500 and EI 25,000, both for speed and for the aesthetic effects of the grain.

spot

diffuser

As for making a big diffuser - this one was $2m (6^{1}/_2ft)$ square - the easiest solution is to buy a Scrim Jim, a metal frame with interchangeable fabric diffusers and reflectors. Other possibilities include tracing paper or bedsheets; nylon sheets are ideal.

key points

- ► Ultra-fast, grainy films are not just attractive in their own right: they also have the advantage that they can be used with comparatively low-powered or distant light sources, including photoflood bulbs of modest wattage
- ► Very large, diffuse light sources can be achieved by diffusion or by bouncing light off a reflector

Photographer's comment

I was attempting to imitate soft, morning light in the studio, with just one lamp.

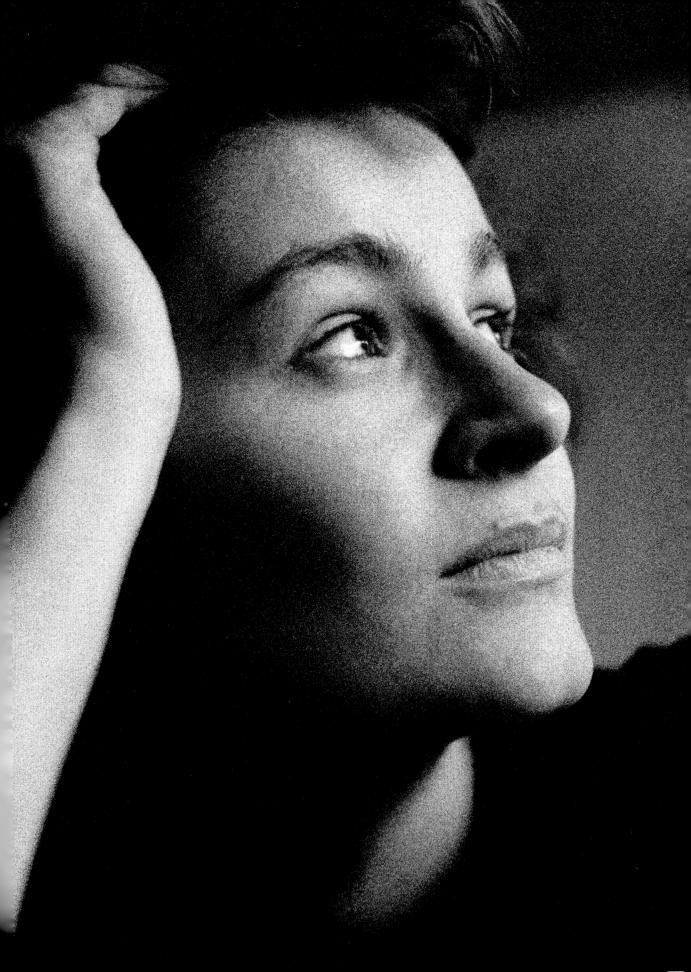

zarina

photographer Ben Lagunas & Alex Kuri

background for a high-key effect.

client Michell Ritz Editorial use model

Zarina

assistants Isak de Ita, George Jacob

art director Many Boy camera 4x5in lens 300mm

film Kodak Ektachrome **EPP 100**

exposure

lighting Electronic flash: 7 heads

props and set White background

Plan View

key points ► High-key backgrounds normally require a very great deal of light. The alternative is to light the subject in the foreground relatively weakly, and give a longer exposure (with tungsten), use a wider aperture, or use a faster film

► Using gels to distort colours is very much a matter of personal taste and vision - and a picture that one person loves, another may hate

After that, everything is easier to understand. The key is the snooted spot, high (2m/61/2ft off the ground) and to camera right. A standard head with a honeycomb provides some fill from camera left, but (more importantly) adds highlights to the model's hair. A purple gel on this head also creates the unusual colour effects that are "washed out" on the right of

the picture by the stronger key light. A (non-filtered) soft box to camera left further softens the contrast.

On a 4x5in, a 300mm lens is ideal for portraits: it equates roughly to 100mm on 35mm and 150mm on 6x6cm. Although f/11 is a relatively small aperture on smaller formats. on a 4x5in format with a long lens it allows highly selective focus.

Seven light sources would normally be a recipe for disaster in a

portrait, unless you know what you are doing. In this case, four

of the light sources are standard heads used to "burn out" the

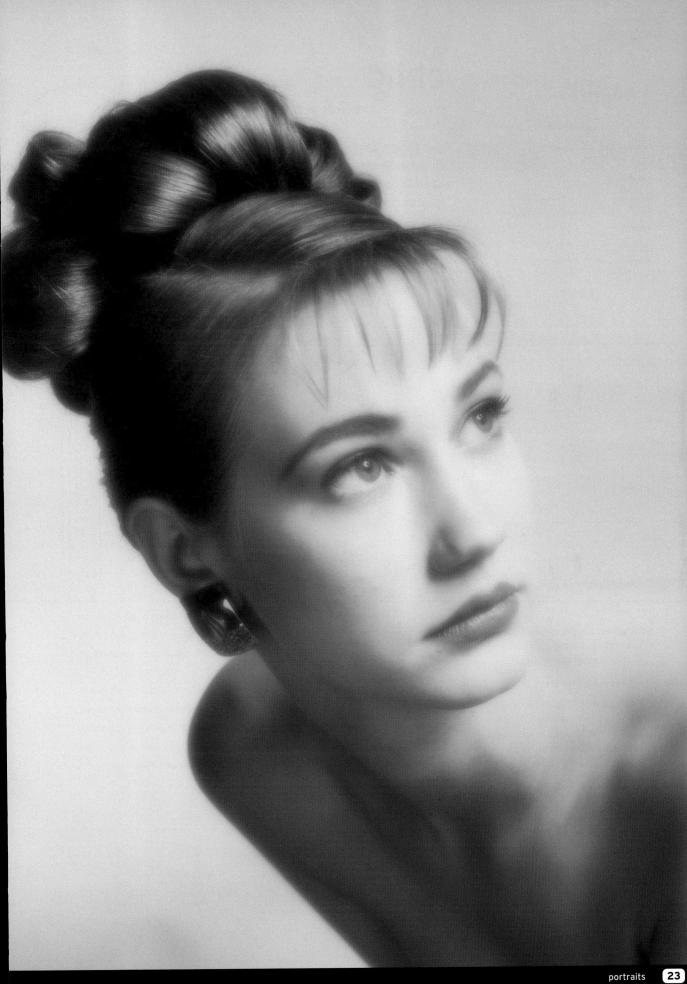

child

photographer Dolors Porredon

chiaroscuro as possible.

The face, the pose, the colours: all are reminiscent of a Victorian

chromolithograph. The effect is achieved in large measure by

careful control of the lighting ratio, while retaining as much

client

Studio Poster

use camera

6x6cm

lens

150mm

film

Kodak Vericolor 2

exposure

f/5.6

lighting props and set Flash: 2 heads

Painted backdrop

Plan View

key points

- ► Catchlights in the eyes are not essential, but sometimes a picture that is lacking them will look curiously dead
- ► Traditional portraitists touched out all but a single catchlight. Today, multiple catchlights are acceptable if they are not too obtrusive

The key is a snooted spot to camera left, fairly close to the child's face and very slightly backlighting her. Opposite this, to camera right, is a 60x80cm (2x3ft) soft box. This is set to give quite a close lighting ratio, but because it is diffuse and the key light is highly directional, the impression of modelling is very clear: modelling is all the more

6x6in camera

clear, of course, because of the very careful angling of these two lights.

A white reflector to camera left. just out of shot, provides a little more fill to the front of the face but also creates the catchlights in the eyes. They would not be there otherwise: the key is a back light, and the fill is shaded from both eyes.

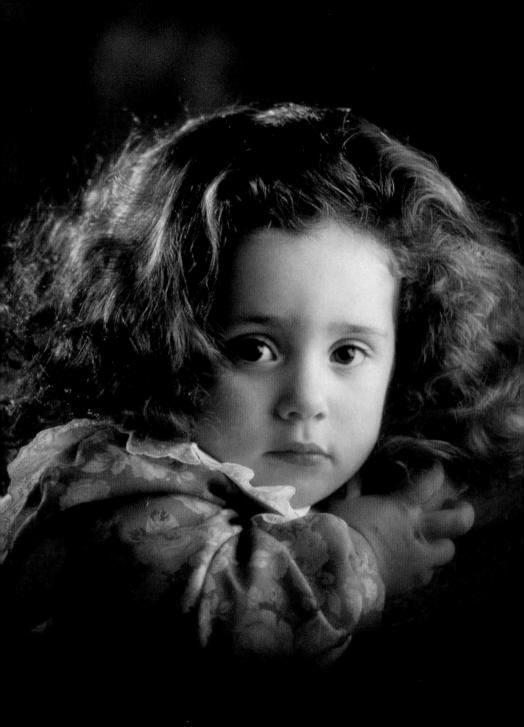

rutger hauer

photographer Alan Sheldon

This is a classic "fake setting-sun" picture. If you try to shoot by the real light of the setting sun, you run into very long exposures and even more redness than you want - and you have only a few seconds to shoot anyway.

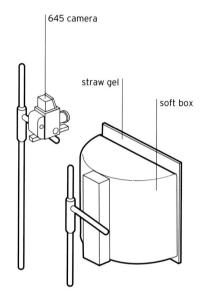

client

Virgin Vision

use art director Publicity Carey Bayley

camera

645

lens

150mm film

exposure

Fujichrome RDP ISO 100

lighting

1/30 second at f/11 Mixed: see text

props and set

Location

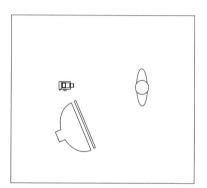

Plan View

key points

- ► Daylight encompasses quite a wide range of colours: the setting sun is actually redder than tungsten lighting
- ► Over-lighting the foreground when using fill-flash is always a risk; as this shot shows, slight underexposure looks much more natural
- ► Keep light sources far enough away so that they do not reflect as unnaturally-shaped catchlights in "sunlit" shots

The technique, therefore, is to meter for the available light; stop down at least one stop, and preferably two, for the "nuit américain" look: then balance your additional light to suit this, still underexposing very slightly in order to get the dark, end-of-the-day look. The

additional light in this case is a surprisingly large soft box, about 80x100cm (30x40in) with a straw gel to simulate the setting sun. It is quite a long way away from the subject, so that the shape of the catchlights in the eyes is not a give-away.

Photographer's comment

I used always to light from the left, but when I lit Rutger Hauer from the left, he looked like David Hamilton! Since then, I have found that it is a good general rule to photograph a man from the same side that he parts his hair.

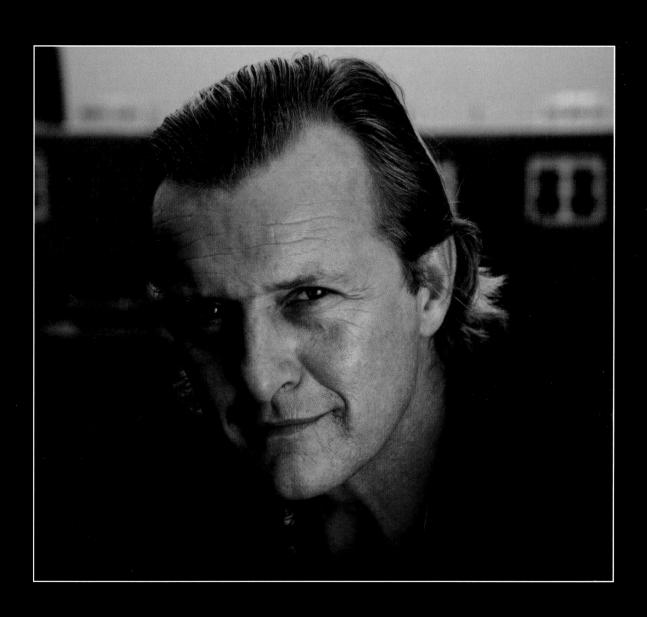

leslie nielsen

photographer Alan Sheldon

client

Planet Hollywood

use

Display and PR

camera

6x7cm

lens

165mm

film

Kodak Tri-X pan at El 320

exposure

f/11

lighting

On-camera flash

props and set

Location

Plan View

photographers could not better this in the studio.

This was shot as part of the publicity material for Naked Gun

331/3 at Planet Hollywood. The only light was an on-camera

Metz 45, mounted to the left of the camera - but many

key points

- "Old-technology" films like Tri-X and Ilford HP5 Plus are much more forgiving of over- and underexposure than more modern films
- ► A secret of using on-camera flash is an uncluttered background – though this can sometimes be improved at the printing stage

The most important feature is the dead black background, achieved partly by shooting at a very modest aperture and partly by looking very carefully through the viewfinder. A close second to this is the superb tonality of Tri-X under this sort of condition: compare this with the photograph of Mel Brooks by the same photographer, using the

same film but under controlled conditions, on page 45. The third thing that gives this picture its magic is the use of the 6x7cm format: a 35mm camera may be more immediate, but it can never deliver the tonality of a larger format. On the other hand, in the photographer's words, the 6x7 Pentax is hell to focus in poor light.

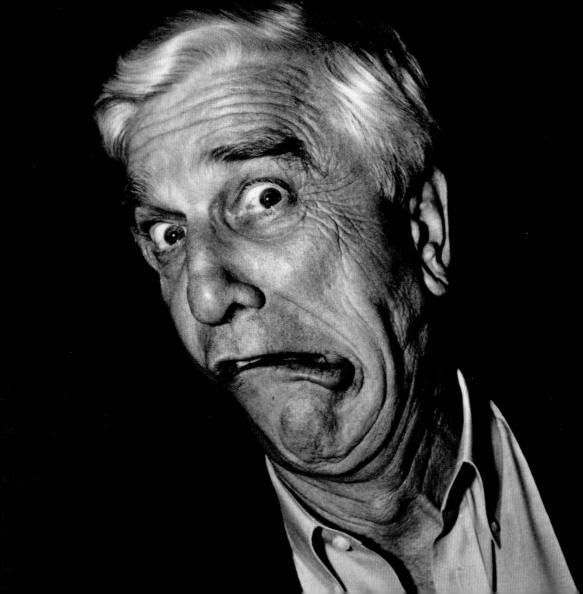

mel brooks

Although an 80mm lens is not normally regarded as ideal for

portraiture on 6x4.5cm - something like 150mm is more usual -

standard head with honeycomb and straw gel

the advantage of an 80mm is that, if it is used properly, it can

convey tremendous immediacy and intimacy.

standard head

photographer Alan Sheldon

645 camera

bounce

client use

20th Century Fox

camera

Press/publicity 645

lens

80mm

film

Fuji RDP ISO 100

exposure lighting

1/60 second at f/8 Electronic flash: 3 heads

props and set

White background paper

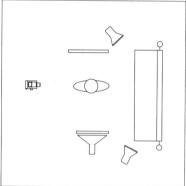

The lighting on Mel Brooks came from a single standard head with a large, square reflector - about 30cm (12in) square - with a medium honeycomb. It was placed to camera right, about on a level with the subject's eye-line and not quite at right angles to the line of sight. The effect created is more

directional than a spot. A straw gel warmed the light slightly to give a sunnier complexion.

standard head

A Lastolite reflector to camera left, just out of shot, provided a modest amount of fill on the right side of Mel Brooks's face. Two more lights, both with standard reflectors, lit the background to a clear, bright white.

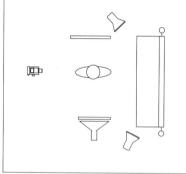

Plan View

key points

- ► For informal portraits, quite modest focal lengths can be appropriate: 80mm on 645 equates roughly to 50mm on 35mm or 180mm on 4x5in
- ► Large reflectors create an effect between standard reflectors and soft boxes

Photographer's comment

directional than a soft box, but less

Mel Brooks had apparently told several people that he wasn't going to have pictures made; but fortunately I knew his manager, and I was able to prevail upon him that way.

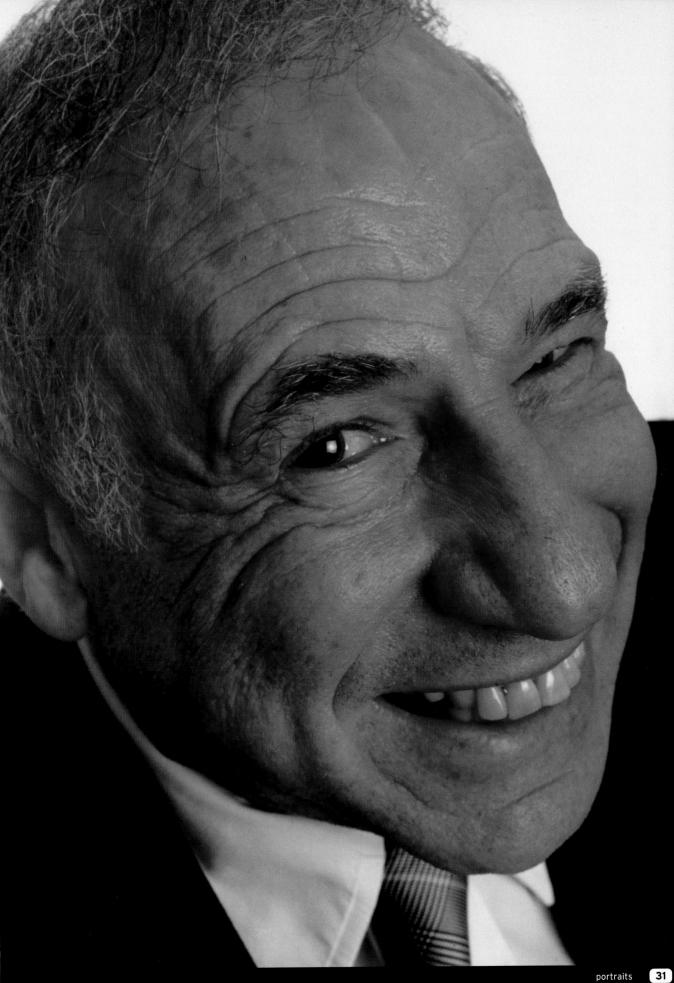

roger corman

subject, with another on the background.

photographer Alan Sheldon

snooted spot

client

United International

Pictures

use

Press and internal

publicity

camera lens 645 150mm

film

Kodak Tri-X Pan rated

at EI 200

exposure

f/3.5

lighting

Electronic flash: 2 heads

props and set

White background

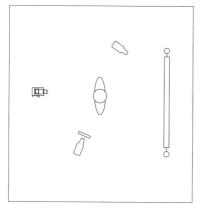

Plan View

645 camera

At first glance - and on closer examination, for that matter - this

snooted spot

with honeycomb

looks very like a classic Hollywood portrait with traditionally

complex lighting. In fact, there is only a single light on the

key points

- Shooting at full aperture reproduces the shallow depth of field that characterizes traditional Hollywood portraits
- Skilled printing can add still more to a dramatic portrait

The key light used here was a single standard head, tightly snooted and honeycombed, from camera right. It is positioned very slightly in front of the subject's eye-line, and rather above it: look at the shadow of the nose. The other light is shaped to the background, which also provides a modest amount of spill to act as fill: look at the reflections on the hair behind the right ear. In practice,

though, a good deal depended on the manipulation of the print. The printer, Volker Wolf, darkened down the "hot" forehead considerably; as the photographer said, if he had had any powder, he could have held the forehead with far less burning in, but he didn't have a make-up person on the shoot. The edges of the print have also been darkened appreciably in printing, and the print was toned.

Photographer's comment

In a picture like this, where depth of field is crucial, do not use the microprism centre of the screen and then recompose. Instead, check the sharpness of the eyes on the ground glass.

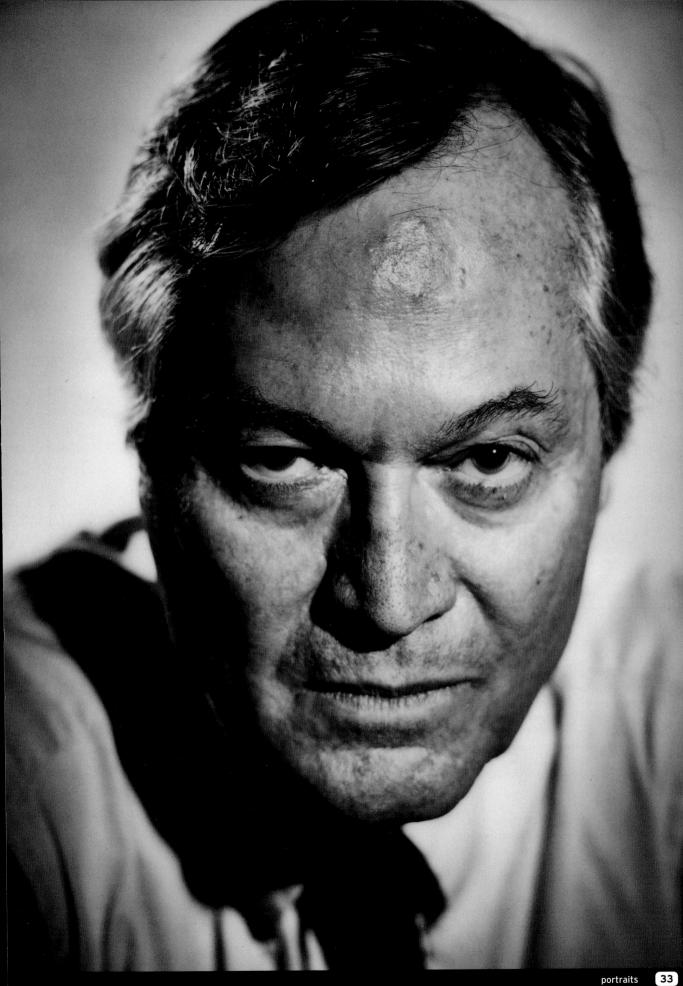

woman with hair over face

photographer Frank Wartenberg

straightforward shot.

use

Portfolio

camera

35mm

lens

105mm

film

Kodak EPR processed

as C41

exposure

Not recorded

lighting

Daylight plus reflectors

props and set

Location

The photographer sums up the location very well: "a flat with

how the light might be attractive, but this is far from a

two big windows and a door to a balcony." One can well imagine

Plan View

key points

- "Full gold" reflectors must be used with discretion, except when colour distortion is deliberately sought
- Cross-processing E6 (transparency) films in C41 (negative) chemistry gives surprisingly widely varying results with different films
- Long lenses and wide apertures are a traditional combination for portraits, but also lend themselves to nontraditional images

First, the light was modified with the help of two gold reflectors: one on the floor, between the model and the window, and one on the far side of the model from the window. Full gold reflectors can have a remarkably warming effect, almost enough to account for the colour without anything further. In addition, though,

the transparency film was crossprocessed in C41 chemistry to give a negative that was used to make the final image. This gives a soft, grainy effect, often with considerable distortions of colour and contrast. A more naturalistic picture might not have worked if cross-processed, but this creates a remarkably dreamy effect.

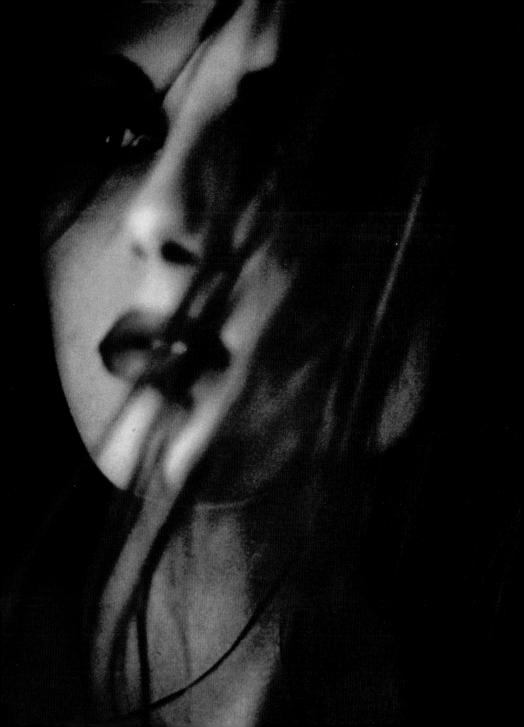

1960s hair

still further.

photographer Frank Wartenberg

use

Portfolio

hair and make-up Susan Swoboda

camera

6x7cm

lens

185mm

film

Polaroid 691

exposure

Not recorded; double

exposure

lighting

Electronic flash: 5 heads

props and set

White background

Plan View

An additional hair light - unusually, a soft box rather than a highly directional light - completes the lighting set-up. There were two exposures: one for the model (with the background lights off), and another for the background (no light on the model).

The whole is recorded on Polaroid Type 691, an 85x105mm (3½x4½in) transparency pack film designed for overhead projector use. As with so many specialised Polaroid products, this is capable of delivering interesting results when used in ways other than those envisaged by the manufacturer.

key points

- Reproduction from Polaroid originals is fully feasible; this is reproduced from just part of the pack film area
- Exposing separately for the foreground and background gives the photographer new opportunities for control
- Do not always believe the instructions on film boxes that say, "Unsuitable for general photography"

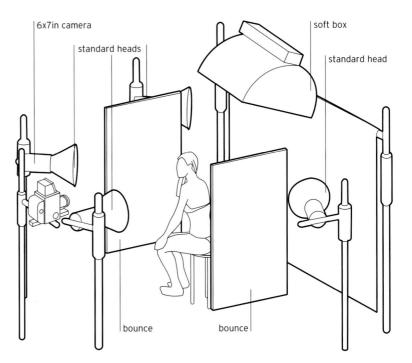

This is classic "high-key" lighting. The background is strongly

standard heads, with two silver bounces to even out the light

lit to get a pure white, while the model's face is lit with two

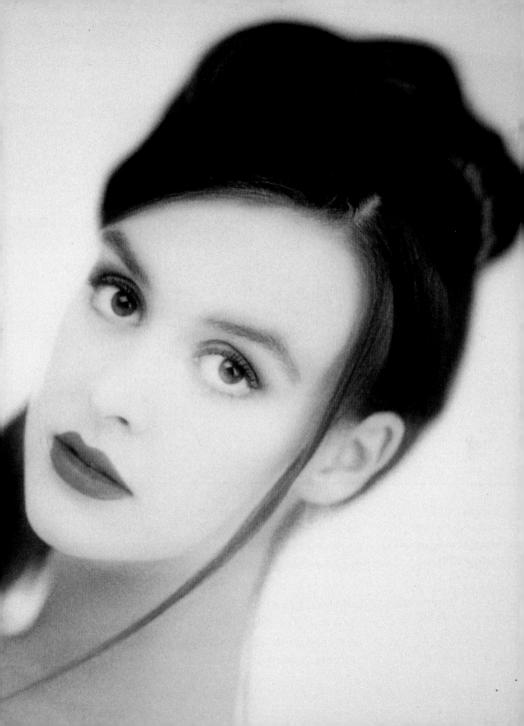

dennis richards

photographer Roger Hicks

Blandford Press

Your choice of format has considerable influence on what you

can get away with. With a true soft-focus lens, 6x7cm is as small

Dennis Richards
Frank Drake

As it is safe to go, and the highlights in this shot hover on the edge of overexposure.

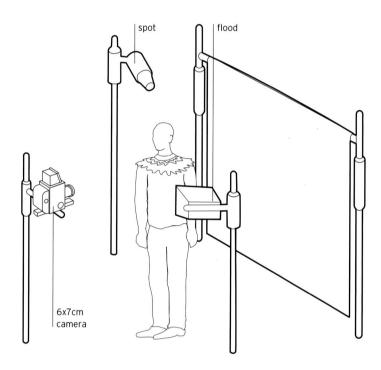

6x7cm

recorded

150mm soft focus

Aperture f/6.3; time not

Tungsten: 5K focusing spot + 2K flood

Black background paper

Fuii RTP ISO 64

Plan View

client

subject

camera Iens

film

assistant

exposure

lighting

props and set:

USE

key points

- Surprisingly powerful tungsten lights are needed for convenient exposure times on slow colour films
- The eyes have a distant look: the effect would be quite different if they were turned more towards the camera

With 35mm the highlights would be "blown" and the soft-focus would be excessive; with 4x5in or (better still) 8x10in there would be more opportunity to "see into the shadows" in the lower part of the picture. But the hair is adequately differentiated from the background, though the underside of the chin is almost lost. The key is a

5K spot to camera left, back lighting the right cheek (to the point of overexposure) and delineating the nose clearly. A 2K flood, diffused with a fibreglass scrim, gives the left cheek a more normal exposure. Plenty of room between the subject and the background allows the picture to come out of pure, shadowless black.

Photographer's comment

The deliberate overexposure of the right side of the face is meant to re-create the bright, clear light of Africa. This photograph was featured in my book Advanced Portrait Photography.

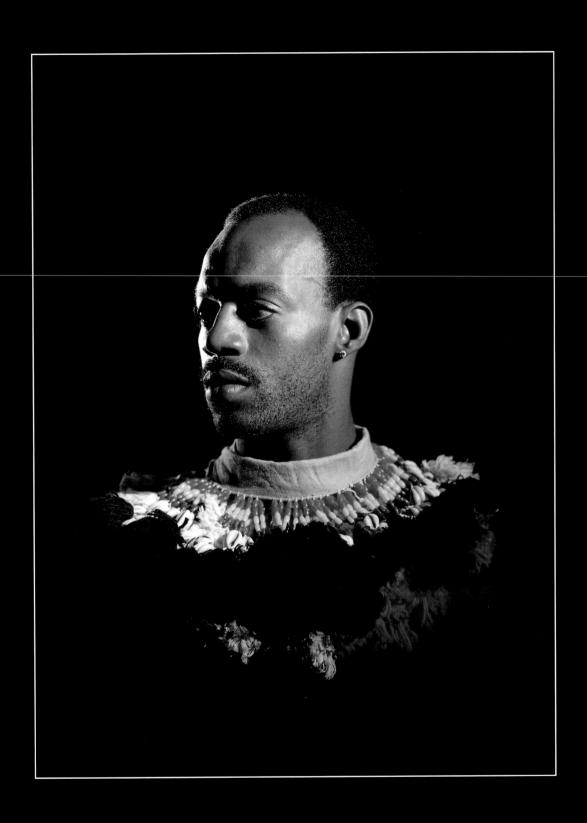

paddy ashdown

photographer Colin Glanfield

hundred copies of this picture."

use Publicity/portfolio subject Paddy Ashdown

camera 8x10in

lens 360mm (14in)

Kodak Ektachrome Type

6118 ISO 64

exposure

film

lighting Electronic flash: 2 heads

props and set Hand-painted

background

Plan View

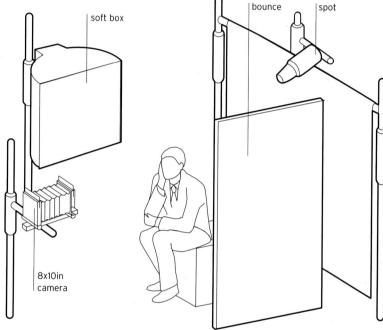

"I wanted this as a portfolio shot; I was considering a book on

eminent figures of Paddy's (and my) generation - people over

the age of about 50. Since then, he has requested several

key points

- ► Even elderly 8x10in cameras and lenses can give wonderful character portraits
- ► There is no need for very powerful lights, as working apertures are normally around f/11 or larger
- ► Very large formats are best suited to formal or semi-formal portraits

Portraiture with 8x10in cameras is relatively rare nowadays, but it gives a quality that is not readily obtainable with smaller formats. There is no need for a great deal of power in the lighting, as 8x10 portraiture is traditionally carried out at, or close to, full aperture.

The key light was a 1000 joule head in a medium-sized soft box: a

90x120cm (3x4ft) "Super Fish Frier", set to camera left, with modest fill from a 120x240cm (4x8ft) white bounce to camera right. Another 1000 joule head, heavily snooted and knocked back with scrims, looked down from above the hand-painted background. It served principally as a hair light, though not in the usual back light sense.

Photographer's comment

I shot this portrait with a 14in f/6.3 uncoated Tessar, which is neither a conventional soft focus lens nor as bitingly sharp (at least at full aperture) as a modern high-quality objective.

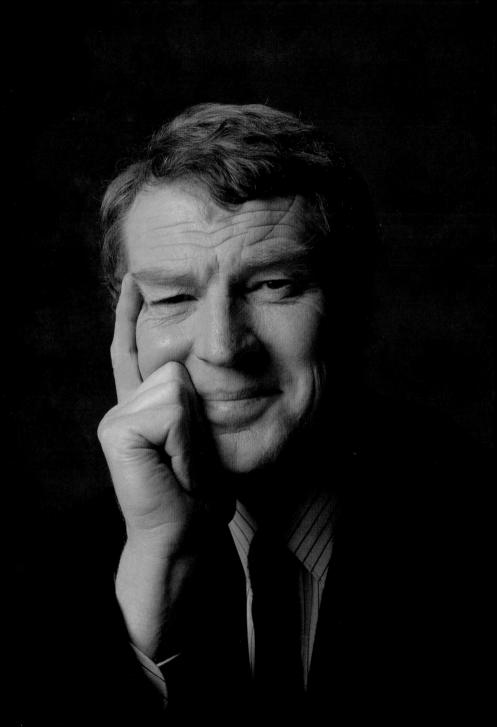

richard branson

photographer Alan Sheldon

client

Gulliver (Japanese travel

magazine)

use camera Editorial 645

lens

150mm

film

Fujichrome RDP ISO 100

exposure

1/25 second at f/8

lighting

Daylight

props and set

Location

Unusually, the photographer says that he exposed for the shadows and let the highlights take care of themselves: a common enough approach in monochrome, but rather less usual in colour. The result is that much of the shirt hovers on the edge of overexposure, and the window frame behind Richard Branson is very bright

645 camera

indeed; but it all works. What is more. this is true sunlight, not overcast light, which is easier to handle from a contrast point of view but is very blue and dull from a pictorial viewpoint. The directionality and warmth of the light is very important, though reflected light from a variety of sources does create a good deal of natural fill.

This is an absolutely straight daylight shot, with no light modifiers, no fill flash, nothing: just a very careful choice of location, and extremely precise exposure. Choosing Fuji RDP, with its inherently long tonal range, was crucial: Velvia would not have worked.

Plan View

key points

- ► Fair skin, fair hair and a light shirt allow very slight (about ⅓ stop) underexposure without making for an unnaturally dark complexion
- ► The eyes are slightly narrowed against the glare of the sun, but the impression is of intelligence and calculation rather than squinting

Photographer's comment

Every shot from this session features the hand covering the mouth. Why? He had a chapped lip, and we didn't want it to show.

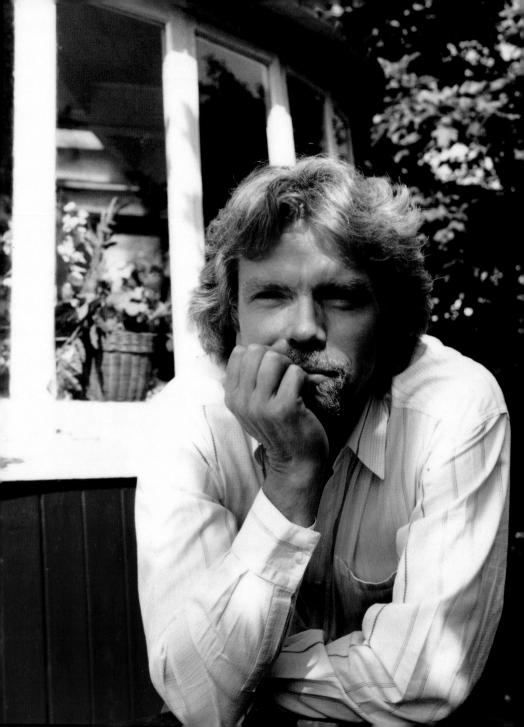

mel brooks

photographer Alan Sheldon

client

20th Century Fox Press/publicity

camera

645

lens film 80mm

Kodak Tri-X Pan at ISO

exposure

1/60 second at f/11

lighting

Electronic flash: 3 heads

props and set

White background paper

Plan View

A light with a large honeycombed reflector, about 30cm (12in) square, to camera right, almost at right angles to the line of sight but slightly in front of the subject's eyes, provides the key to this picture. Kodak Tri-X pan, rated at its full speed, is fairly contrasty and very dramatic. There is a Lastolite reflector just out of shot, to camera

left, to provide fill. Some more fill comes from reflections from the brightly lit background, which is illuminated by two standard heads. All three lights (key and two background) are 500 joule units. All of the equipment – lights and background included – was brought to the location for the portrait.

The lighting of this portrait is substantially identical to that of the large head portrait of Mel Brooks on page 31, but it illustrates how much difference can be made by pose and by switching from colour to monochrome.

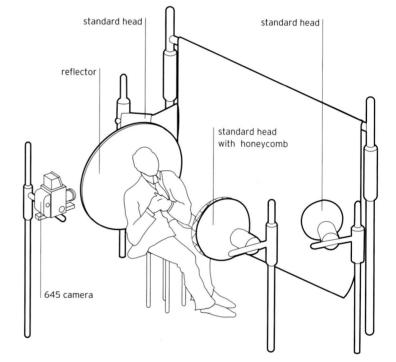

key points

- Even in portraiture, depth of field is sometimes important: the hands would not "work" if they were not sharp
- Even the smallest roll-film format, 645, can deliver exquisite texture and detail
- Broad areas of extreme tone (the jacket, the background) are well balanced by areas of detail and texture (the face, the hand, the tie)

Photographer's comment

This was one of my earliest portraits. Looking at it now, the hands seem rather too big – they would have been better with a 150mm – but they still serve as a useful counterbalance to the face.

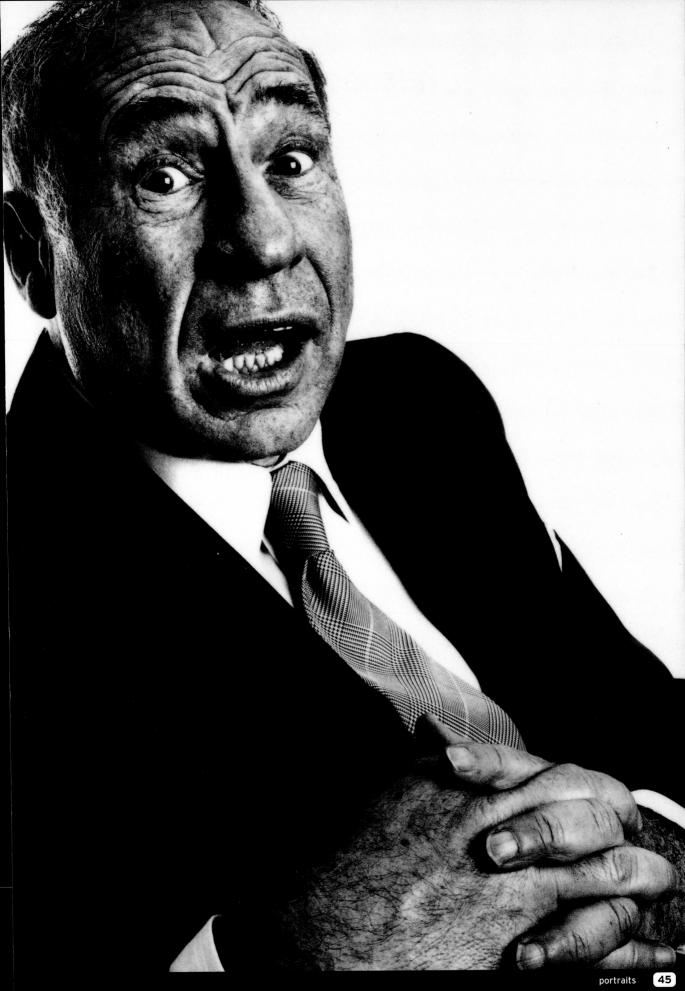

hat model

photographer Alan Sheldon

client

Slags (hatters)

use

Editorial

assistant

Dave Hindley

camera

645

lens

150mm with short extension tube

film

Fujichrome RDP ISO 100

exposure

⅓₀ second at f/11

Tunasten

lighting

Painted backdrop

props and set Pa

Some daylight-balanced films react better to tungsten lighting than others, and Fuji RDP films are among those that respond particularly well. This was lit only with tungsten lighting, using three heads: a key light, a back light, and a background light.

Plan View

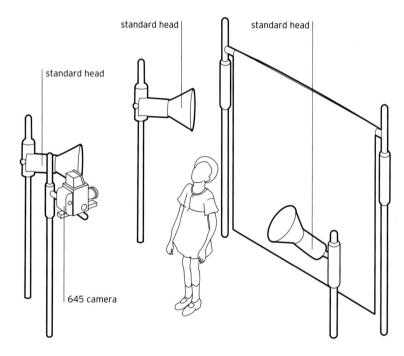

key points

- You should err on the side of overexposure when shooting daylight film under tungsten lights
- Hair lights and similar back lights should be used with caution as they are easily overdone

The key light is a standard head to camera left, but at a fairly acute angle to the line of sight of the camera and rather above the subject's eye-line. Going to the edge of overexposure means very bright highlights, but it helps to hold the colours and textures in the hat and clothes and is no problem in the light of the model's

dark complexion; it also "works" well when shooting daylight film under tungsten lights.

A second light behind the model and very slightly to camera right serves to differentiate the hat from the background - look at the very edge - and a third light is shaped to give a "hot spot" on the painted backdrop.

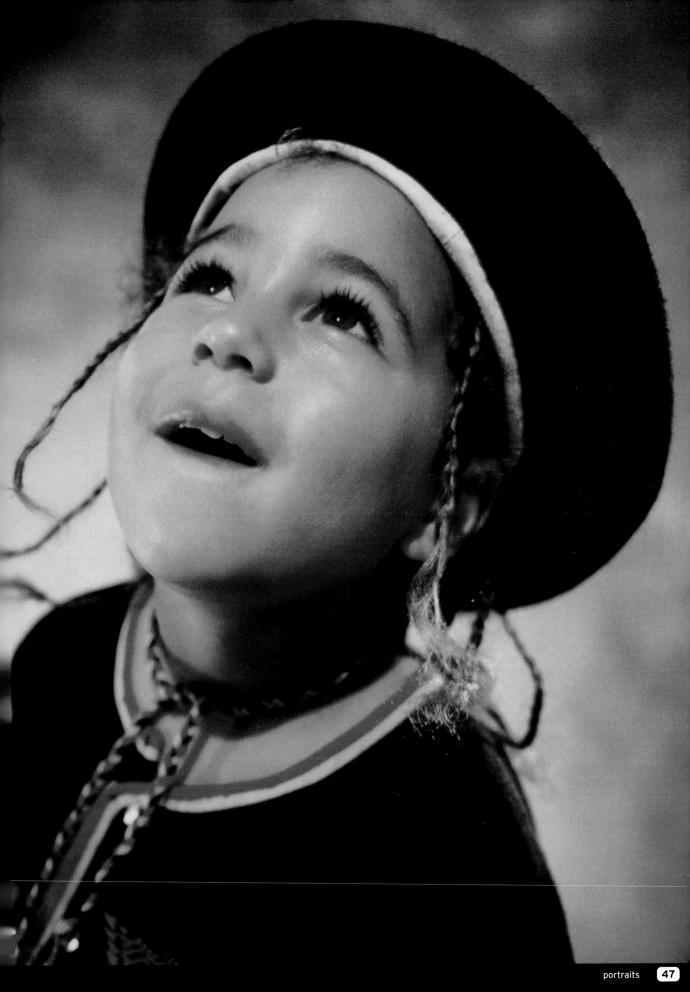

stephen fry

photographer Alan Sheldon

client

ES Magazine

use

Editorial

assistant

Quintin Wright

camera

6x6cm 150mm

lens film

Kodak Tri-X rated at El

exposure lighting

Electronic flash: 3 heads

props and set

Location studio

1/60 second at f/8

(see text)

Plan View

This was shot in the rehearsal room at a theatre, in between all the other things that go on at a rehearsal: the actual photographic session lasted no more than 15 to 20 minutes. The print is selenium toned. The key light is a 500 joule light with a standard

reflector and a medium honeycomb, to camera right at about 45° to the line of sight; the shadows clearly show the angle. The only other light is on the background, where two standard heads burn the white paper out to a clear, bright maximum white.

standard head

Although he works in many other areas as well, Alan Sheldon is particularly well known for his "portable studio" technique: he carries with him not just his lighting but also his backgrounds

standard head

standard head with

honevcomb

and even (if necessary) a generator.

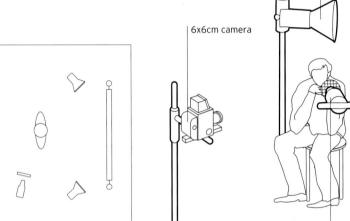

- ► Portable background stands and a roll of seamless paper can transform location portraits
- ► There is a difference between a pure white background and an overlit or apparently luminous background
- ► This photograph is a rare example of a genuinely square composition in the square format

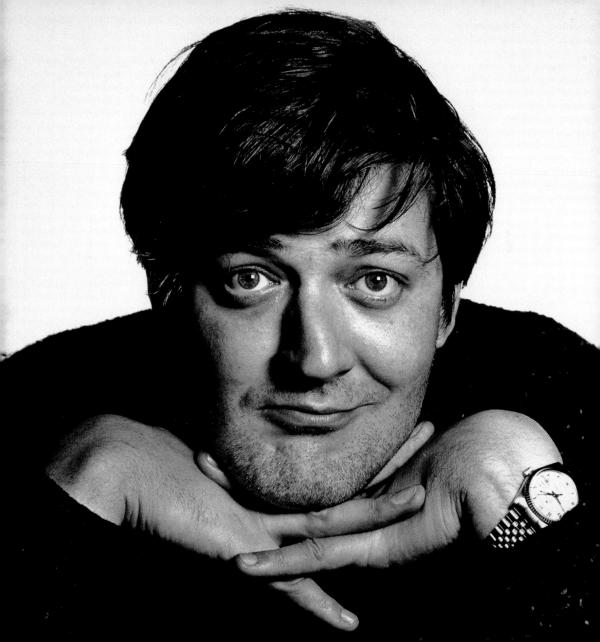

mephistopheles

Mephistopheles comes in many guises; here he is smooth,

urbane, ready to strike a deal, always willing to compromise -

until he has your soul, when suddenly his true nature is revealed.

photographer Johnny Boylan

Quite like the average client, really.

client

Royal Shakespeare

Company

use

Poster for Faust

assistant

Belinda Pickering

camera

6x7cm

lens

180mm Agfa APX 100

exposure

f/11

lighting

Electronic flash: one

head

props and set

Painted grey background

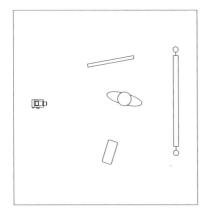

Plan View

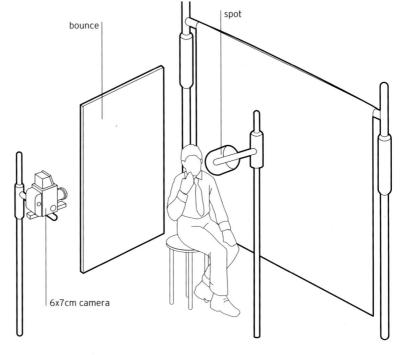

key points

- Monochrome films can deliver superb skin texture
- Different skins differ not only in tone but also in the way that they handle highlights: some are shinier than others, for example
- Adaptation of large, old tungsten lights to flash can create some interesting light sources

Lighting dark skin presents different challenges from lighting light skin because highlights tend to be brighter and shadows darker.

The key and only light is high and from camera right; the shadows show clearly where it is coming from. The light itself is unusual: an old 2K focusing spot with the hot light source replaced by a flash head. A number of photographers have made similar

conversions of big old hot lights because they give a unique quality of light: a relatively large source, yet highly directional.

The lighting set-up is completed with a white bounce for a fill to camera left, described by the photographer as a "half poly board"; in other words, a 120x120cm (4x4ft) white polystyrene reflector, half of a full 4x8ft sheet.

Photographer's comment

I like Agfa APX because it delivers contrast that is both gentle and clear: not harsh, but not flat either.

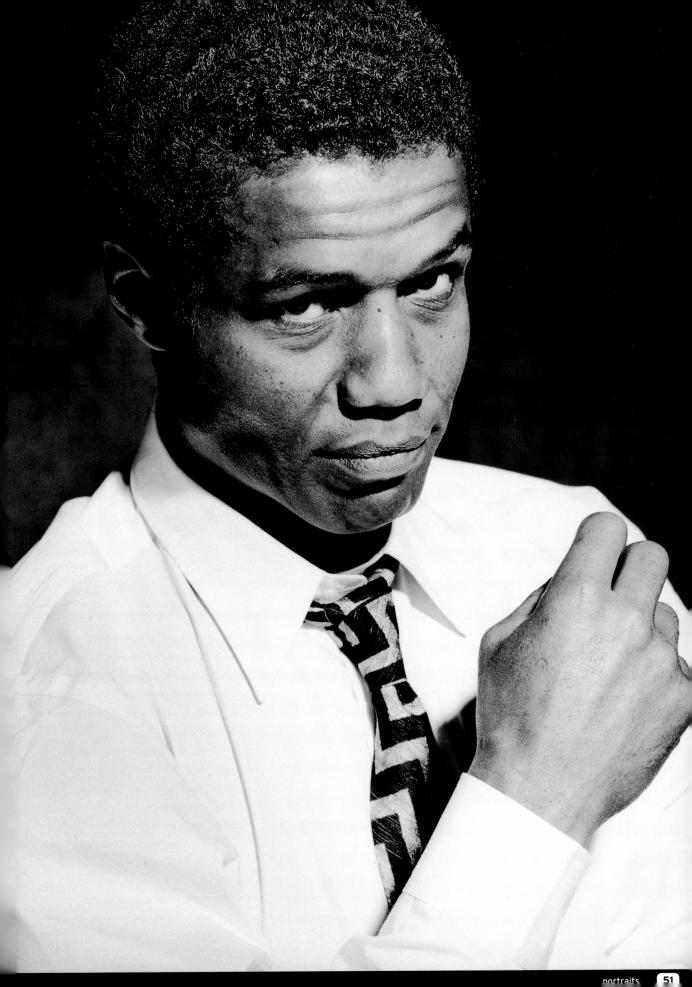

chinese girl

photographer Clive Stewart

use

Self-promotion

camera

6x7cm

lens

180mm plus vignette and

soft focus screen

film

Ilford FP4

exposure

f/8

lighting

Electronic flash: 3 heads

props and set Paint

Painted canvas backdrop

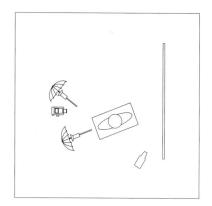

Plan View

key points

- Different umbrellas (silver and white) give different qualities of light
- Choosing monochrome films for portraiture is an intensely personal business, but many photographers reckon that they get better results with "old-technology" films like Ilford FP4 than with "new-technology" films like Ilford Delta 100

The key light in this photograph is a silver umbrella to camera right,
1.5m (5ft) above the ground, with fill provided by another umbrella directly above the camera, which itself is about 1m (40in) off the ground. The technique of using a silver umbrella for extra directionality and reflectivity, and a white umbrella for a softer fill, is well worth remembering. As usual with successful portraits, there is plenty

of room between the model and the background: in this example, about 2m (61/2ft). This prevents spill from the main lights illuminating the whole background, which is separately lit with a snooted spot.

A home-made vignette and a very weak soft focus screen completes the set-up: soft focus screens normally work better and better as formats get larger, and with 6x7cm they are fine.

standard head with umbrella snooted spot standard head with silver umbrella 6x7cm camera

If ever proof were needed of the fact that, today, 6x7cm can

calls to mind the daylight studios of our ancestors.

replace 4x5in even for the most traditional portraits, this is it -

though soft, directional lighting, very skillfully used, still further

Photographer's comment

My aim was simplicity with regard to lighting and props, thereby allowing the model's expression to dominate.

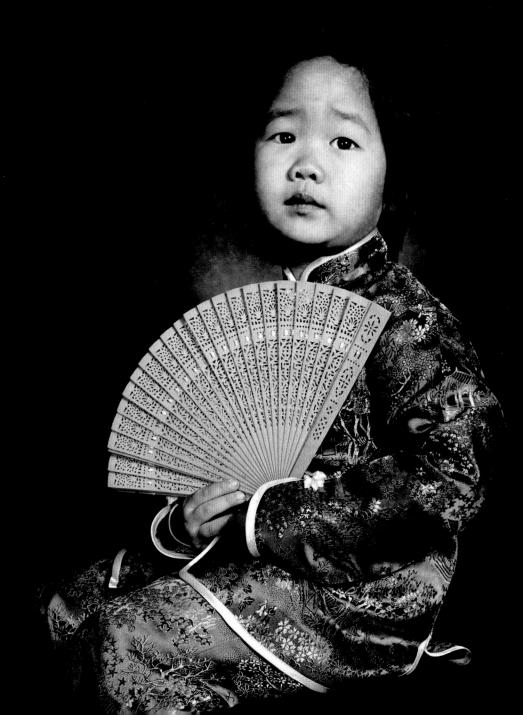

red sari

photographer Kay Hurst, K Studios

Exhibition Kate Maneckshaw

assistant Katy Niker camera 645

lens 75mm

use

film

model

exposure f/11

lighting Electronic flash: 2 standard heads, 1 soft box

props and set Fabric "tent": print

heavily reworked

Kodak T-Max 100

Plan View

key points

- "Tents" of translucent or diffusing fabric can also be very effective when employed in conjunction with more conventional high-key, soft-focus techniques
- ► The two best ways to create an impression of antiquity while retaining photographic quality are with grainy, overexposed, low-saturation images or with the sometimes vivid colours of hand tinting

Like many of Kay's pictures, this has been heavily reworked. However, the lighting is more complex than it seems. The key light is simple enough – a soft box to camera right – but the background is interesting.

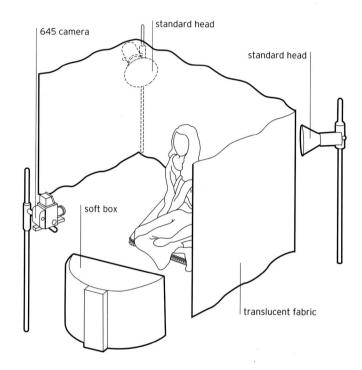

The subject of this unusual portrait is sitting, enclosed on three sides in a tent of translucent material, which is back lit by two standard heads to bring out the texture and drape of the cloth. She is also sitting on an Indian-patterned throw.

The original black and white image was printed onto Kentmere Art Classic paper, and the vivid colour of the sari was added with photo dyes; The sari was red in the original, too. Other

details were added in dye, and then the whole picture was reworked with a heavy, fairly dry gouache. Finally, it was mounted on hardboard and varnished to give the cracked, antiqued appearance. Although much of the detail of both the lighting and the backgrounds is obliterated by the after-work, enough of it remains to create the impression of a carefully-made picture that has weathered many years.

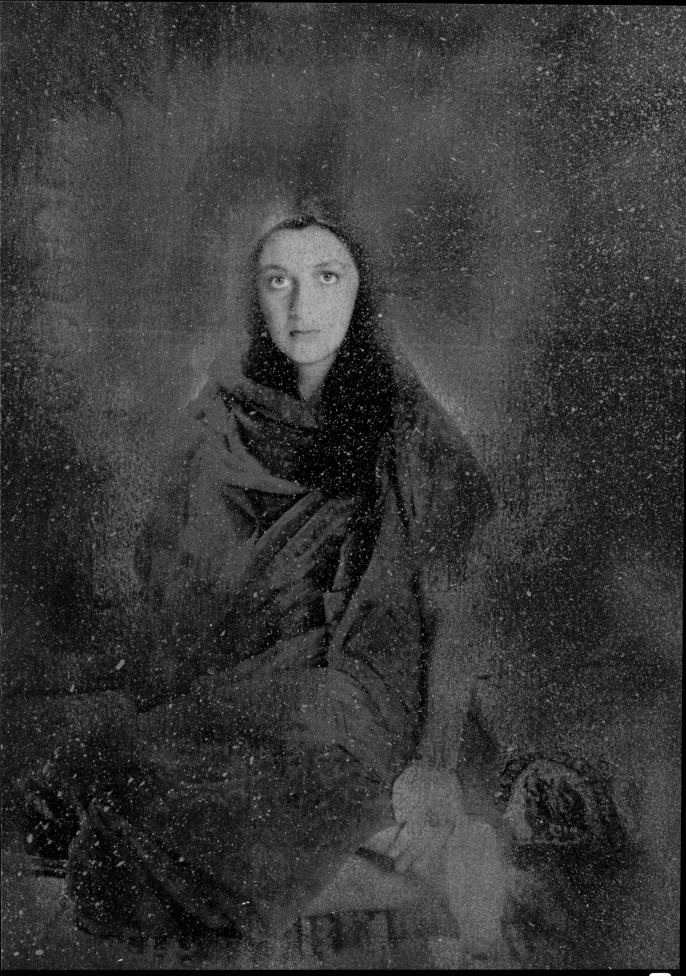

susan

photographer Massimo Robecchi

35mm camera

client

Studio Magazine

use

Editorial

model

Susan

assistant and stylist Teresa La Grotteria

art director

Olga Stavel

make-up and hair

Gianluca Rolandi

camera

35mm

lens

300mm

film

Ilford XP2 ISO 400

exposure

1/500 second at f/2.8 Available light + bounce

lighting props and set

Location

Plan View

Even so, Massimo Robecchi added a white bounce in front of the model to even out the light still further: the white drop of the table-cloth is thereby brought nearer to the tone of the clothes and the background, and the dark stockings are made to read just a

little better. This is one of those cases where a collapsible reflector such as a Lastolite or a Scrim Jim can be extremely useful - and where the effect is completely different from fillflash, touted by camera manufacturers as the answer to everything.

bounce

This picture well illustrates that an overcast day can be vastly superior to sunshine, especially if you are shooting in monochrome. With light coming more or less evenly from all directions, the tonality can be exquisite.

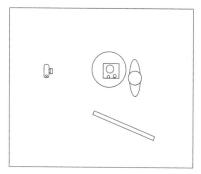

- ► Exposure is a subjective art: arguably, everything in this picture is just a tiny bit darker than it "really" is, but this holds the tones in the white clothing
- ► A 300mm lens, used wide open at f/2.8, allows the background to be subtly suggested rather than too clearly delineated

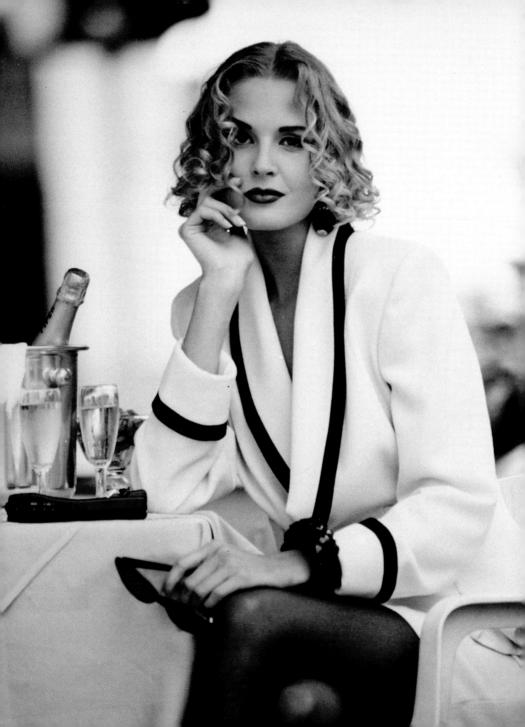

kings road portrait

photographer Alan Sheldon

The leading exponent of this photographic style - the character Personal research model Passer-by on King's Road portrait against a plain white background - is Richard Avedon. assistant Nick Henry Following the lead of the master, Alan Sheldon has explored the camera 4x5in same techniques in both colour and monochrome.

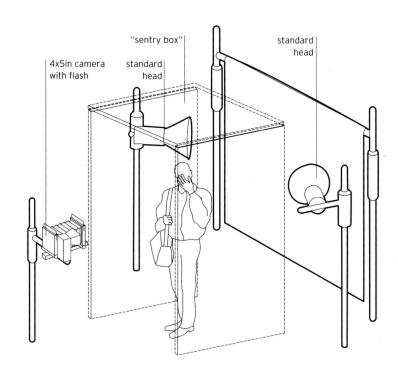

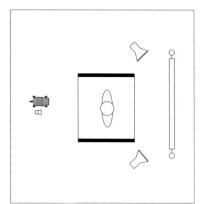

180mm

EI 200

Kodak Tri-X rated at

1/60 second at f/5.6

Daylight plus tungsten

plus flash (see text)

Built "sentry box"

(see text)

Plan View

use

lens film

exposure

props and set

lighting

key points

- A "very small" flashgun on the camera (power not recorded) gives the catchlight in the eyes
- Increased exposure and decreased development allow the film to capture a long tonal range

This was shot on the King's Road in Chelsea, London. The uprights of the "sentry box" were made of 240x120cm (8x4ft) sheets of expanded polystyrene, painted black; the roof was a half sheet, 120x120cm (4x4ft). The whole was held together with gaffer tape and meat skewers.

The box is about 180cm (6ft) in front of a white backdrop - another 240x120cm (8x4ft) sheet - which is lit with two 800 watt tungsten lamps powered by a generator. This gives a bright, neutral background, while the black sides and roof ensure that the only light on the subject is frontal daylight.

Photographer's comment

After this series I went to a 300x300cm (10x10ft) backdrop: I had trouble with the edges of the 240x120cm (8x4ft) drop getting in the picture.

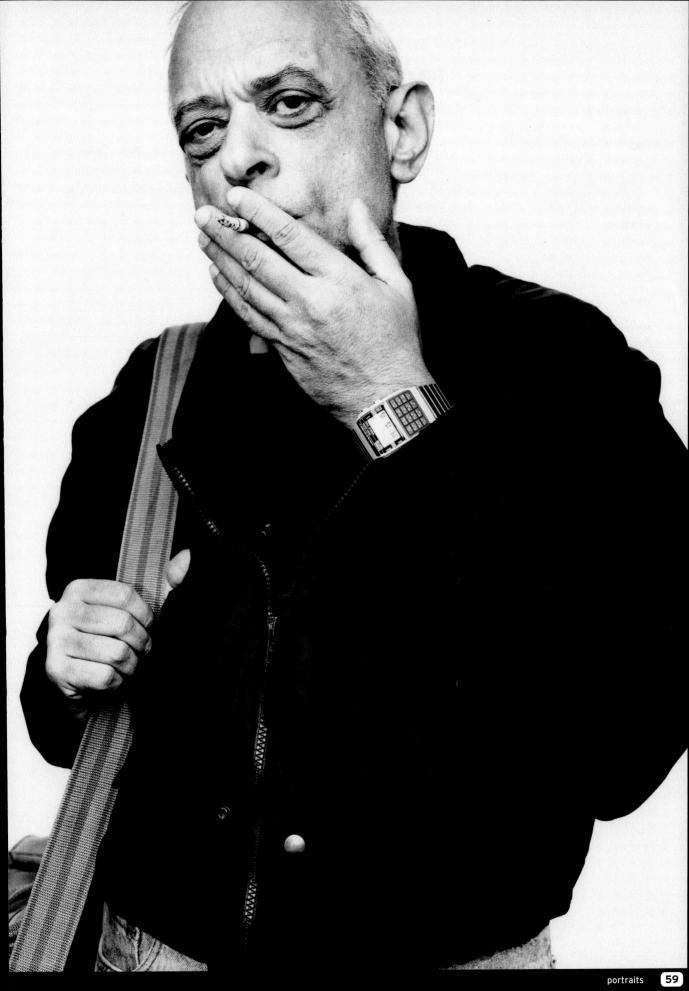

lee

photographer Johnny Boylan

casual snapshot that it seems to evoke.

client

Lee Jeans

use model Advertising Rufus (from Storm

agency)

assistant art director Siri Hills Richard Stevens

camera

35mm

lens

200mm

film

Kodak Tri-X rated at EI 1600; toned print

exposure

Not recorded; maybe

1/500 at f/11

lighting

Daylight

props and set

Location

Plan View

To begin with, the choice of "pushed" Tri-X adds a note of gritty realism. Boylan normally uses Agfa APX in black and white, but he switched to a faster, grainier, "old-technology" film and then accentuated its vintage

Few people who saw the advertisement would have known how it was created, but they would recognize the James Dean/Marlon Brando 1950s style of the image. A

qualities by pushing it to EI 1600.

200mm lens compresses perspective for a strongly graphic appearance, and creates a shallow depth of field. A long lens has been used to echo the cinematic style. Close-ups like this in the movies are often made with surprisingly long lenses.

Finally, choosing the right tree, and the right side of the tree, so that the light falls right (the subject is shaded by the tree), distinguishes the skilled photographer from the snapshotter.

Daylight is an obvious choice for the natural look, and 35mm

often has a sense of immediacy that is not readily obtainable

with larger formats. This is, however, a very long way from the

- ► "Pushed" fast films often exhibit surprisingly subtle tonality
- ► Grain can be an integral part of an image. "Old-technology" films, or Kodak TMZ P3200 pushed beyond El 5000, give the most grain

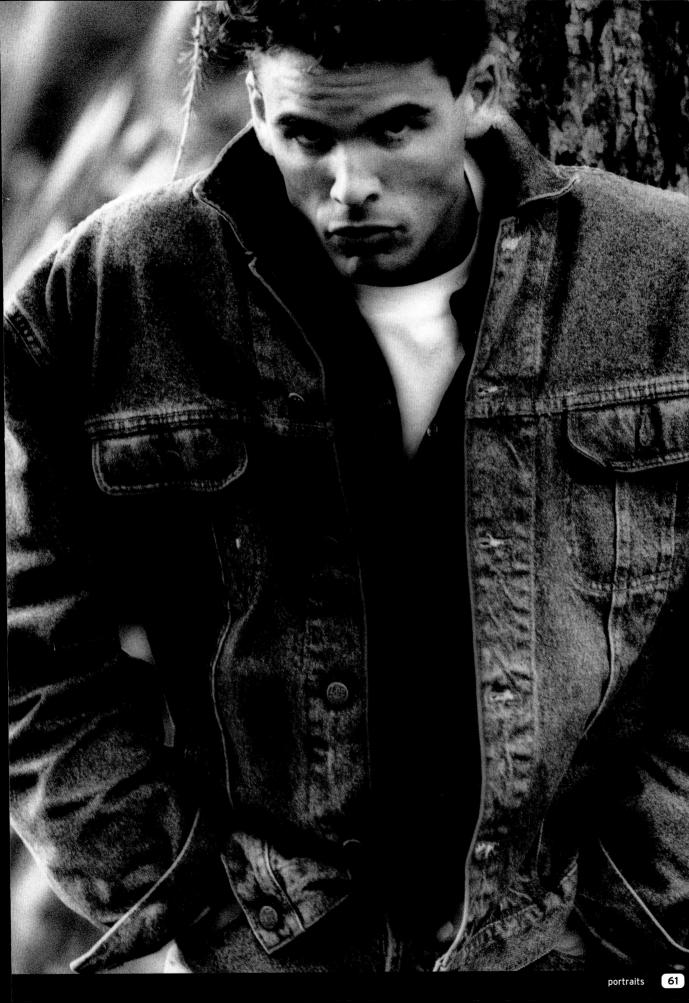

jeannette arata de eriza

photographer Maria Cristina Cassinelli

looked at ease holding an airline ticket."

client

Swissair

use

Advertising

art director

Carlos Gerard & Alberto

camera

Paladino 6x6cm

lens

150mm

film

Kodak Ektachrome EPP

ISO 100

exposure

f/11

lighting

Electronic flash: 3 heads

props and set

Location

Plan View

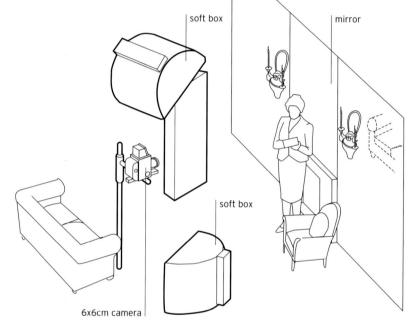

Maria Cristina well describes this herself: "This was a part of a

campaign for Swissair where photographers around the world

were each asked to create an image in which a VIP customer

key points

- Lighting parts of a scene to be reflected in a mirror is often difficult but can be very effective
- Strip soft boxes can give very controllable light for taking "environmental" portraits of people in their surroundings

She continues: "Very soft lighting was used to flatter the looks of this extremely elegant lady. I like her reflection in the mirror, which also reflects part of her living room; this creates a mood without interfering with the main subject."

Three lights were used here.

Because the lighting is so soft, there is no strong key. The lighting on the

subject comes partly from the 75x100cm (30x40in) soft box over the camera and partly from the 45x150cm (18x60in) strip to camera right; the latter creates the slight modelling on the skirt. A third large soft box illuminates the wall opposite the mirror. Extremely careful exposure holds texture in the white suit without being too dark overall.

Photographer's comment

There were the usual problems with mirrors: you have to be very careful or you'll find some of the lighting, yourself or even the make-up artist included in the picture.

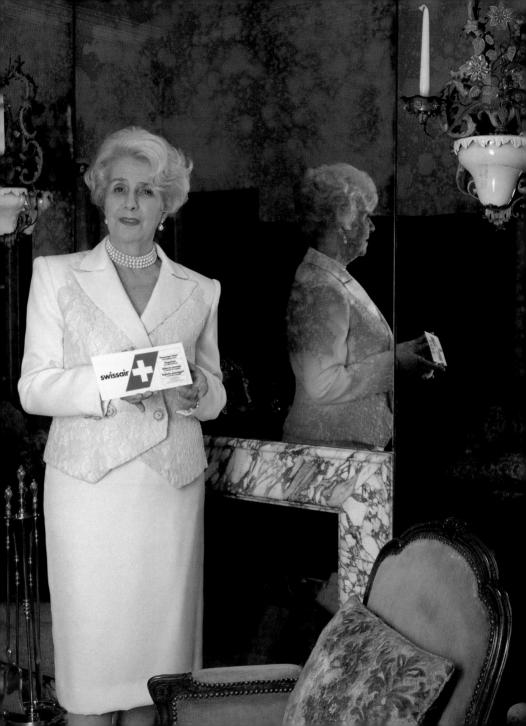

mercedes sosa, folk singer

photographer Maria Cristina Cassinelli

The folk singer is lit with a single large 100x200cm (40x80in) soft box to camera left. The other five heads were fitted with grids or snoots and were positioned to create lights and shadows on the background.

client Polygram Records

use CD cover

art director Sergio Perez Fernandez

camera 6x6ci

lens 150mm with Softar soft-

focus screen

film Kodak TMX ISO 100 exposure ½25 second at f/11

lighting Electronic flash: 6 heads

props and set Built set

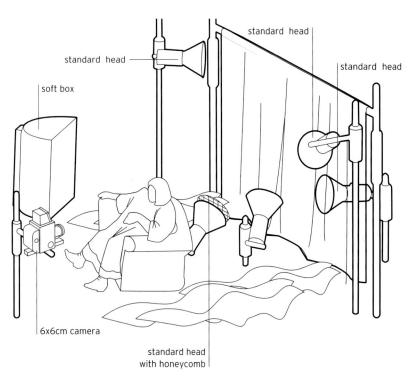

The photographer comments, "The set was made by a specialist, with dozens of yards of a very light fabric, covering an area of about 6x6m (20x20ft). The idea was to achieve an atmosphere that was light, soft and romantic, to convey the mood in her songs." The set is unique, so there is no point in describing the functions of each light in

detail. However, it is worth noting that they are used in a number of different ways: flat head-on illumination, transillumination, and glancing light to bring out texture. Because of the depth of the fabric, a single light might fulfil two or more of these functions: the positioning of the material can be as important as positioning the lights.

Photographer's comment

She has a wonderful voice, and during the shoot we had a recording of her music playing to help us with the mood.

- ► There are more ways of creating lightness and airiness than by simple high-key
- ► When using very light, trailing fabric like this, remember that even modelling lights can start a fire

Plan View

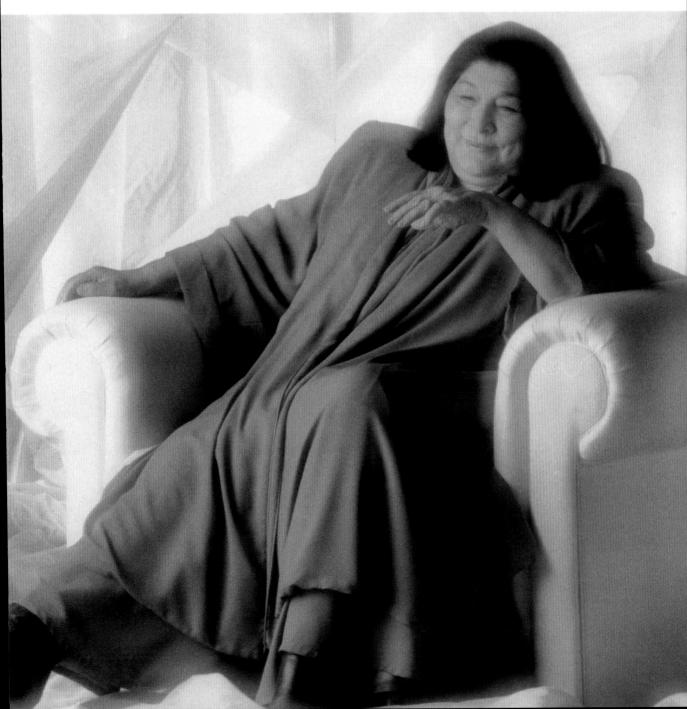

louise

photographer Stu Williamson

"break the rules" in such a way.

soft box

Tri-Flector

Louise is a singer, and this was shot as a publicity photograph.

It is a good example of Stu Williamson's dramatic, contrasty

lighting style: a less original photographer might not dare to

client

Louise

IISE

Publicity

camera lens

6x7cm 150mm

film

Kodak Plus-X Pan

exposure

f/11

lighting props and set Electronic flash: 2 heads

Black shiny material,

black gloves, jewels, floor stand fan blowing hair

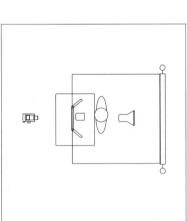

Plan View

The reflections in the subject's eyes reveal the lighting. The upper reflection is of a 100x100cm (40x40in) soft box, about 100cm (40in) from the subject, above and in front. The lower reflection is of the Tri Flector, a threepanel reflector of the photographer's own design. A small light on the

6x6cm camera

background completes the set-up. The dramatic-looking cloak is just a length of shiny black material; Louise was also wearing black gloves. In the photographer's own words, "The real key to this picture is the wind machine, which was blowing her hair upwards. I just shot the way the hair fell."

standard head

key points

- ► A monochrome portrait does not always have to exhibit "camera club" gradation and skin tones
- ► Wind machines do not always have to be used horizontally
- ► Hand colouring does not always have to be naturalistic

Photographer's comment

Eye contact is always important, and Louise has beautiful eyes. I coloured them yellow to draw still more attention to them.

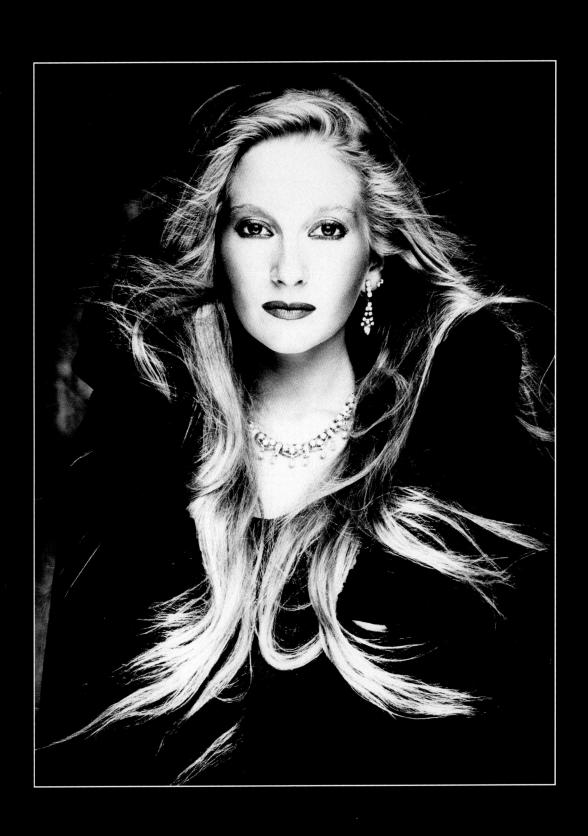

diva

photographer Ben Lagunas and Alex Kuri

client

Miami Magazine

use

Editorial

model

Cristina

assistant

Isak de Ita, Janina Cohen

art director

Alberto Mellini

stylist

Toto

camera

4x5in

lens

300mm

film

Kodak Tri-X Pan

exposure

f/8

lighting

Electronic flash: 7 heads

props and set

White background

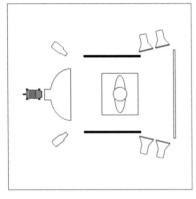

Plan View

With a pure white burned-out background you do not need as much space behind the subject as usual – but you do need a great deal of light on the background, such as the four standard heads used here.

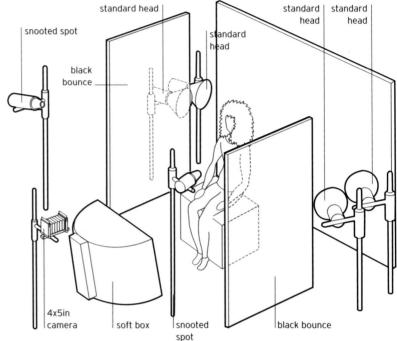

key points

- Dark feathers and dark fur "eat" light and require plenty of illumination if you want to show texture
- Very brightly illuminated high-key backgrounds will often flare through or around the edges of the subject, for good or ill
- High-key effects are often more dramatic in monochrome than in colour

The three remaining lights are two snooted spots, mounted high (2m/6½ft) and symmetrically on either side of the camera, with a soft box unexpectedly mounted below and in front of the camera. Normally, lighting a portrait from below is regarded as anathema but in this case it is entirely logical as the soft box is only a fill. In fact, it is similar to the "troughs" of tungsten lamps that were similarly positioned in the portrait studios of

yore; unlike them it does not melt the subject's make-up. Considerable amounts of light are needed to make the feathers read at all, and the model's face is at the limit of what would normally be acceptable exposure. In black and white this adds to the magic of the picture: in a colour photograph, it would probably be impossible. The lightness of the model's face is also counterbalanced by the very bright background.

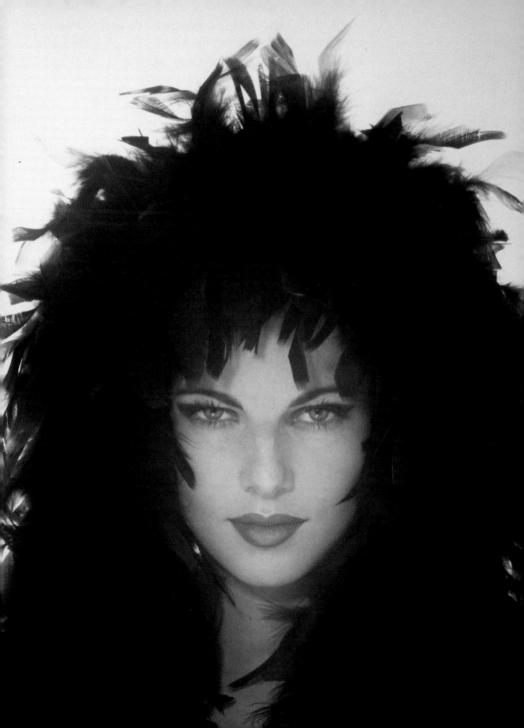

mourning flowers

Lewis often describes his own pictures best: "Déja-vu all

over again... My main job here was to open up the window

shades/venetian blinds and say 'aaahhh!' to the lighting."

photographer Lewis Lang

Exhibition/Print Sales use

camera 35mm 28mm lens

film Ilford XP1 rated at EI 250

exposure Not recorded lighting Daylight (see text) props and set

Basket of flowers; table with pedestal and statue

Plan View

The key light is in effect a large window to camera right, about 1.2-1.5m (4-5ft) from the subject. This provided soft yet directional side illumination from indirect sky-lighting. A very large, long window behind the camera provided frontal fill, again from indirect sky-lighting. This window was 3m (10ft)

35mm camera

The white walls acted both as background and as built-in reflectors to

or more from the subject.

even out and fill in the large area taken in by the wide-angle lens. Although 28mm lenses are normally associated with "violent" perspective, the strong symmetry of the composition, together with careful alignment of the camera, means that the picture "works" very well indeed. Also, the quality available from the best 35mm lenses and the best films can surprise the users of larger formats.

- ► The control available from opening and closing curtains and blinds (fully or partly) can be immense. Remember, this is how our ancestors' daylight studios worked
- ► Available light does not always look more natural than careful artificial lighting: the eye adapts quickly to widely varying illumination levels

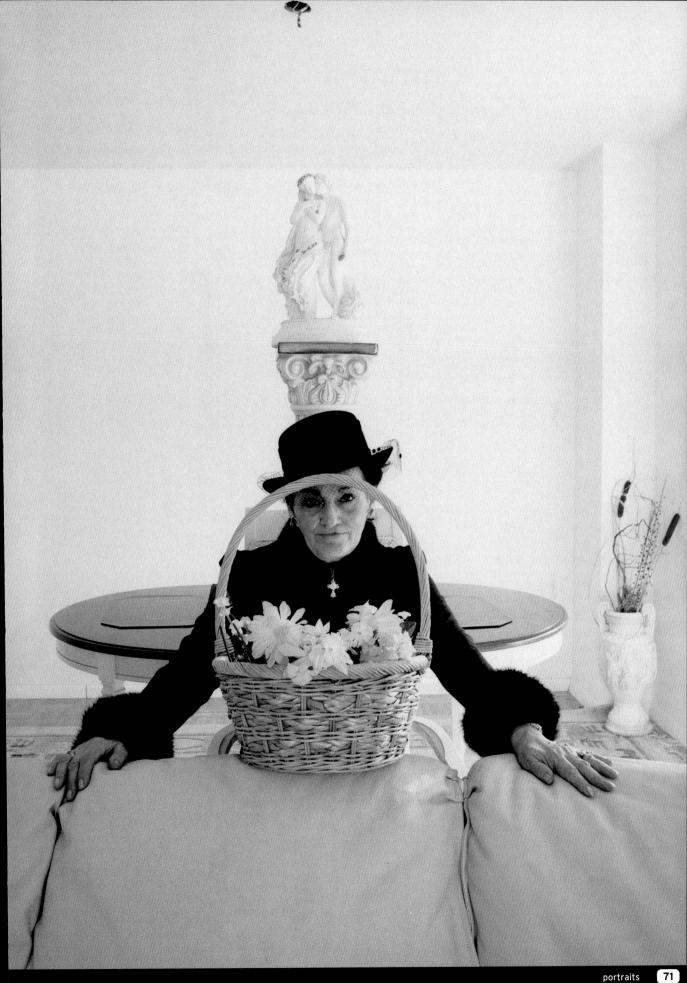

monica

photographer Peter Laqua

use

Self-promotion

model

Monica

stylist

Silke Schöepfer

camera

35mm

lens

85mm

film

Monochrome ISO 125/22

exposure

f/1.8

lighting

Electronic flash: 2 heads

props and set

White paper background

Plan View

The lighting is simple enough, though the background well illustrates the need to light the background separately (and reasonably powerfully) in a high-key picture. A standard head fulfils this task.

The key light is a 100x100cm (40x40in) soft box to camera left, set

slightly forward of the model's head: this provides some light even on the left side of her face, though a more conventional high-key approach would also have used a reflector to camera right to approach more closely Japanese-style notan, the antithesis to European chiaroscuro.

soft box standard head

The glasses, the hair, the self-conscious pout: the effect is pure

1950s, with overtones of Gary Larson's The Far Side cartoons.

The high-key effect is rendered more dramatic by the dark hair.

key points

- With 35mm, long lenses of wide or very wide aperture are required in order to approach the shallow depth of field our ancestors took for granted in portraits
- The "photo booth" simplicity of the presentation adds still more to the surrealism of the image

Photographer's comment

The eyes and the lips are the point of focus.

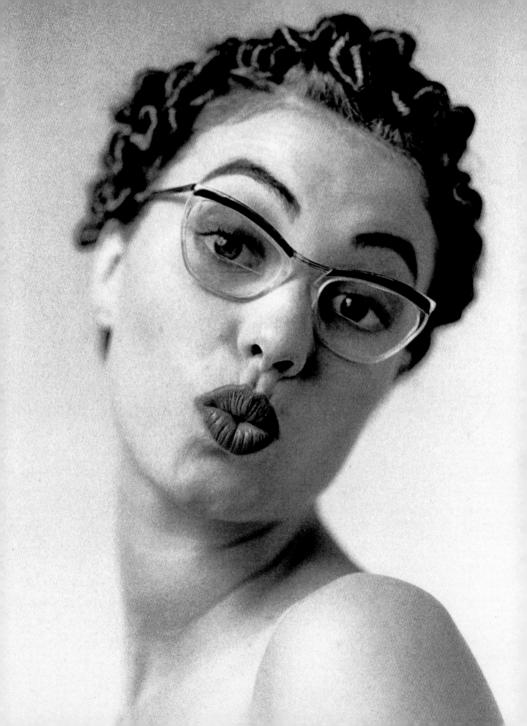

cigar

photographer Frank Wartenberg

use Portfolio camera 6x7cm

lens 185mm with warming

filter

film Fuji Velvia ISO 50

exposure Not recorded (multiple exposure)

lighting Electronic flash: 4 heads

props and set Grey background paper

Plan View

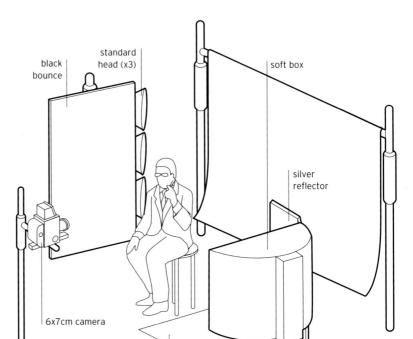

This is a good illustration of the "black-bounce" technique for

successful such lighting can be when the source is very broad.

dramatically directional lighting - and it also illustrates how

key points

- The line around the head is achieved by multiple exposures with only the background lights switched on
- Bear in mind that there is no such thing as correct exposure; there is only pleasing exposure
- With slow, contrasty films, ⅓ stop bracketing may be essential and ⅓ stop is generally the most that can be used

Three of the four heads illuminate the neutral grey background; the effect of the warming (pale orange) filter is most obvious here. The fourth light is a broad soft box to camera right with two big silver reflectors, one beside it and one on the ground in front of it. The black bounce on the other side helps to kill any potential fill.

silver reflector

Perhaps surprisingly, the film chosen is Velvia, which is very contrasty and "punchy". On the one hand, this emphasizes the directionality of the lighting; on the other, it means that the hand holding the cigar is effectively overexposed in conventional terms, though this makes the lighting still more dramatic.

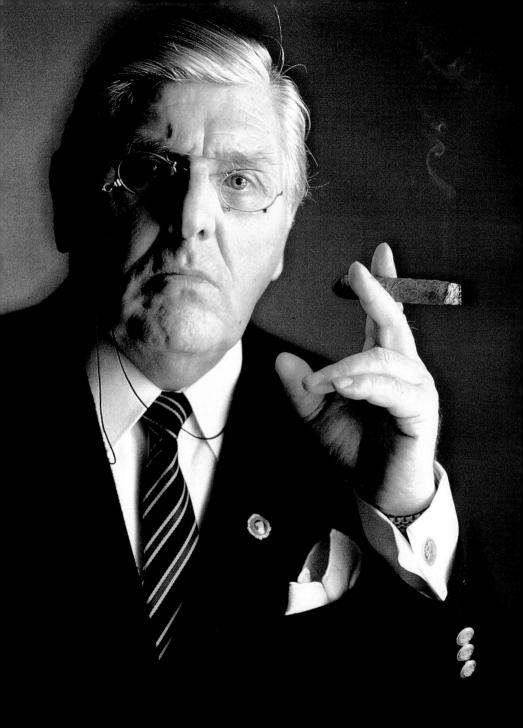

smoker

photographer Frank Wartenberg

use

Portfolio

camera

35mm 200mm

lens film

Polaroid Polagraph

exposure

Not recorded (but see text)

lighting

Tungsten: one spot

Back lighting and a long exposure are obviously the best way to represent smoke, capturing the model's hair at the same time; but what is the best way to get detail in those parts of the picture nearest the camera?

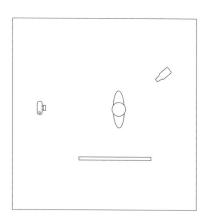

Plan View

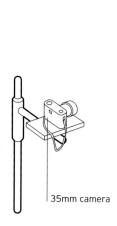

spot

reflector

- The length of exposure necessary to capture an image like this is unlikely to be much less than ¼ second or much more than two or three seconds
- The highlights on the zip, etc, on the front of the jacket have blurred during the long exposure

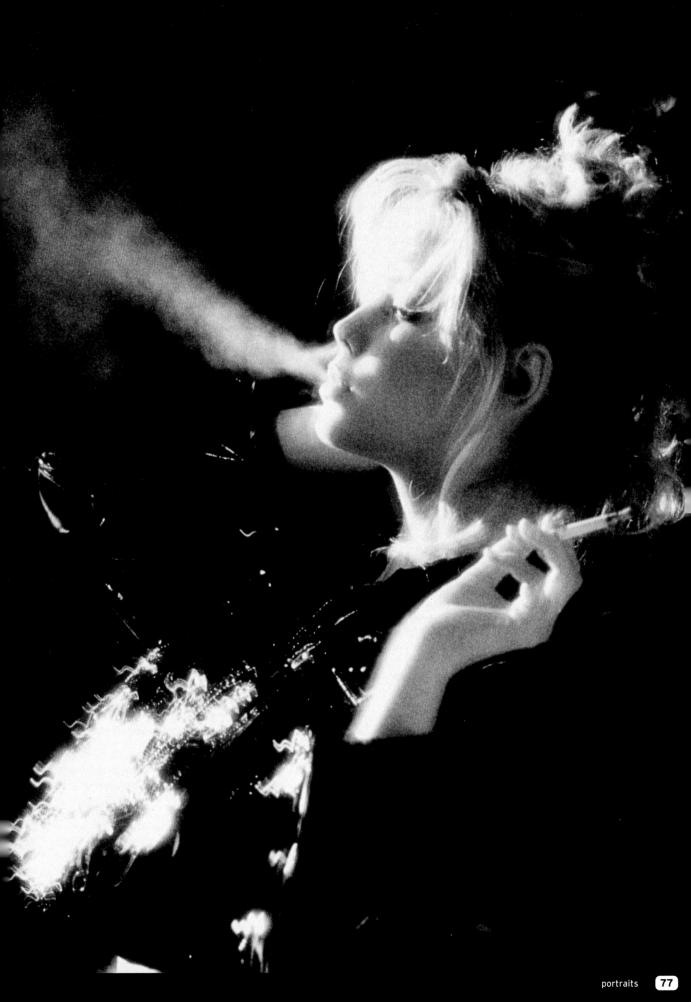

old man and cane

Strongly directional lighting is often very successful when

photographing people who are no longer in the first flush

of youth - though men are normally more willing to accept

photographer Frank Wartenberg

"character" portraits than women.

use

Portfolio

camera

6x7cm

lens

185mm + light orange

filter

Fuii Velvia

exposure

Not recorded; probably

about f/5.6

lighting

Electronic flash: 4 heads

props and set

Grev background paper

Plan View

standard head (x3) soft box silver reflector

key points

- Lighting the subject from one side, and grading the background from the other, can be very effective
- ► The larger the format, the better it will "see into the shadows"

The subject is very slightly back-lit from camera right by a large soft box supplemented with silver reflectors, so illumination is much stronger to camera right than to camera left: a black bounce kills any reflections that might act as a fill on the right side of the subject's face.

silver reflector

The background is lit with three heads to provide a graded ground that

is darker to camera right and lighter to camera left, thereby making the subject stand out all the more clearly.

For the initial exposure, both the soft box and the background lights were on; for several subsequent exposures, only the background lights were on. This produced the black shadow around the head and the softness of the outline.

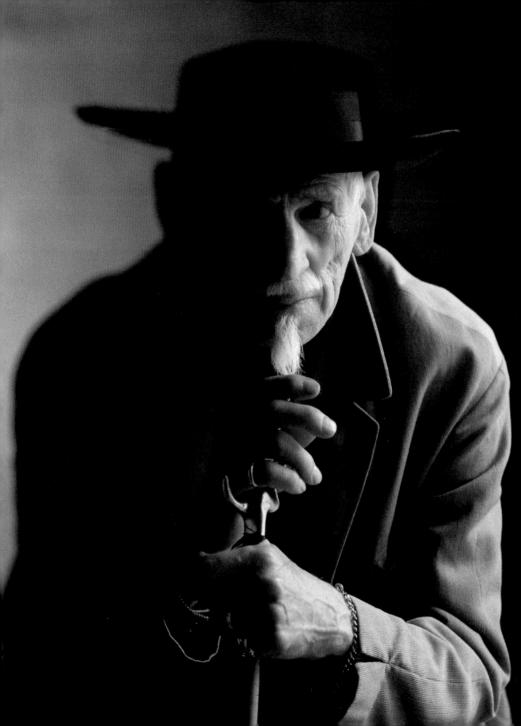

miner

photographer Johnny Boylan

striking and powerful.

There is a variety of portrait, unusual today, which was popular

reportage and the formal portrait. The overall effect can be very

with our Victorian ancestors. It is effectively a cross between

client

S.M.I./Powergen

USE

Advertising

assistant

Siri Hills

art director camera

Rov Brooks 4x5in

lens

210mm

film

Agfa APX 100

exposure

f/8; shutter speed not

recorded

lighting

Mixed flash and tungsten

props and set

Painted backdrop, timber

Plan View

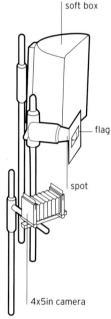

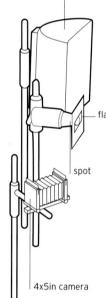

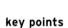

- ► Large formats not only render detail well; they also have an ability to "see into the shadows" that is unequalled by smaller formats
- ► In a built set a very skilled make-up artist is usually necessary to make the scene convincing

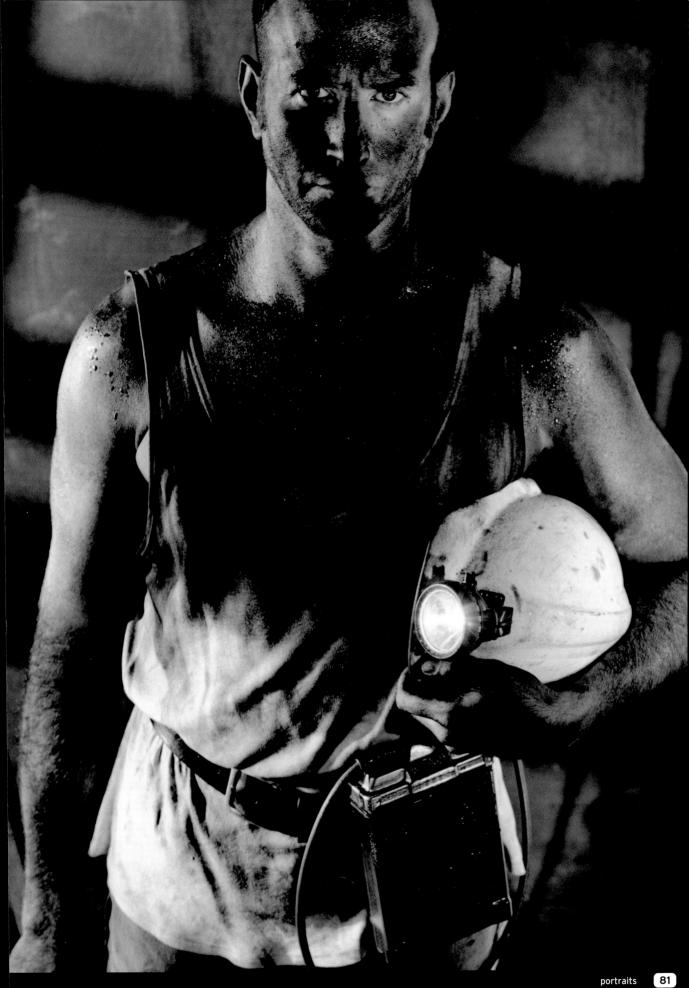

niña detras de la ventana

photographer Dolors Porredon

A perfect moment, captured by chance – or careful planning? The latter, of course. The window is part of a built set, transilluminated with a 100x100cm (40x40in) soft box, supplemented only by a white bounce to camera left.

 client
 Studio

 use
 Poster

 camera
 6x6cm

 lens
 150mm

 film
 Kodak Vericolor III

exposure f/8

lighting Electronic flash: single soft box

props and set Built set

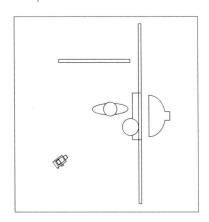

Plan View

key points

- Soft yet directional lighting is often very effective with children
- Flash is usually best for children, as they may screw up their eyes against tungsten lighting
- Some photographers believe that flash can damage the eyes of young children, but there is absolutely no evidence to support this: it seems to be an old wives' tale

Although this was designed for a poster, the same techniques (and forethought, and organization) could equally be applied to a picture for less public consumption. Window sets are not particularly hard to build; a selection of hats can be kept at hand; the rest of the clothing is hardly elaborate, though the light colour emphasizes purity and innocence; and the lighting is elegantly simple. It is true that, often, surprisingly

complex lighting set-ups are used to mimic simplicity; but it is also true that a simple lighting set-up can (if it is well executed) be remarkably effective.

Diffuse light generally works very well with children, emphasizing the delicacy of their skin texture and the roundness of their features: "character" lighting is considerably more difficult before the features have reached their adult lineaments.

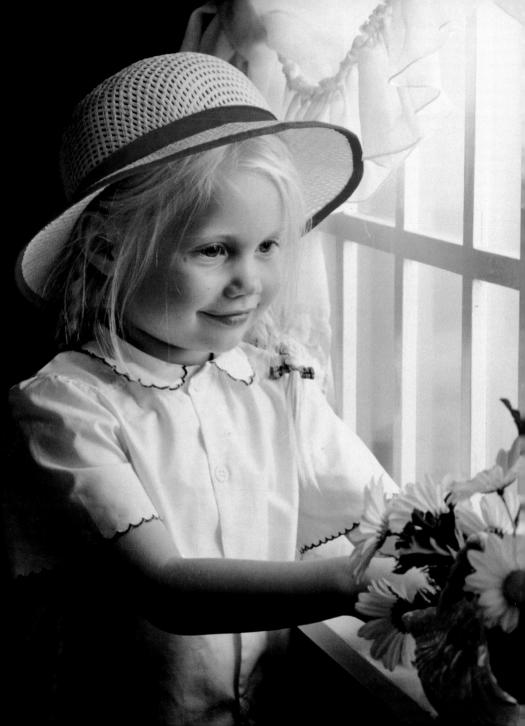

wallflower

photographer Lewis Lang

use

Exhibition/print sales

model

"My mom"

camera

35mm

lens film 28mm

....

Fujipan 1600 at EI 1000

exposure

Not recorded

lighting

Available: daylight plus

tungsten

props and set

Assembled from available materials

Plan View

key points► One of the advantages of monochrome with available light (and

- modified available light) is that you can mix daylight and tungsten with impunity
- Very small self-slave flash units can be useful for modifying the lighting in interiors
- ► Films with extended red sensitivity may give a slight infrared effect under tungsten light unless they are used with the weakest available blue filter

"Available light" is a relative term. This was shot in Lewis Lang's mother's kitchen. He pulled back the translucent curtains covering the kitchen windows, and turned on the tungsten lights shown in the diagram.

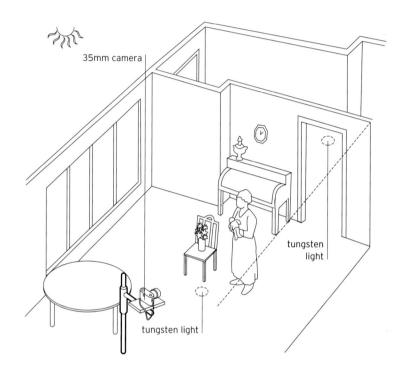

The four kitchen windows to camera left were each about 150x60cm (5x2ft) tall and wide and were about 2.2-3m (7-10ft) from the subject. The light coming through them was indirect sunlight, from open sky. A tungsten lamp to camera left (out of shot, alongside the camera) provided extra fill, as did two tungsten lights built into the ceiling to camera right; the further lamp at the right also added some

"kicker" top/back lighting to the woman's hair. Beyond the backdrop wall, a glass-panelled front door provided some fill in the foyer seen through the kitchen door to the right.

Skilled use of "available light" (modified with curtains, etc, as seen here) reminds us how our ancestors could achieve such good results in their daylight studios, always lit by indirect windowlighting.

Photographer's comment

Home is where the light is. I especially like simple lighting when it enhances the subject. The incongruous sneakers add a humorous note.

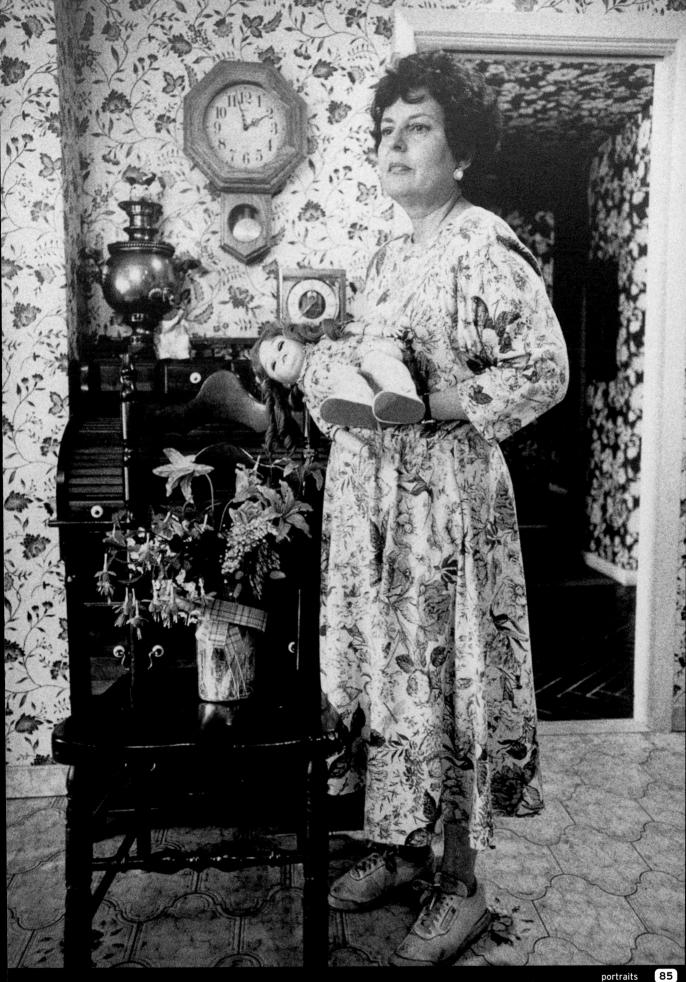

carlo maria giulini, conductor

As with so many pictures that look as if they were taken by

carefully lit with two heads - one of which illuminates the

portrait of the conductor on the wall behind him.

unusually felicitous available light, this picture is in fact quite

photographer Terry Ryan

client art director Symphony Hall Malcolm Davis

camera

6x6cm

lens

120mm macro

film Kodak Ektachrome

exposure

1/250 second at f/11

lighting

Electronic flash: 2 heads

props and set

Location

Plan View

soft box reflector 6x6cm camera standard head with honeycomb

key points

- Without the background light, the portrait on the wall would be unhappily bisected by a line of light and would not read well at all
- The face is arguably slightly overexposed, but this adds to the light, sunny, even joyful mood of the picture

The key light is a 90x90cm (3x3ft) soft box with 1600 joules of light to camera left. This is supplemented by a Lastolite folding reflector below the subject's knees, throwing some light back up to lower the contrast – particularly important as the subject is wearing a dark suit and a white shirt.

The other light, on the background, is a 500 joule standard head to camera right; it is honeycombed to reduce spill, and to obviate having two catchlights in the subject's eyes. There is also sunlight coming through a window to camera right: it is this that casts the shadows of the flowers.

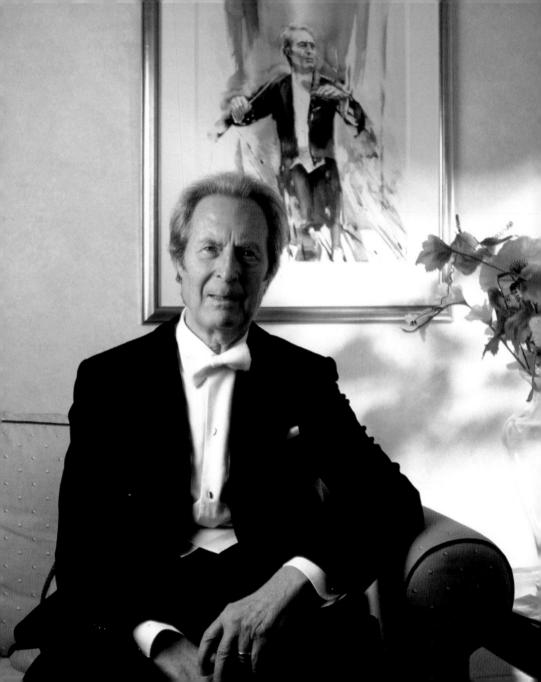

raymond's revuebar

Revuebar, and, second, to balance the lighting.

London's Raymond's Revuebar and its proprietor Paul Raymond

are Soho landmarks. The challenges here were, first, to show

both together in a way that showed as much as possible of the

photographer Johnny Boylan

photographer

Johnny Boylan

client Sunday Telegraph Magazine

use subject Editorial

assistant

Paul Raymond Siri Hills

camera

6x7cm

lens

127mm

film

Kodak Tri-X rated at

EI 200 exposure

1/15 at f/11

lighting

Electronic flash plus

available light

props and set

Location

Plan View

The obvious approach would have been to use a wide-angle, but that would have reduced the impact of the Revuebar itself. Equally, too long a focal length would have led to depth of field problems. A 127mm lens on a 6x7cm camera provided a useful compromise, but Mr Raymond had to stand on a milk-crate to allow precisely the right angle. Because it is so

recognizable, and because all the print

is so large, the Revuebar could be left to go slightly soft. This set-up required more power than would readily have been available from small, portable flash, so a studio flash unit with a long extension cable was used. It was mounted high and to camera left, while an assistant with a Lastolite collapsible white bounce stood just out of shot to camera right to provide some fill on the left side of the subject's face.

bounce 6x7cm camera

key points

- ► Any slight movement by the subject during the 1/15 second exposure would be insignificant compared with the flash exposure which "freezes" him
- ► In pictures like this you have to decide which compromises to make on composition, sharpness and lighting

Photographer's comment

The power cable to the flash snaked into a nearby sex club. I had fun plugging it in.

RAYMOND REVUEBAR

Paul Raymonds

LAVISH REVUE LICENSED BARS

RAYMOND 2 SHOWS REVUE P S THE WORLD CE STORE STATES

Pia

steve

photographer Peter Goodrum

use

Portfolio

model

Steve

camera lens 4x5in 210mm

film

Polaroid Type 55 P/N

exposure

1/15 second at f/5.6

lighting

Daylight: window 3.5m

(12ft) away

props and set

Engraving plate

Plan View

key points

- Kentmere Art Classic (available from Luminos in the United States) is an unusual paper without a baryta coating or paper whiteners
- Hand colouring can be both naturalistic and deliberately exaggerated at the same time

Even though the subject was 3.5-4.5m (12-15ft) from the window, this allowed a reasonable 1/15 second exposure at f/5.6 even on slow (ISO 50) Polaroid Type 55 P/N, which affords both a positive and a negative. The negative was printed on Kentmere Art Classic, processed in Rayco chemistry then toned with Rayco Seltone selenium

toner. The finished print was then hand-coloured using Zig graphic ink markers and Daler watercolour pencils. The markers work better in the highlights, while the watercolour pencils have more body for colouring the darker tones. The overall effect is clearly hand-worked, yet equally clearly photographic in origin.

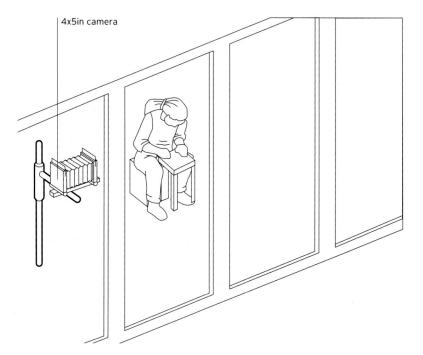

An artist's studio requires a good windowlight - and the sitter

(61/2ft) or so high and 8-10m (26-32ft) long.

was making an engraving plate in a big studio with windows 2m

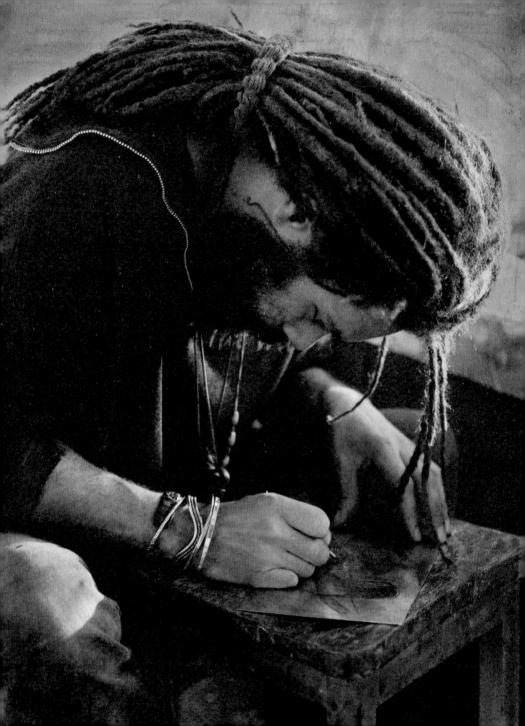

guo brothers

Printing an FP4 negative through a heavy grain screen

grain. The lighting is, however, deceptively simple.

preserved the tonality and contrast of FP4, as compared with

the tonality and contrast of a film deliberately "pushed" for

photographer Frank Drake

client

Peter Gabriel/Real World Records/Virgin Records

use

Record cover

subjects

Guo Yue (left) Guo Yi (right)

assistant

Sarah Ménage

art director

E.A. Tredwell

camera lens 35mm

film

35-135mm at 110mm

exposure

Ilford FP4

lighting

1/60 second at f/5.6 Mixed: see text

props and set

White background

Plan View

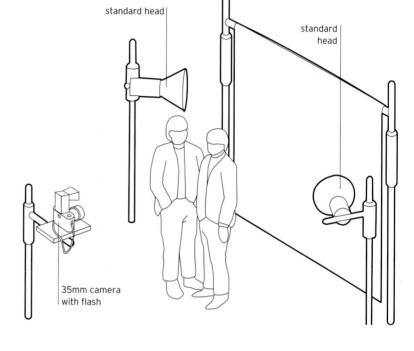

key points

- Combine "reportage" (on-camera) lighting with a separately lit background for a dramatic effect
- Grain screens are often an easier alternative than using fast films and processing in paper developer for maximum grain
- Remember the importance of catchlights in eyes

The background is lit with two tungsten floods to give a slightly lighter tone than the faces of the two brothers (this part of the exposure is controlled by shutter speed as well as aperture). The only other lighting is an on-camera electronic flash, where the exposure is of course controlled solely by aperture.

This is a surprisingly sophisticated technique. On-camera flash gives a dramatic, "reportage" effect, which is

enhanced by the grain screen.

However, the results do not look
like on-camera flash because the
background is separately illuminated
to be lighter than the brothers.

The single catchlight in the eyes is clear and effective, and there is the kind of resolution reminiscent of ring flash - though the use of a non-ring flash also introduces a surprising degree of modelling.

Photographer's comment

The brothers were barely speaking to one another, and I brought them as close together as I could in order to exploit that tension. I think it worked.

strange trinity

photographer Lewis Lang

"This shot breaks several 'rules' of lighting. It was taken at noon with the sun overhead, with full-frontal on-camera flash to illuminate the ugly shadows cast by the overhead sun – and the camera's built-in flash cast the shadow of the lens into the picture!"

use Exhibition/print sales

camera 35mm lens 20mm

lighting

film Fujichrome 100 RDP

exposure Not recorded

Daylight plus on-camera

props and set Truck wheel

Lewis sums up his own photography best. He goes on: "Normally, these 'three strikes' would justify throwing such a shot into the trash, but here they add up to a powerfully wild and wacky portrait - the lens's shadow over the bottom of the two gentlemen's faces makes them appear more ominous/sinister/mysterious, and the smiling dog seems to agree."

He also describes the light as "Weegee-esque", after the New York photographer who gained fame and notoriety for his harshly-lit scene-ofcrime shots; an example of the intellectual resonances that often suffuse powerful pictures, whether we recognize their origins or not.

All too often, photographers ask other people what will "work" in a picture - and are too often willing to accept others' views. Lewis Lang demonstrates that the best answer is normally, "Try it!"

- On-camera flash can be exploited in a surprising variety of ways
- ► Harsh lighting, bright colours and simple shapes often go together well

Plan View

algerian family

photographer Alan Sheldon

This was shot using a development of the "sentry box" technique described on page 58. The background is 3x3m (10x10ft) while the box is made from two 120x240cm (4x8ft) black uprights and an improvised roof.

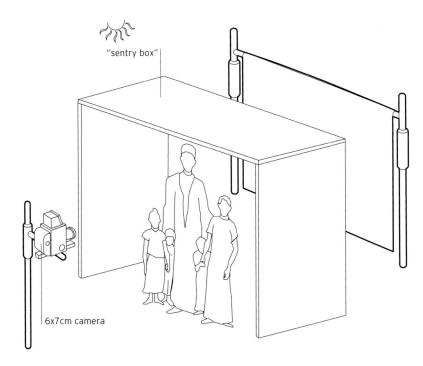

photographer

Alan Sheldon

client use Elle magazine Editorial

assistant

Nick Henry

camera

6x7cm

lens

165mm

film

Agfa APX 25

exposure

1/125 second at f/8

lighting

Daylight: see text

props and set

Built "lighting box":

see text

Plan View

key points

- A large background and a significantly longer than standard lens reduces problems with the edge of the background showing (165mm on 6x7cm is equivalent to 240-280mm on 4x5in)
- Bright sun on the background and shaded sun on the foreground gives a naturally high-key effect

The increased size of the custom-made backdrop of eyeletted canvas stretched over a collapsible frame means there is no problem with its edges intruding into the picture, even when it is placed well behind the box (as here) so that it is lit by bright sun while the subjects in the box are shaded by it. Because the

backdrop is independently supported (it was in fact secured against the side of the photographer's van), both the backdrop and the box can be manoeuvred into the appropriate position with respect to the sun. The subjects come from Berber villages in North Africa.

Photographer's comment

I had to improvise a roof because I could not get them all under the standard 1.2m (4ft) wide roof.

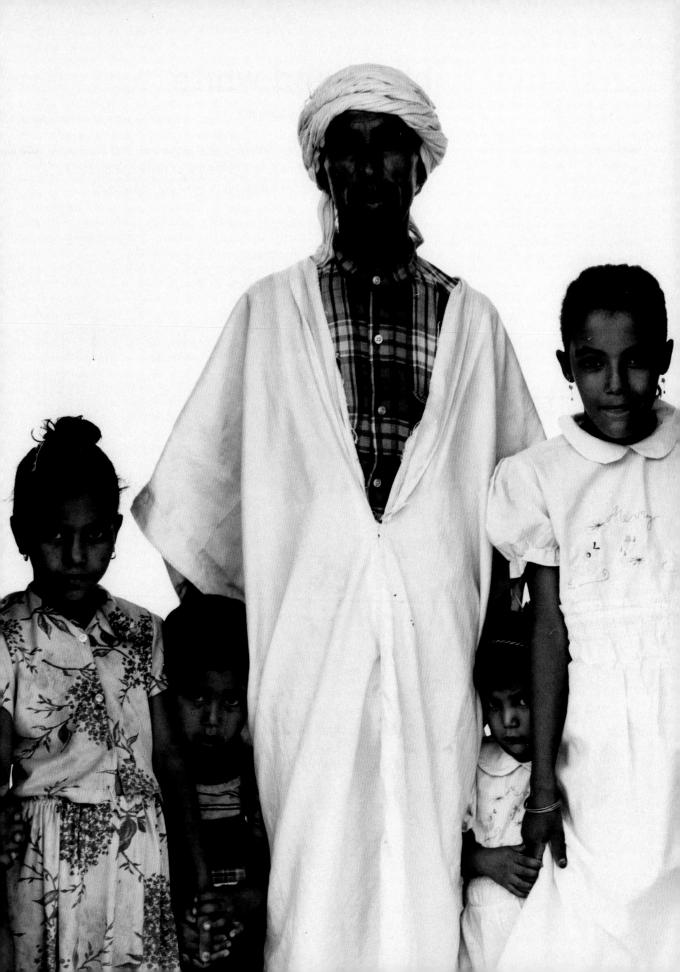

black and white

photographer Frank Wartenberg

use Portfolio camera 35mm lens 105mm

film Polaroid Polagraph

exposure Not recorded; probably f/4 to f/5.6

lightingElectronic flash: 4 headsprops and setGrey background paper

Plan View

A single large soft box to camera right is the key and only light here; it is further softened by a large silver reflector on the floor in front of it, and another large silver reflector beside it.

key points

- "Specular" skin reflections often work better in monochrome than in colour
- Abrupt transitions from light to dark require careful composition if the picture is not to appear "busy"

A black bounce to camera left means that there is no fill, and the choice of a contrasty film (Polaroid Polagraph) further accentuates contrast: the dark parts of the faces merge into the black background. This technique, using the kind of skin reflections which for want of a better term are often called "specular", is feasible with

monochrome but with colour can lead to an unpleasantly greasy or sweaty looking skin texture.

With such contrasty lighting, a large part of the skill in the picture comes from very precise posing, so that the bright part of the face to camera left overlaps with the deeply shadowed part of the face to camera right.

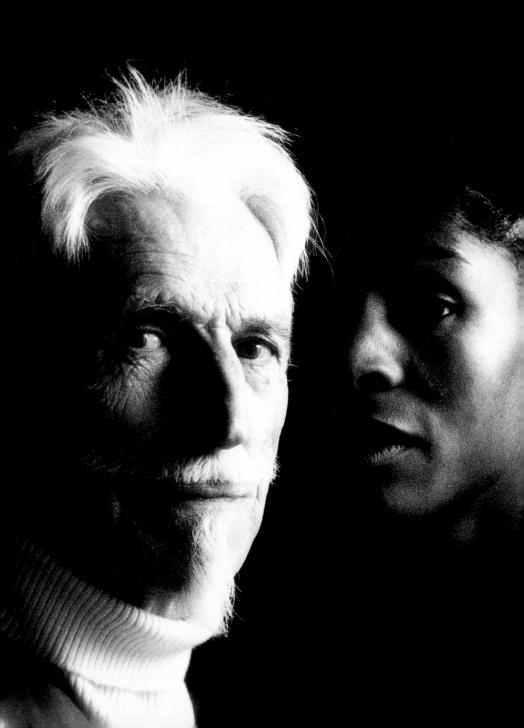

fragile movement

People used to call a portrait a "likeness", and commonly

demanded just that: a picture that was as literal as a police

mug-shot, but preferably more flattering. Today, we are perhaps

photographer Rudi Mühlbauer

more open to artistic interpretation.

use

Self-promotion

model

Eva

camera lens 6x6cm 80mm

film

Agfa Pan ISO 100/21

exposure

1 second at f/2.8

lighting

Tungsten

props and set

White background,

black leather jacket

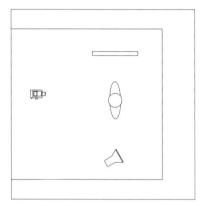

Plan View

Rudi Mühlbauer used a low, white ceiling (3.2m/10½ft) to diffuse the light: the 1000 watt lamp was mounted on a lighting stand roughly at head height (1.7m/5½ft) and bounced upwards. The subject was only 50cm (18in) from the wall, which served as a background and was lit solely with spill from the key. A white bounce to

camera left and just out of shot

provided some fill on the face. Asking the subject to move during the exposure is necessarily experimental, and it is normally necessary to shoot a good number of exposures from which only a few - or even just one - may be usable. Finally, the monochrome negative was printed on Kodak Ektacolor Ultra paper in order to achieve the colour.

- Deliberate subject movement during exposure is normally most effective in the 1 second to 1/8 second range
- Printing monochrome negatives onto colour paper gives a wide range of colour options
- Second-curtain flash synch (or synch on the closing of a leaf shutter) can be very effective, though it was not used here

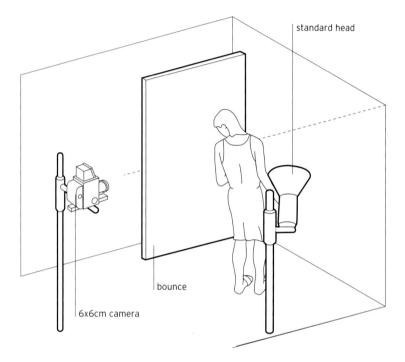

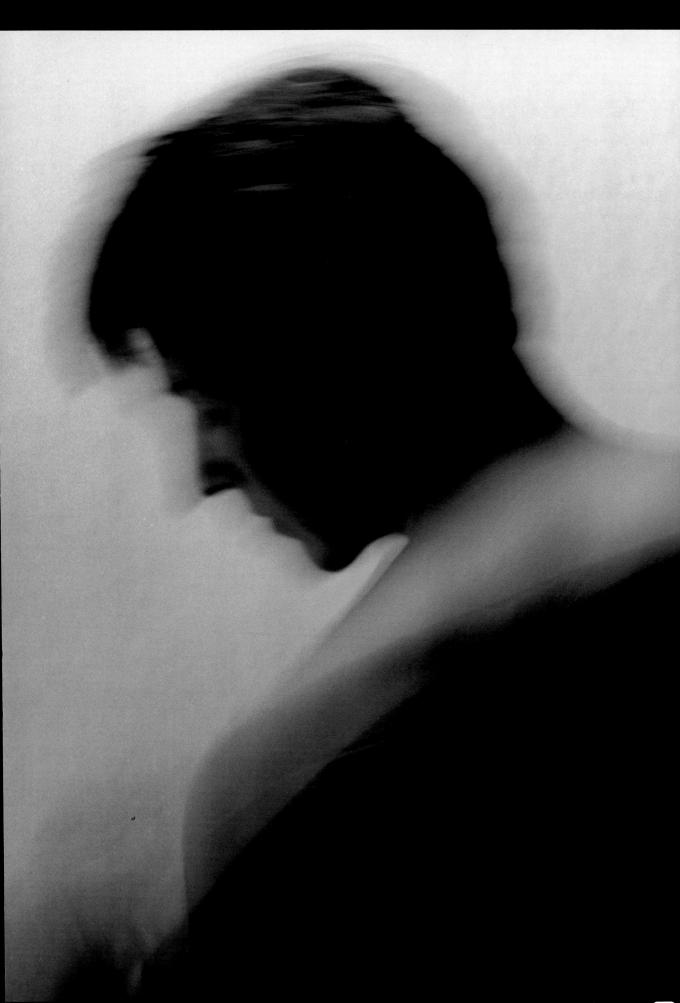

dark angel

photographer Lewis Lang

Remarkably, this is a self-portrait. The shadow of the camera is blocked by the shadow of the head; it is pointed at the wall, and slightly to the right, at an angle of 45° or less. use Exhibition/Print Sales
subject Lewis Lang
camera 35mm

lens 25-50mm zoom at 25mm

film Fujichrome 100 RDP
exposure About 1/125 at f/16
lighting Direct setting sun
props and set Sta. Barbara County

Sta. Barbara County Court House, California

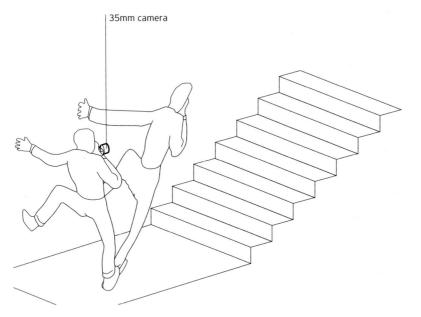

Most photographers are intrigued by the light of the setting sun, and want to play with it - but to get the best results you have to plan ahead, so as to be in the right place at the right time, and you have to hope there is no cloud. Californians, more than most people, can generally rely on the latter.

Much the same considerations apply to shadows: they are fascinating to play with, but getting a successful shadow picture depends on very precise exposure (usually slightly under, against a white background, in order to get adequate density) as well as a combination of imagination and determination.

Although Lewis works with formats other than 35mm, he believes that the very best 35mm equipment and materials can deliver more than adequate quality even for fine art photography - but they must be the very best.

Photographer's comment

A low, west-coast setting sun at an oblique angle to the court house, and some deft positioning of my body, enabled me to get a shadow that is both a flat shape and appears to recede three-dimensionally.

- ► Plan ahead to be in the right place at sunset
- ► Look for a white-painted or at least pale-coloured wall
- ► Use stairs, etc, to create distortions in the shadows

Plan View

zena

photographer David Dray

This picture demonstrates a technique for which David is noted, that of colour photocopy transfer. The original photograph is made into a colour photocopy, then transferred by a solvent technique onto water-colour paper, which gives a unique effect.

use Stock/library
model Zena Christenson
camera 35mm

camera 35mm lens 100mm

film Fujicolor ISO 100 (negative)

exposure f/8

lightingElectronic flash: 1 headprops and setWhite paper, length of

White paper, length of muslin material

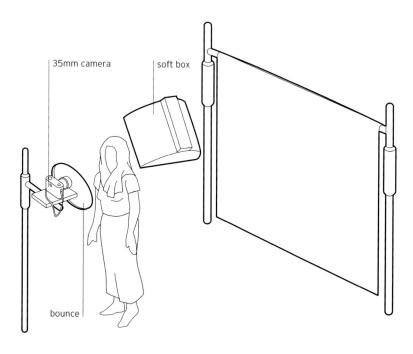

The subject here is positioned well in front of the background, which is about 2.5m (8ft) behind her; the amount of spill reaching it is therefore trivial. The only light is a small 40x40cm (16x16in) soft box set rather above the model's eye-line and angled down at her. It is about 1m (40in) away from her.

Immediately out of shot, low and to camera left, is a bounce that throws light back up into the model's face. The white muslin also acts as a combination flag (or at least scrim) and bounce, partially shading the model's face but also reflecting light down onto the bounce.

- ➤ When pictures are subject to aftertreatment of this kind, there is rarely any need to use formats larger than 35mm
- ► A landscape (horizontal) composition emphasizes the drape of the muslin head-covering; a conventional portrait (vertical) orientation would have created a completely different mood

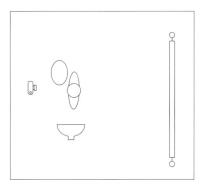

Plan View

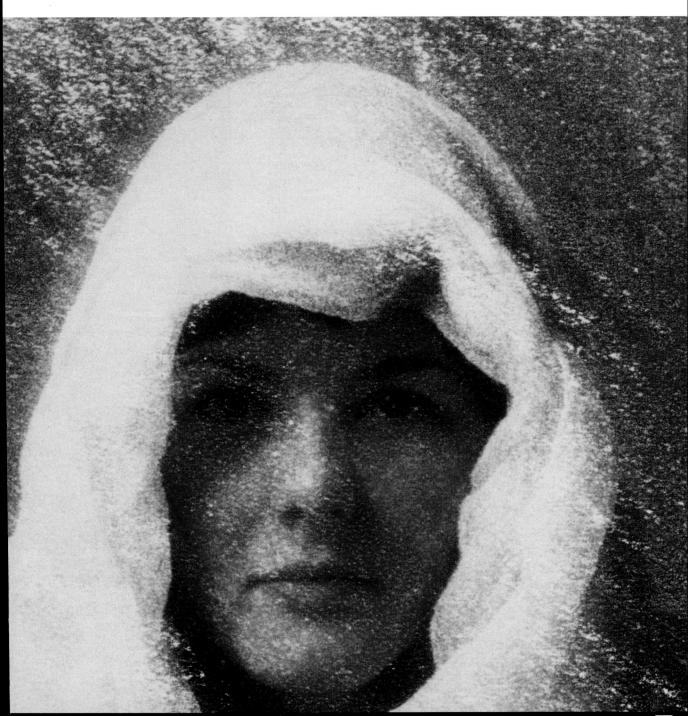

portrait of simone

photographer Peter Laqua

All children make "moustaches" by holding something between their top lip and their noses – but most people stop when they are children and do not take it to extremes like this! The reversed baseball cap adds to the playful spirit.

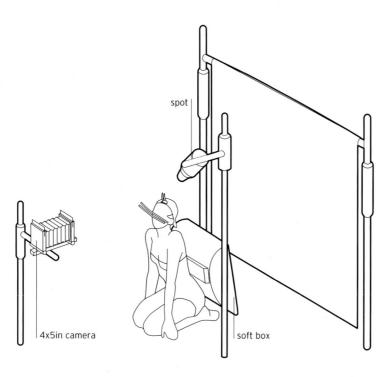

The key and indeed only light on the face is a focusing spotlight, high and to camera right, shining more or less straight down on the model: look at the shadows in her ears. It has to be a focusing spot, as a snooted spot or honeycomb spot would not provide

such directional light. A 70x130cm (28x50in) soft box behind and below the model illuminates the background, grading from light to dark. The texture of the background, which is normally invisible when it is lit frontally, adds to the composition.

use Competition entry

model Simone

stylist Silke Schöepfer

camera 4x5in lens 300mm

film Monochrome

transparency

Electronic flash: 2 heads

exposure Not recorded

props and set Spaghetti

lighting

key points

- ► Agfa's Scala direct-reversal film is available in 35mm, 120 and 4x5in; the only other convenient direct-reversal monochrome films come from Polaroid
- ► The exquisite detail of the 4x5in image should be visible, even in reproduction

Plan View

peter scissorhands

photographer Peter Barry

Peter Barry's Christmas cards are eagerly awaited by his friends Christmas card Peter Barry Celia Hunter

and business contacts every year: he has been The Joker from Batman, a pantomime dame, Scrooge, The Mask and more. The lighting on this is actually one of the simpler ones.

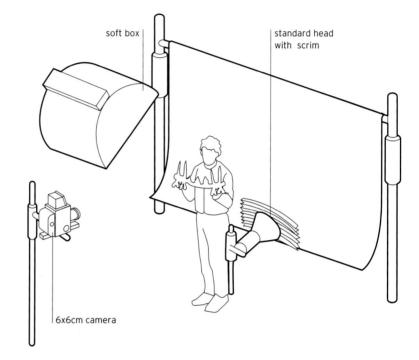

6x6cm

150mm

f/11

Ilford FP4

Electronic flash: 2 heads

Scissors, paper cut-out Christmas trees

use

model make-up

and hair

camera

exposure

lighting

props and set

lens

film

key points

- ► Classic "horror" lighting is from underneath, but flat frontal light can be just as menacing
- ► There is a place for humour in photography, though successful humour is not always easy to achieve

A single soft box, 150cm (5ft) square, was placed directly over the camera for a dead flat "horror film" light; reflections off the blades of the scissors (which were taped to his hands) were essential, as was the threatening leather jacket which also reflected the light well. A large print was made, and the cut-out Christmas

trees were hand-coloured (they were white in the original). The painted canvas background was lit by a single diffused light on the floor behind the subject: a scrim over a standard head. A great deal obviously depends on the make-up, and on the topicality of the image: this was made in the year that Edward Scissorhands was released.

Photographer's comment

I do this sort of thing every year. It's fun, and it is effective promotion as well.

hysteria

photographer Johnny Boylan

client

Terence Higgins Trust

use

Publicity (not used)

assistant

Christine Donnier-Valentine

camera

6x7cm

lens

180mm

film

Agfa APX 100 printed on

lith paper

exposure

f/11

lighting

Electronic flash: 4 heads

props and set

White background

Plan View

standard head bounce bounce bounce bounce bounce strip

This was from a series of pictures designed to convey emotion;

in this case, "hysteria". Rather than going for the sort of

harshly-lit pseudo-reportage shot that some might choose,

Johnny Boylan went for a very formal, graphic interpretation.

key points

- Directional lighting, no matter how heavily modified with reflectors, always gives more modelling than flat frontal lighting
- ► The reflections on the hair are from the bright background

Two lights were used here, a hard top light from above (look at the shadows on the tongue) and a "beauty light" from the right, a soft spot that gives extra modelling: look at the differences between the two sides of the neck, and the cheeks. The directional effects of these two lights are much diminished by generous use of white expanded

polystyrene bounces all around the subject; you have to look closely to see that the light is directional at all, though the modelling of the face would have been far less obvious if it were not. Finally, the high-key background comes from two strip-lights on either side of the subject. It is lit about half a stop down from the main subject.

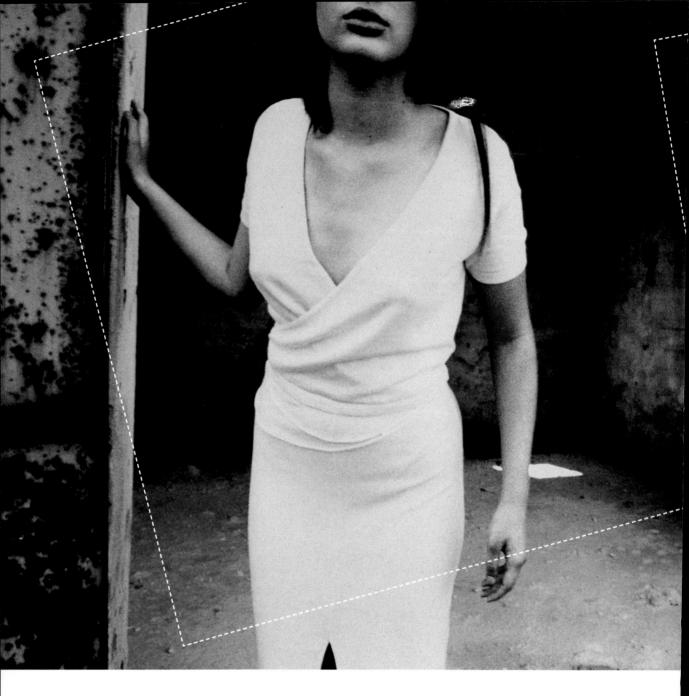

fashion

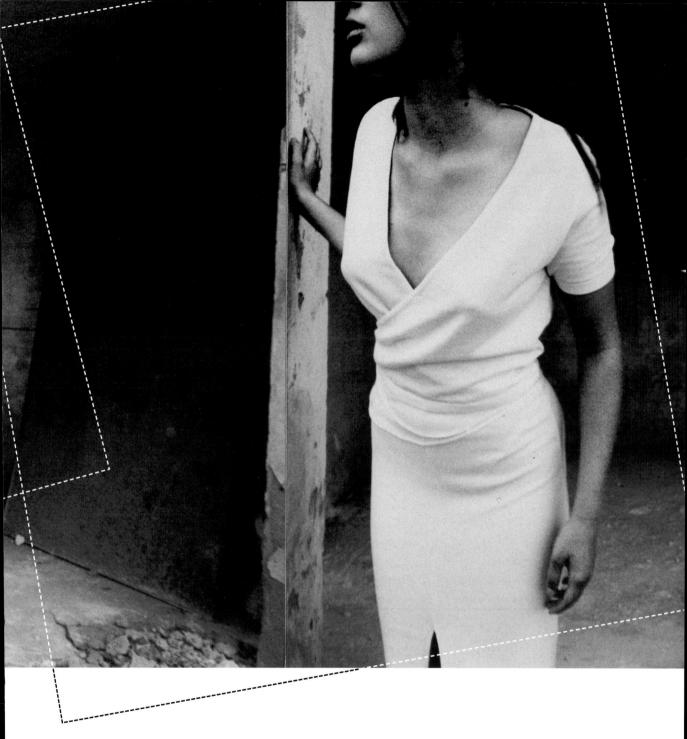

This section demonstrates the variety possible in a field known for its tempestuous, fleeting and often fickle nature. The shots here explore a wide range of work, from the influence of setting and costume to the creation of different moods with a slight shift in lighting. Fashion images produced for commercial, editorial, personal and fine art work are featured.

Photography is an ideal medium for the fashion industry to utilise as a publicity machine. Just as fashion is swiftly changing, so the photography industry can quickly produce the images needed to keep up with the fashions, giving the necessary immediacy and sense of 'the moment'. In many ways the two industries feed off each other. An enormous proportion of commercial photography is associated with the world of fashion. Ironically, it is the very accessibility, the ease and swiftness with which images are produced and the ease of mass reproduction of the images, that has been held against photography in its struggle to be recognised as an art form in its own right. The fact is that photography does seem instant. However, not everybody has the creative vision or the eye for an image that distinguishes the casual snapper from the masters such as Norman Parkinson and Cecil Beaton.

Working with fashion models

The evolution of the supermodel is a phenomenon heavily dependent on the photographer. Many supermodels, indeed, attribute their breakthroughs to one pivotal photograph, the one that got them the crucial front cover or campaign. The relationship between certain models and their photographers is legendary, and a good long-term working relationship with a model gives the photographer certain insights and advantages when on a shoot.

Matters of personality are always going to be important when working closely with individuals, but it is especially important to be aware of the sensitivities of fashion models, whose face is their fortune.

Modelling is an intensely competitive industry, emotions can run high and

the potential problems of highly-strung individuals are exaggerated by an over-excitable press in pursuit of a good story. Reality rarely matches up to these hysterical accounts. The more experienced the model, the more reliable the photographer can assume they will be during a shoot.

The situation to strive for is a clear brief, a good rapport with the model, and clarity of communication. Professionalism on both sides of the camera is the key.

The team

There will usually be a make-up artist and stylist on hand to create the look required by the client and photographer. Studio assistants will also be needed, especially where the lighting set-up is complicated and extra help necessary to position gobos, handheld bounces and props. While the camera assistants concentrate on technical aspects of the shoot, the photographer can take on more of an artistic director role.

The client's representative is often a crucial member of the team. It may be that the agency and/or the client require art directors and publicity managers to be present to ensure that the look created is the one wanted for a particular fashion product. In such situations, it is essential that the brief has been thoroughly discussed and agreed beforehand.

Hospitality is a consideration. If the client enjoys the shoot as well as liking the end result, they are more likely to return to that photographer. It is also important to keep the working team refreshed, since a long shoot can be tiring and no one cannot afford to have any team members flagging. This is particularly important in the case of the model.

Cameras, lenses and films

As constant variation in style and techniques is the key to the fashion industry, it is difficult to generalise about what equipment is appropriate for a fashion shoot. Most fashion photographers swap between different formats and stocks to exploit the different qualities of the formats and films available. It depends on what look is wanted, what is currently in vogue, the nature of the product and what the client has in mind.

The 35mm camera is very light and ultra-fast; a 36 exposure film can be shot in as little as 4 or 6 seconds. Medium format (645, 6x6cm, 6x7cm, 6x8cm, 6x9cm) is slightly more cumbersome but is still very quick and easy to use. Motor winders are commonly available for these formats. as are camera movements, and of course the benefits of interchangeable backs are immeasurable. Large format (4x5in and 8x10in, among others) need more time, but offers the potential for crystal-clear images and excellent shadow detail - as well as the sheer joy for the enthusiast of those glorious, beautiful large transparencies!

Telephoto lenses are generally used as they give a more flattering look all round. This means that more studio space is required to take full-length images, although less background area is required.

The choice of film stock is down to the individual. Transparency film offers superior quality, but at the expense of a relatively small exposure latitude. But with Polaroid testing and experience this is not such a high price to pay. Negative stock, although theoretically of lower quality than transparency film, offers a greater degree of flexibility in exposure latitude and tonal renditioning. Some people choose

negative film specifically because of the look of the inferior film quality, and this is a valid choice if circumstances allow for it.

Lighting equipment

A whole plethora of lighting equipment is required for the fashion shoot. Large soft boxes, small soft boxes, several standard heads for lighting the background, accessories such as honeycombs, coloured gels, barn doors, gobos, umbrellas, bounces and panels, white, gold and silver reflectors, mirrors and flags will often be used. Fashion shoots are model-based, so the only item of lighting equipment that is not commonly used in a fashion shoot is the light brush, which generally needs a perfectly still subject for an extended period of time.

The flash-versus-tungsten decision will be based on the look that is required and personal preference on the part of the photographer; again, there are no hard and fast rules. One reason for preferring electronic flash is that it has lower temperatures and so may help prevent the model - and indeed the whole team and studio from getting overheated. An advantage of the more physically hot tungsten light, which is in fact traditionally preferred for the fashion shoot, is the aesthetic quality inherent in the continuous source. It is something for the individual photographer to weigh up depending on the particular conditions of a particular shoot.

Studio or location?

In a fashion show situation, there is no choice but to be on location, and that location will be the venue of the catwalk show. There are implications to this. For one thing, there will be a considerable amount of ambient

lighting from the spotlights in the hall to light the runway. There are matters such as flare to be taken into account, and little opportunity to have the space to set up the camera to avoid this. There will be little elbow room. probably no choice of position or view, not to mention the constant flashes from the sea of cameras of the other photographers attending the show. There is only one attempt at every shot - the show will go on whether the photographer has the image that he wants or not - so speed is of the essence and a sense of anticipation is invaluable. The photographer must be ready to shoot a great deal of film in these less than ideal circumstances to have a chance of a reasonable number of shots turning out successfully amid so many uncontrollable factors.

In other situations, a commissioned shoot may take place in the studio or on location. The studio offers the fullest control of the situation, and especially of the lighting, whereas the location may offer a more elaborate set than can be managed in the studio and this may be essential for the particular brief and setting of the shot. The choice of site for the shoot can only be determined in relation to the needs of the final image; whether the setting is significant, what kind of look is wanted, and so on. It is broadly true to say that the more spontaneous kind of 'street' images may well happen more commonly on location, while the more formal cover shot-type images are likely to take place in the studio.

The clothes

In a fashion shoot the clothes are the very raison d'être of the session. It is therefore essential that every detail is right; that the clothes are displayed exactly as the client wants and any important features are noted beforehand so that the photographer knows which elements are to be emphasised in the final image.

The assistance of a stylist/costume dresser will be extremely helpful in ensuring that the clothing is worn and presented correctly, that it is pressed and free from specks or flaws, and that replacement items are available in case there are any problems with one particular item in the collection. In cases where a unique designer garment is the subject, it will probably be the case that the designer of the item will be on hand to supervise the wearing and presentation - and safety! - of the clothing. In such cases, the designer may be the only person who can decide what to do should any accident or problem arise with the garment; whether to repair or amend the garment, or whether to replace it entirely. Needless to say, when valuable unique items are involved, insurance is even more important than usual!

If the garment is especially unusual in some way, it is essential that the photographer has an opportunity before the shoot to become familiar with its particular features and become aware of any peculiarities that might require special treatment during the shoot. This is really no more than normal good practice in terms of making sure that the briefing session is thorough and comprehensive, but it is just as well to be aware of any surprises that a designer fashion item can present.

It may also be necessary to allow for rehearsal and fitting time for the model who is to work on the shoot so that time is built in for any adaptations to the garment to take place to allow for a particular model's height and figure.

Good preparation is essential.

orange trousers

photographer Corrado Dalcò

use

Personal work Manici Patrizia

assistant

Matteo Montawari

art director camera Corrado Dalcò Polaroid Instant 636CL

lens

38mm

film

Polaroid 600 Plus

exposure

Not recorded Electronic flash

lighting background

Corchia, Italy

plan view

key points

- ► A built-in flash allows the photographer to be mobile and to adjust position and view constantly, in the safe knowledge that the lighting will be in a constant position in relation to the lens
- On-camera or built-in flash can be modified by gel or tissue paper

Immediacy and spontaneity are often vital ingredients in a fashion shoot to get the model to perform well, to get the shutter snapping and the results flying out of the back or front of the camera with an air of excitement and capturing an "of the moment" look. The Polaroid range of cameras and stock

are excellent tools for just these circumstances, coming into their own for a more permanent result than their other major use as a tester before the real thing is shot on a different format. As Corrado Dalcò shows here, they are more than capable of producing "the real thing".

about for a location shoot, and in certain circumstances it is as much as you need to get the right look for a shot.

A built-in flash can be the simplest of lighting devices to carry

Polaroid

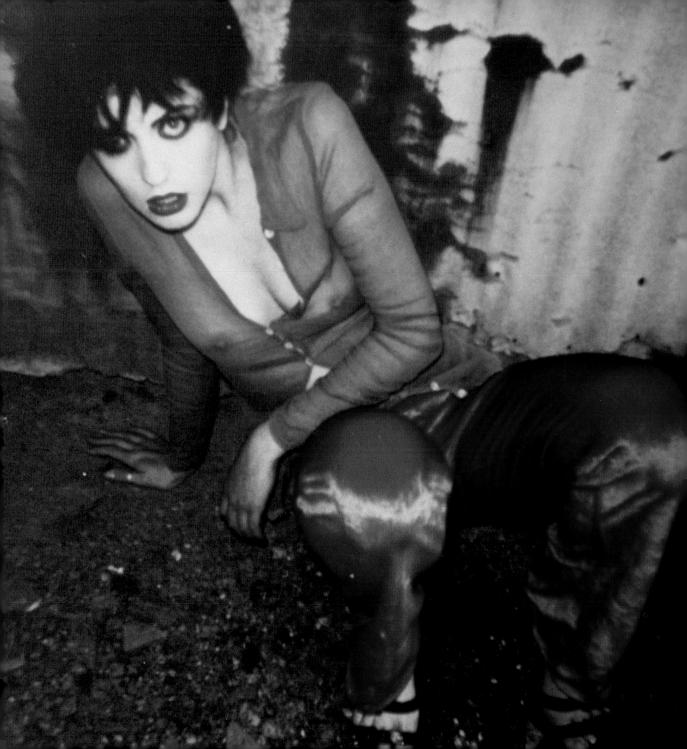

bicycle shot

photographer Jeff Manzetti

This shot is a classic example of a photographer using coincidental elements as if they were the closely controlled elements of a studio situation.

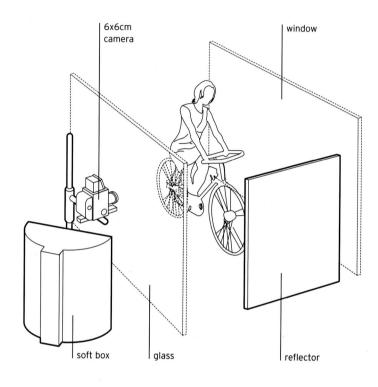

Natural sunlight swathes the scene from high overhead; note that such shadows as there are, are very short and give a good indication of the midday position of the sun.

The diffusion material above the camera and model reduces the intensity of the sunlight, while a reflector panel in front of the model reduces the depth of the shadows that there are. The foreground glass pane acts as a kind of diffusion filter, slightly softening the image. This is doubly the case for the background, being shot through two panes of glass.

A polarising filter was used over the lens to alleviate any reflections in the glass and accentuate the colours.

client Madame Figaro
use Editorial
model Viola
art director William Stoddart
hair Brunno Weppe
make-up Elsa Auber

Charla Carter

6x6cm

 lens
 100mm

 film
 GPX 400

 exposure
 f/8

stylist

camera

lighting Available light

props and Fondation Cartier
background (rooftop terrace)

plan view

key points

- Reflections in glass can be avoided by use of a polarising filter
- ► It is possible to lose up to 3 stops of light when using a polarising filter, so bear this in mind when choosing film stock

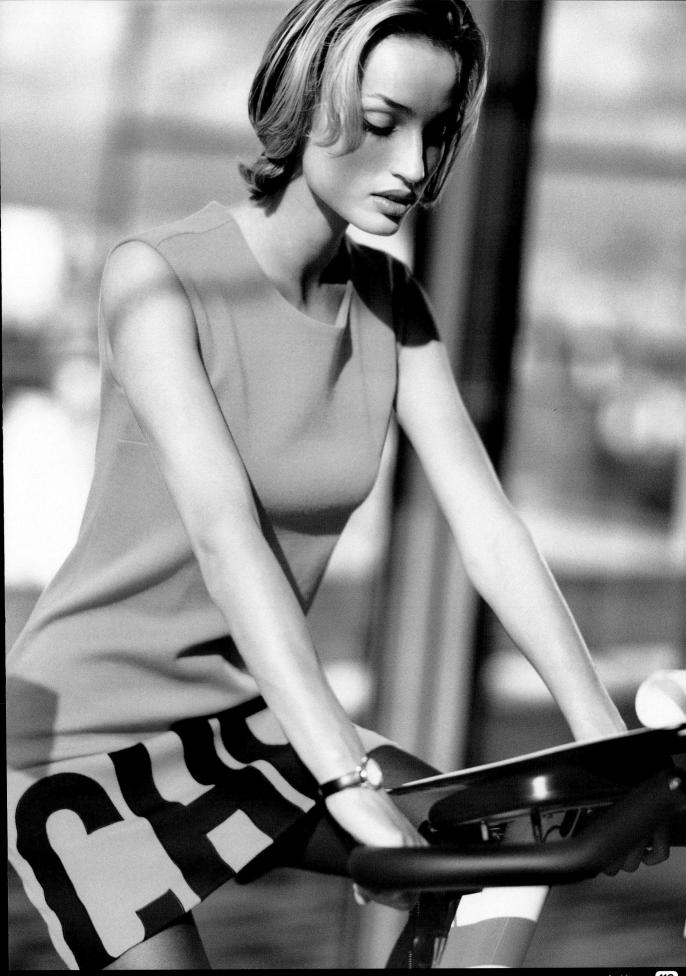

hand-painted dress

photographer Gèrard de Saint-Maxent

use

Editorial

camera lens Mamiya 645 55-110mm

film

Tmax 400

exposure lighting Not recorded Available light The camera was as much as four metres above the model for this shot. The rocky cliff terrain is visible in the outcrop formation in the lower edge of the picture.

plan view

- Push-processing black and white film stocks is another method you can use to increase contrast
- Capitalise on naturally occurring reflectors by considered positioning of the model

The model was kneeling on the seashore with her face tilted upwards towards the sun and towards the camera above. Her eyeline, however, is downwards, to protect her eyes from the brilliance of the sun and therefore avoiding squinting.

No reflectors were used as this would have undermined the whole

effect the photographer was trying to achieve; sufficient fill is provided by the rock faces of the landscape behind the model.

The hard, stark, high-contrast imagery is a combination of the direct sunlight and the contrasty film stock. To add an extra element of interest, selected areas were finally hand-tinted.

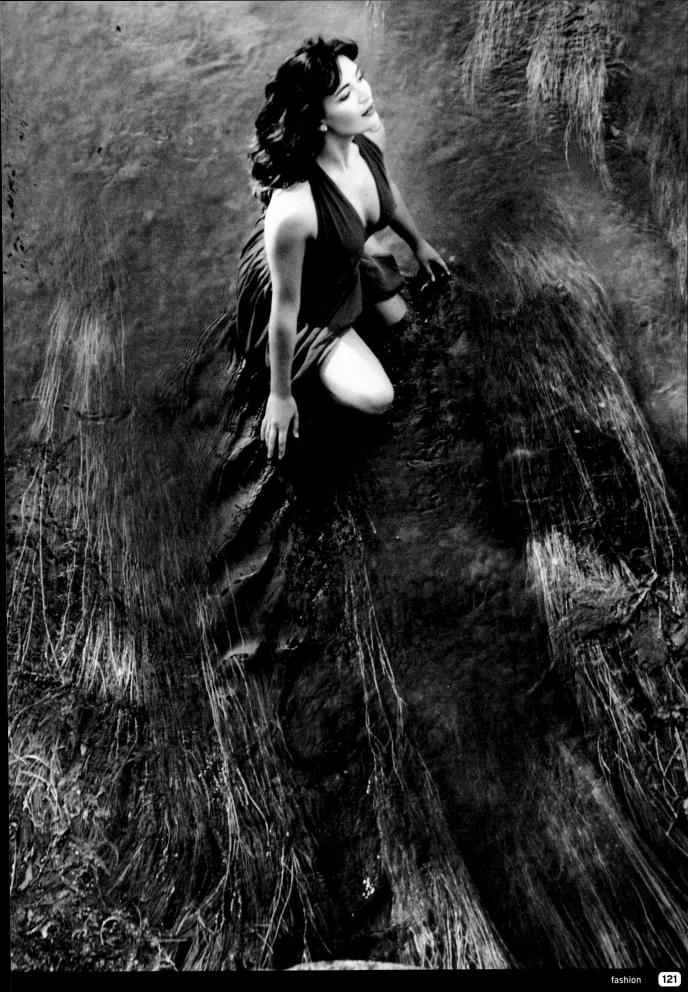

roof sway

photographer André Maier

client Mode-Info, Berlin use Editorial

> Hila Marin for Next Models

art directorJörg Bertrammake-upHélène GandstylistJörg Bertram

model

lighting

designer SWAY hair Yoshi Nakah

Yoshi Nakahara for Oscar Blandi Salon

camera 6x6cm lens 90mm

film Kodak E100SW exposure Not recorded

props and Rooftop, chair background found on the roof!

Available light

plan view

key points

- This image is cross-processed; an E6 film put through a C41 process. The cyan tints to the highlights are classic features of this technique
- It is the end look that determines where a meter reading needs to be taken from

"This was shot on a roof in the East Village, as asked for by the client," says photographer André Maier.

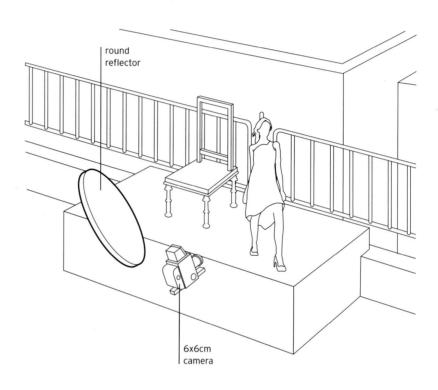

"They wanted a 'downtown New York look' for this fashion story on young emerging New York designers." The October day may have been cold for the team to work in, but it also had its advantages: the sky was overcast, and this even cloud cover acts as a huge diffuser, providing even non-directional

light across the whole of the subject. The cool sky also provided a smooth, even backdrop against which both the featured fashion item, the modelled dress, and the dark-haired, dark-eyed model showed up well. The low angle of the camera is used to make the most of this possibility.

photographer's comment

A long October day; it was cold, the model (and everyone else) was freezing; we had to fit in six outfits from three designers, with three complete hair and make-up changes.

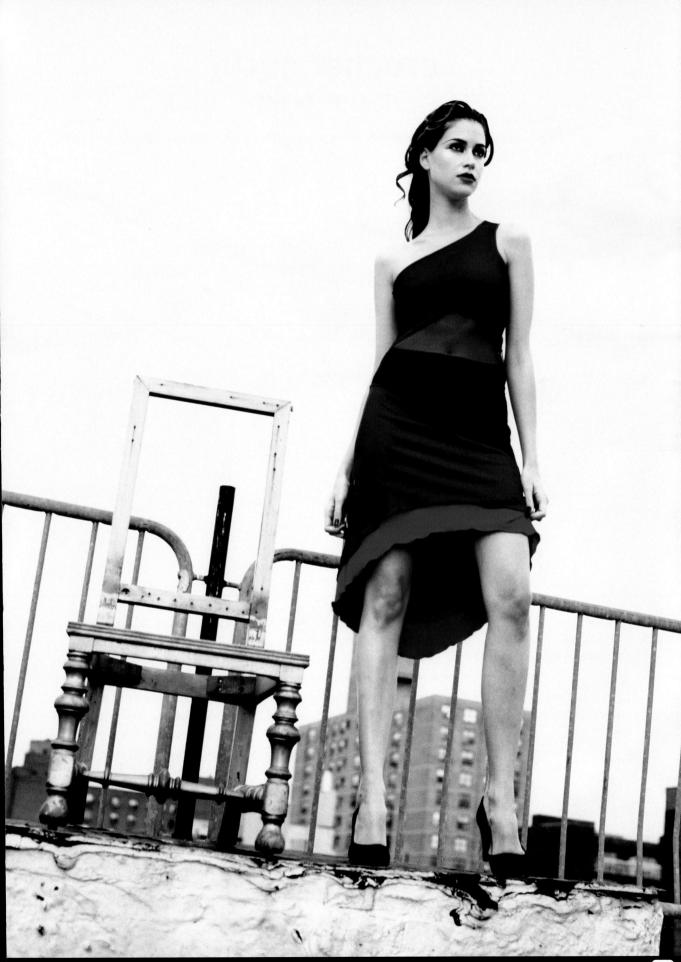

crochet outfit

photographer Frank Wartenberg

use camera Publicity 6x7cm

lens

105mm

film exposure Fuji Velvia 1/2 second at f/5.6

lighting

НМІ

plan view

Frank Wartenberg searched very hard to find this fabulous and evocative location.

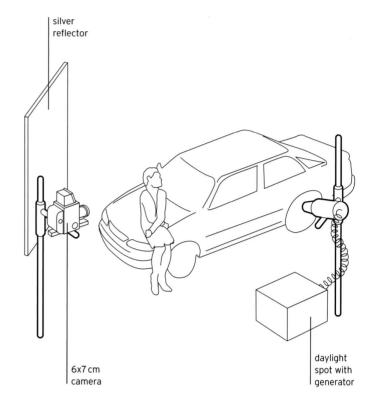

key points

- Key lighting from behind is a good way of avoiding inappropriate shadows
- When shooting on location, it is as well to inform the local police and to be very vigilant of equipment and safety

Of course, if a night shot is what you have in mind, then the locations must be viewed after dusk and when the normal available ambient light is present. In the daytime, this scene would look completely different. The HMI, which is three-quarter back lighting the model and car, is the key

light in this shot. A large silver reflector opposite the light lifts the near side of the model's costume and the car bonnet.

The daylight balanced key light is deliberately chosen to match with the film stock so that the background ambient light adds warmth.

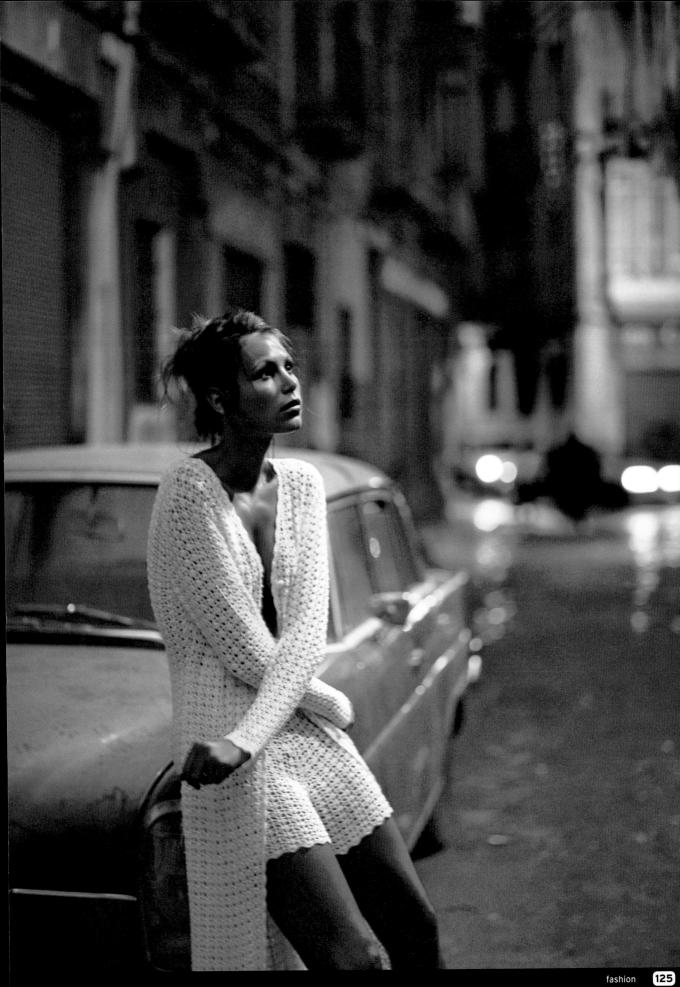

water bed

photographer Jeff Manzetti

client

Madame Figaro

use

Special beauty editorial

model

Viola

art director

William Stoddart

hair

Brunno Weppe

make-up stylist Elsa Aubert

camera

Charla Carter 6x6cm

lens

100mm

film

Fuji EPT 160

exposure

f/5.6

lighting

Available light

props and background

Pool

plan view

key points

- Controlled use of colour can add to the coherency of a shot
- ► An orange 85 filter will correct tungsten-balanced film for daylight

The shot was taken at midday with the sun at its highest point in the sky

giving good overhead light.

The blueness of the pool colour in the rippling water is echoed by the shade of the bathing costume. Taking this use of a colour further, Jeff Manzetti has also achieved blueness in the shadows on the model's body by use of a blue filter combined with a tungsten film. Both of these contribute to the blue hue. The skin is so brightly lit by the direct sunlight that it avoids a blue pallor, but the shaded areas on the throat, shoulder and arm show the colour quite distinctly.

The model is floating in an outdoor pool of water and is

positioned directly under a bridge, which provides access for

the photographer to gain this viewpoint from directly overhead.

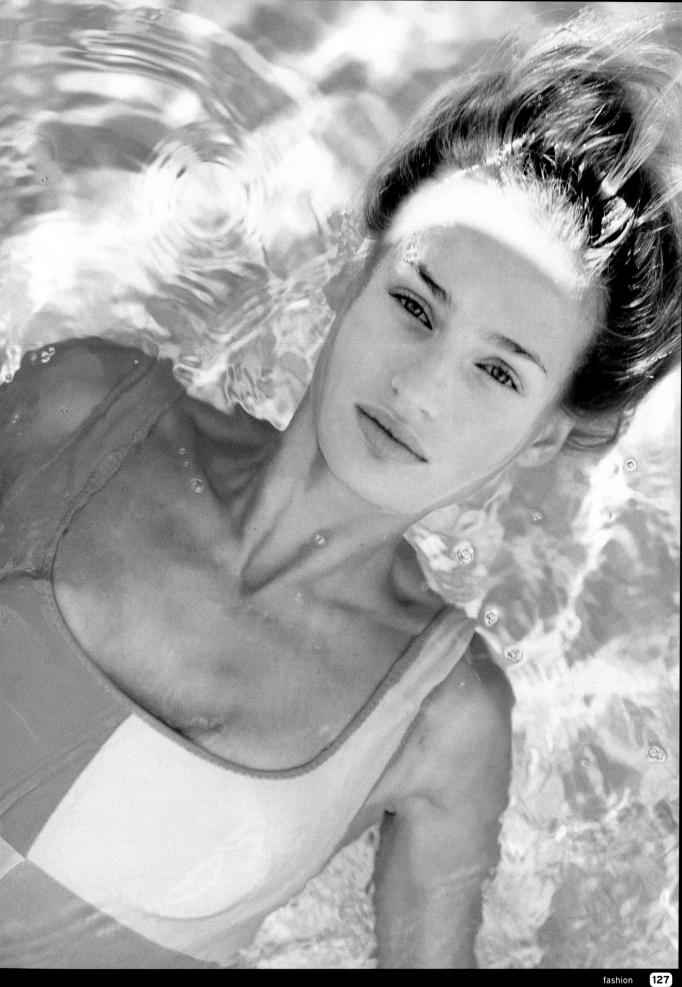

shadow

impact all of their own.

photographer Craig Scoffone

35mm camera

The long, low shadows of the late afternoon sun have a dramatic

client

Fad Magazine

use

Editorial

model camera Dawn 35mm

lens film

75-125mm

exposure

Pan-X Not recorded

lighting

Available light

props and background Abandoned industrial site

plan view

In this situation, photographer Craig Scoffone has used the difficult direct light on the model's face to emphasise the discomfort that the model is feeling while looking into the bright sun. The model's whole pose, body language and expression illustrate this discomfort. This is the motivation for her holding the shawl protectively around her body.

model's face "giving a flat, bright evenness with the features of eyes and lips apparently painted onto a tabla rasa," says Scoffone. "The geometric hairstyle adds to the flat, graphic effect of the head. The modelling and textural interest comes lower down, in the curvature and folds of the shawl and tassels and the highlights in the fabric of the skirt."

key points

- ► It is important to get permission to shoot on derelict sites, and possibly inform the police beforehand. Check that there are no guard dogs on patrol that might interrupt the shoot!
- ► It is much more difficult to work with direct hard light than it is to work with soft light, but when it is used well the effect is stunning

The sun falls unrelentingly full on the

photographer's comment

The sun was very near the horizon. This was the last shot of the day. The shadows that were being cast were too dramatic not to incorporate into the final composition.

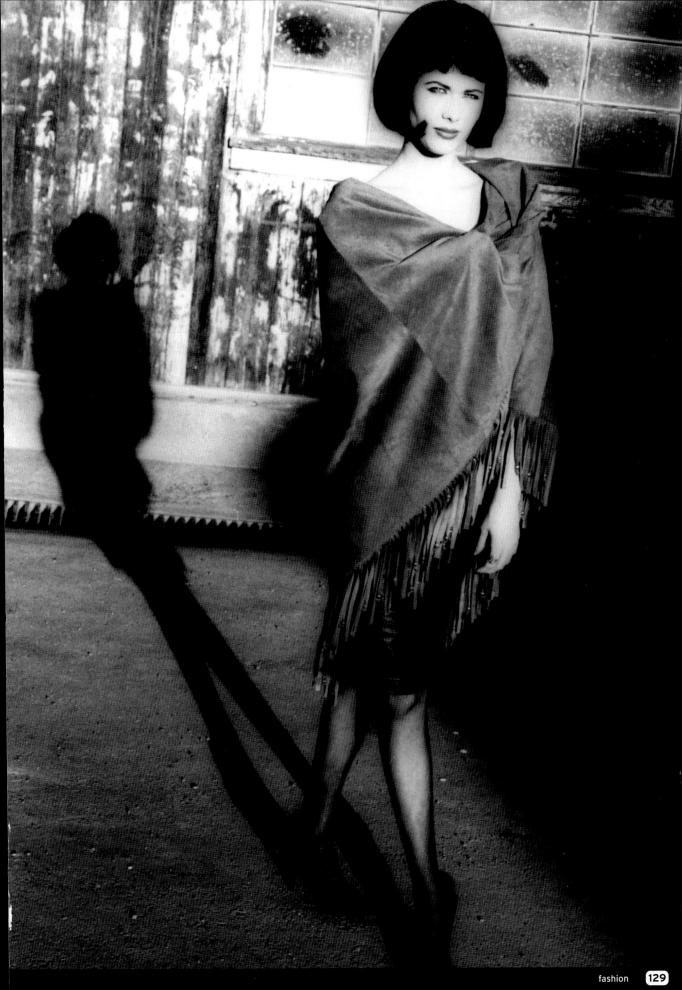

man

photographer Antonio Traza

use

Model's portfolio

camera lens 4x5 inch 210mm

film

Polaroid 55

exposure

1/125 second at f/5.6

lighting

Tungsten

props and background Painted background

key points

plan view

- Rear camera movements were used to make the axis of focus fall along the eye and temple of the model
- Polaroid 55 stock is an unusual type of film because it produces a negative as well as a positive

"The choice of lighting was determined by the mood of the picture, looking very much like Hollywood lighting," says Traza. "The one-kilowatt tungsten head is useful because it is quite light and the Fresnel glass concentrates the beam of light, making an extraordinary tool for focusing the light."

The model, with his rugged face, adds to the male movie-star image.

The lighting for this shot comes from three one-kilowatt heads. One illuminates the background. The second keys the model from the right-hand side of the camera, which gives the modelling under the chin. The third head, which is placed behind the camera on the left and somewhat further away from the subject, provides fill light.

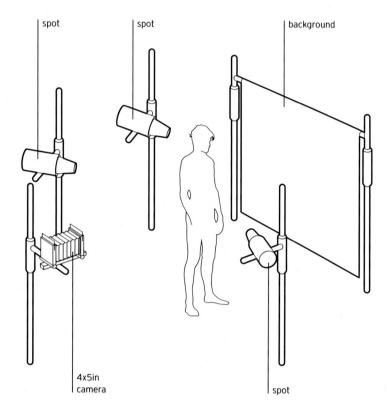

Some styles of photography are so distinctive that they

are associated with a particular era or look, as in this shot.

photographer's comment

The important elements here were the type of film that was used, which created an unusual border around the negative, and the out-of-focus look obtained by tilting the back of the 4x5 rear panel.

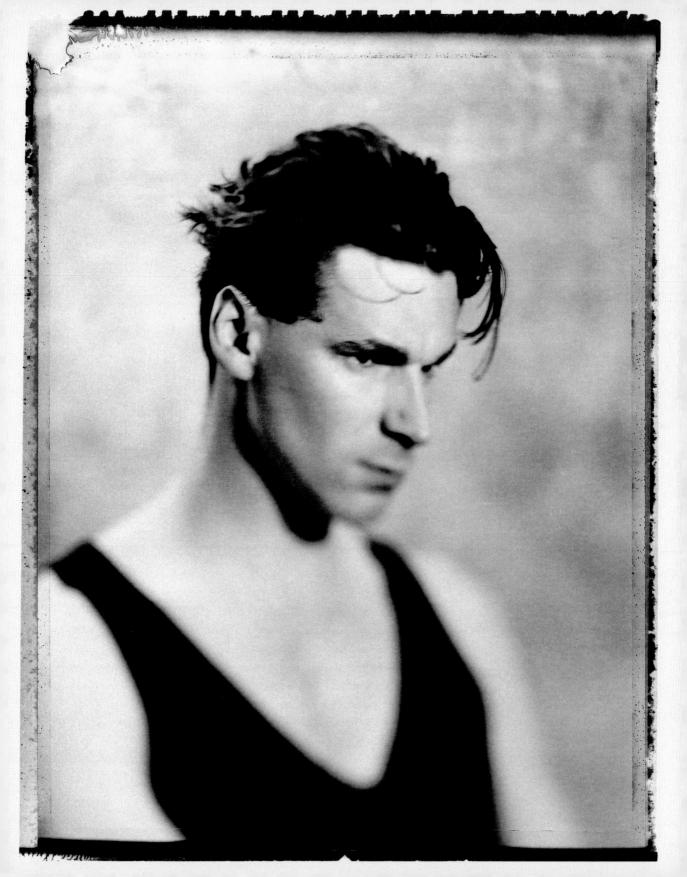

woman

photographer Antonio Traza

use

Self-promotion

camera Iens RZ67 127mm

film

Ilford FP4

exposure

f/8

lighting

Electronic flash

"It is said that if you have a beautiful model to photograph, you already have 95 per cent of the picture done. The other five per cent is the lighting - very easy in this case, just a soft box and a reflector!" comments Antonio Traza.

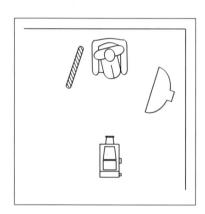

plan view

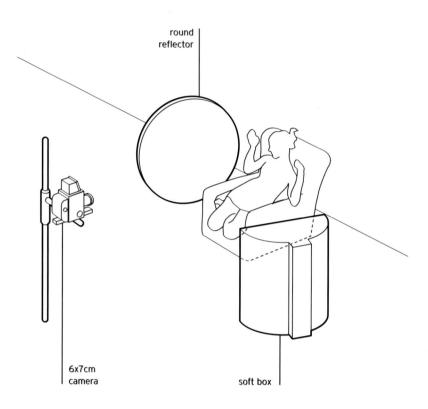

key points

It is interesting to note the absence of a catchlight. In classic Hollywood movies, a catchlight was often applied by the use of a small light directly above the camera Indeed, the lighting set-up here could not be much simpler. A soft box is placed on the right-hand side of the model and tilted 30 degrees downwards to give top light. A reflector is placed on the left-hand side very close to the armchair to fill in the shadow. The impression is of a woman in a pensive mood, sitting in an armchair with the beautiful morning light streaming in through a window. The straightforward, unobtrusive way in which the pose shows off the simple lines of the clothing, within a realistic context, make this a simple and classic fashion shot.

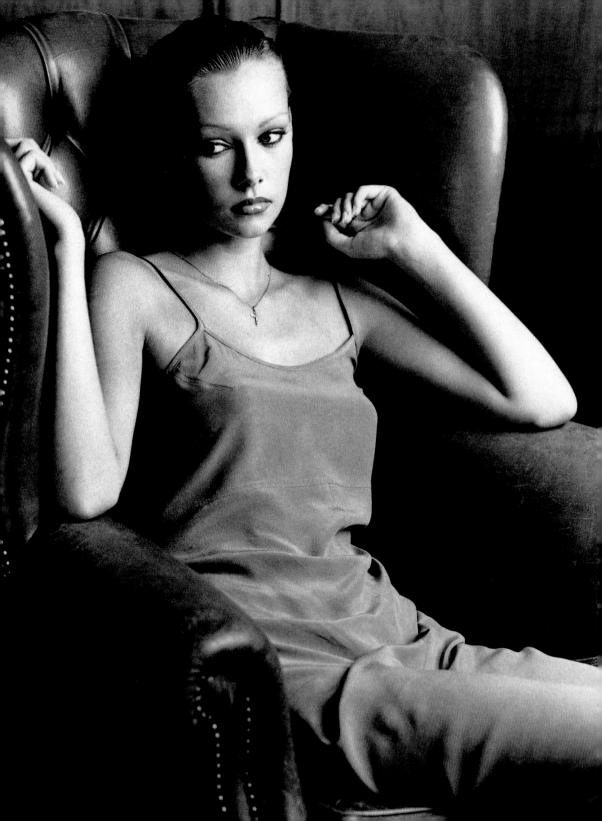

strap top

photographer Simon Clemenger

6x7cm camera

Model portfolio use

camera

model Gurri to good effect. Here it creates a halo for the hair and a silvery make-up Caroline definition for the arms.

stylist Siobhan

lens 50mm reflector film Kodak Plus-X

exposure 1/60 second at f/16 lighting Electronic flash

RZ67

props and Blue Colorama background

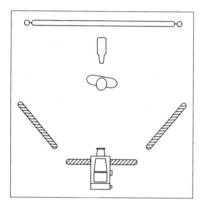

plan view

key points

- ► It is very important that the flash head is hidden, not only because it is unwanted in the composition, but also because the model's head flags the camera from flare, which might otherwise appear as a milky cast across the image
- ► A light grey background can often be preferable to a white background when using black and white stock to reduce the contrast ratio

This effect is especially striking on the model's right arm, where the pose ensures a bold vertical line in contrast with the curved body parts.

A single standard head is placed directly behind the model's head so that she completely obscures the lamp itself. This is what produces the auralike sparkling rim light around the model's hair and limbs. There is no frontal light source, but the three large white panels arranged around the

back onto the face and background. The choice of a blue Colorama background for a black-and-white shot creates an appropriate shade of grey behind the model.

The starkness of the image derives from the way the make-up and styling combine with the dramatic lighting. The strong, dark eye make-up gives the model an intensely moody look and sets the atmosphere for the whole shot.

reflector reflector camera bounce any available light

Rim light can add an almost magical quality to a shot when used

spot

blue

background

photographer's comment

I metered off a grey scale card in front of the model's face.

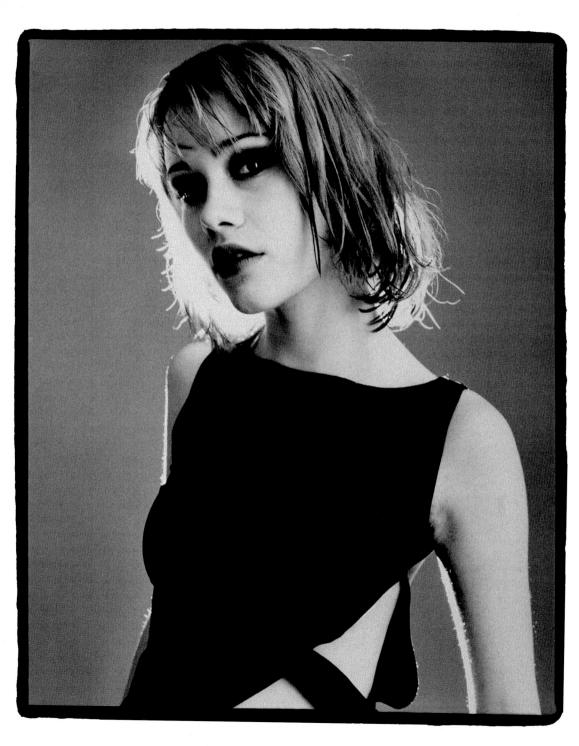

purple velvet

soft box

photographer Frank Wartenberg

to the model.

use

personal work

camei

6x7 cm

lens

90mm

film

Fuji Velvia

exposure

not recorded

lighting

electronic flash

props and background coloured paper background

plan view

6x7 cm silver reflectors

A pair of soft boxes are placed alongside each other, straight on

key points

- ► Honeycombs can be used to give soft light a degree of directionality
- Props and even a model can be used to hide a light source

A wall of silver styro reflectors are arranged into a crescent-shaped wall to either side, and these reflect back the spill light on to the model. The coloured paper background is lit by a single light, which is located directly behind the

model and hidden from the camera's view by her. The even light across the whole subject gives the bright, smooth look to enhance the model's skin, and shows off the velvet of the costume to good effect.

standard

head

background

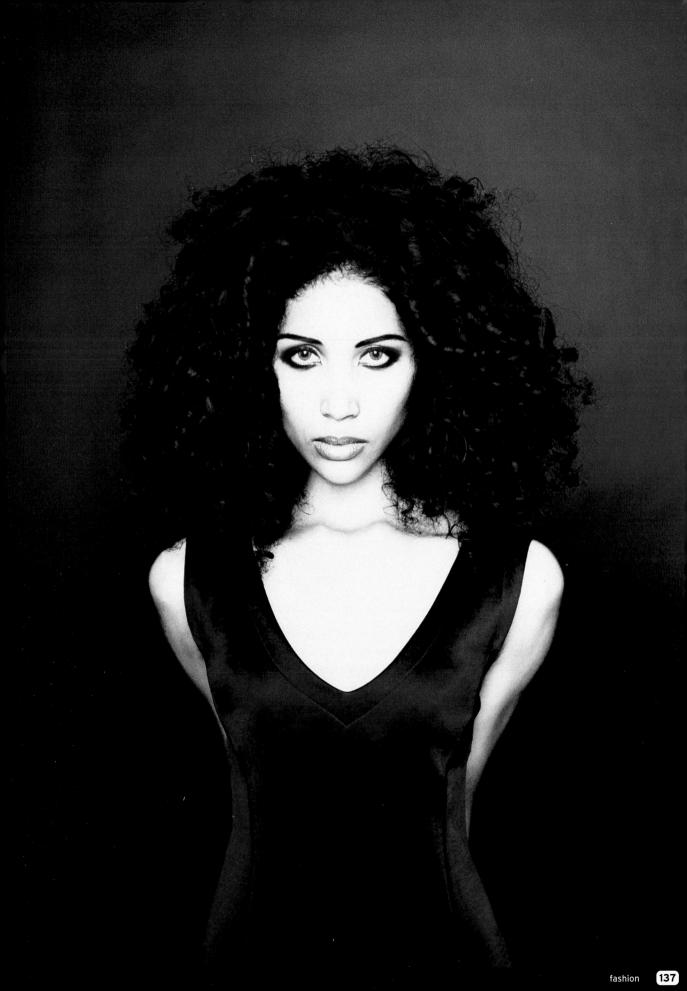

smile

photographer Jeff Manzetti

client

Grazia

use model

Petra

hair

Lucia Iraci

make-up

Michelle Delarne

editor

Stefania Bellinazzo

camera lens 6x7cm 135mm

film

Fuji EPL 160

exposure

f/4

lighting

Electronic flash

plan view

key points

- ➤ The purpose of a shot will dictate aspects of the look and technique
- Using just a restricted range of saturated colours against a predominantly light or pale background can create a very strong impact

A large assortment of lights contribute to the dazzling look of this beautiful cover shot.

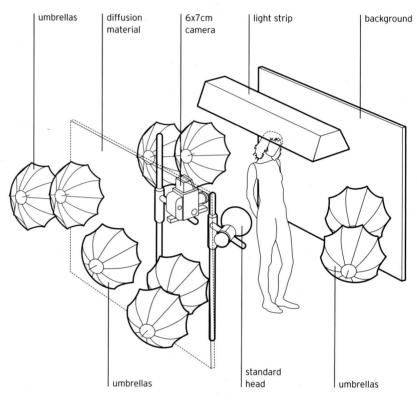

The dazzling smile and gleaming complexion are shown to good advantage as they are bathed in an even spread of light emanating from a virtual wall of light in the form of a series of umbrellas arranged in an arc behind and around the photographer. These all shoot through a curtain of diffusion material, softening and evening the effect on the subject. In addition to this is a key light, a daylight-balanced HMI to camera right, which is the only direct light on the

model. It is positioned just high enough to give a gentle amount of modelling below the chin.

On the background are four more umbrellas, one pair on either side. The resulting lightness and evenness of a large part of the final image makes a good background against which the necessary cover text can 'read' clearly. A very mottled or light-and-dark image makes it difficult for text to show up well, and this is always a major consideration for a cover shot.

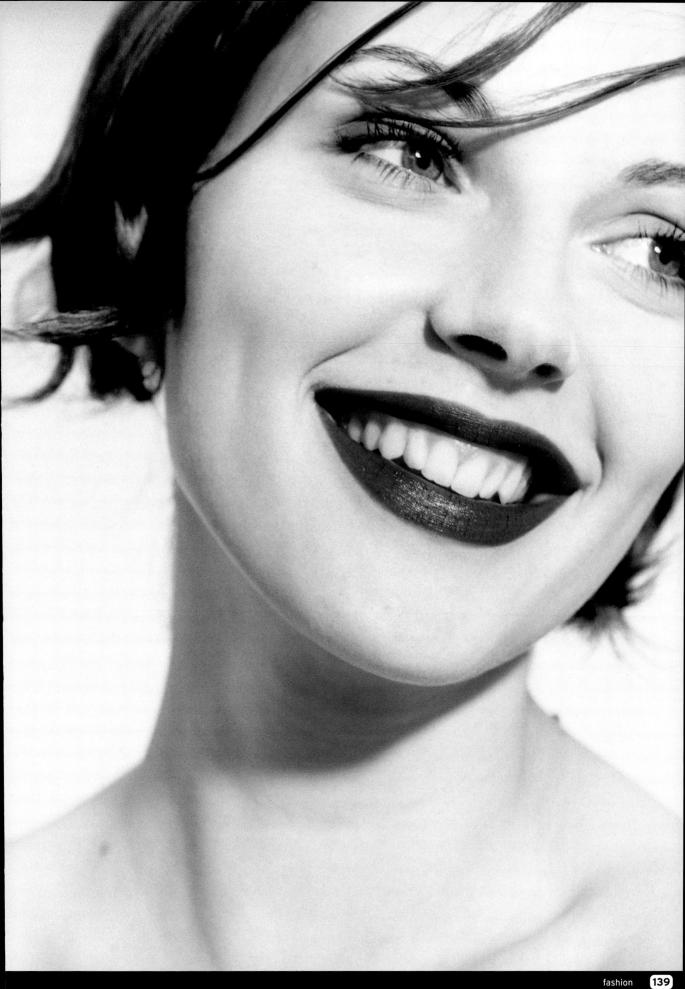

emma

photographer Jörgen Ahlström

use

Personal work

model

Emma 6x7cm

camera lens

90mm

film

Kodak PXP 125

exposure lighting Not recorded Available light

plan view

key points

► Depth of field is dependent on several factors: the proximity of the subject to the camera, the focal length of the lens and the aperture setting

Depth of focus, not to be confused with depth of field, is located at the film plane Though this may look like a classic studio portrait, it is in fact a location shot.

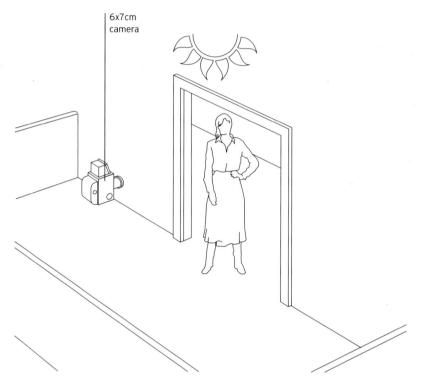

The model is standing in a doorway with a white wall providing a plain background behind her. The photographer is on a balcony a little higher than the model. The sun is to camera left, but the position in the location chosen gives a relatively non-directional look as the light is bounced from the building walls and doorways around.

There is a shallow depth of field and the camera is in close proximity to the

model to give the soft look to the peripheral areas of the shot. Only the detail of the central face (specifically, the eyes and complexion) is in sharp focus, to emphasise the model's features and immaculate make-up. There are shapely highlights on the cheekbones, but the make-up ensures that these do not register as an unflattering shine. Instead, the make-up maintains a perfect gleaming matt complexion.

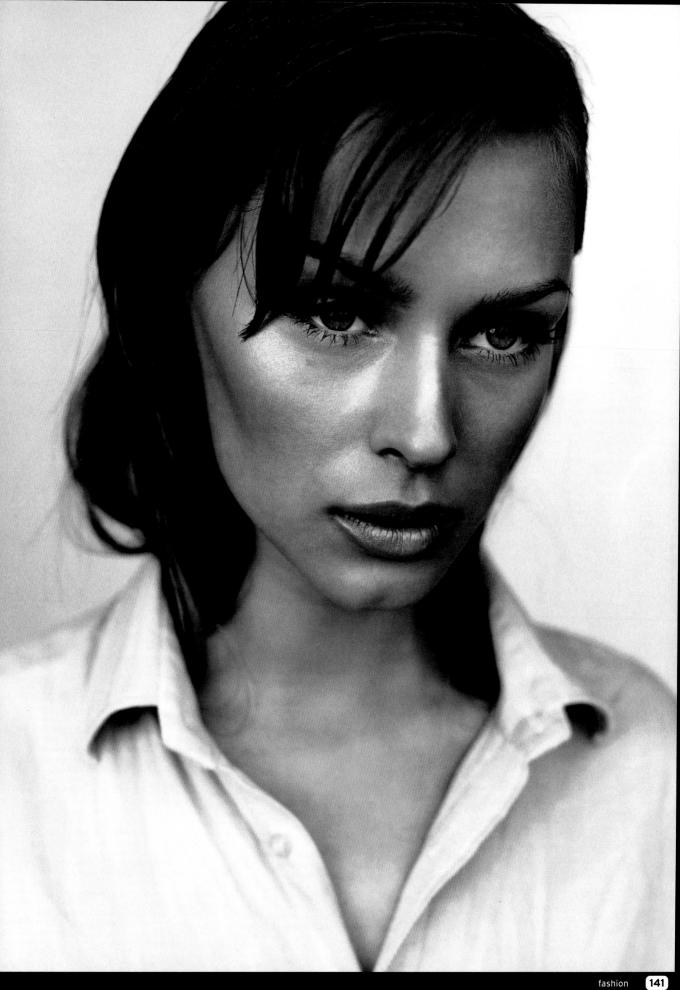

hila

photographer André Maier

client

Mode-Info, Berlin

use model Editorial Hila Marin for Next

Models

art director

Jörg Bertram Hélène Gand

make-up stylist

Jörg Bertram

hair

Yoshi Nakahara for Oscar Blandi Salon

designer

Mark Montano

camera

35mm

lone

135mm

lens film

Kodak E100SW

exposure

1/15 second at f/11

lighting

Available light, fill-in

flash

props and background

Rooftop at sunset

plan view

key points

- The introduction of a small amount of coloured light can really add to the impact of an image
- Sometimes areas of both sharp and soft focus on the same main subject can enhance the shot

This shot was executed on a rooftop, with the New York skyline visible behind serving as a backdrop. It is dusk and the colour of the sky ranges from rich mauve orange to deep blue.

A hot-shoe flash is linked to the camera via an extending cable, allowing for greater flexibility in positioning what is basically an on-camera flash, off the camera. The flash is hand-held to the right of camera and gives even illumination on the face and good catchlights in the eyes. A straw filter on the flash adds warmth to the face.

This is a long exposure for a handheld shot at 1/15 second. The flash is fired only at the end of the exposure (rear curtain flash) to ensure the frozen clarity of the final image, so that only the periphery of the subject melts away into a haze as a result of the small amount of movement during the first part of the exposure.

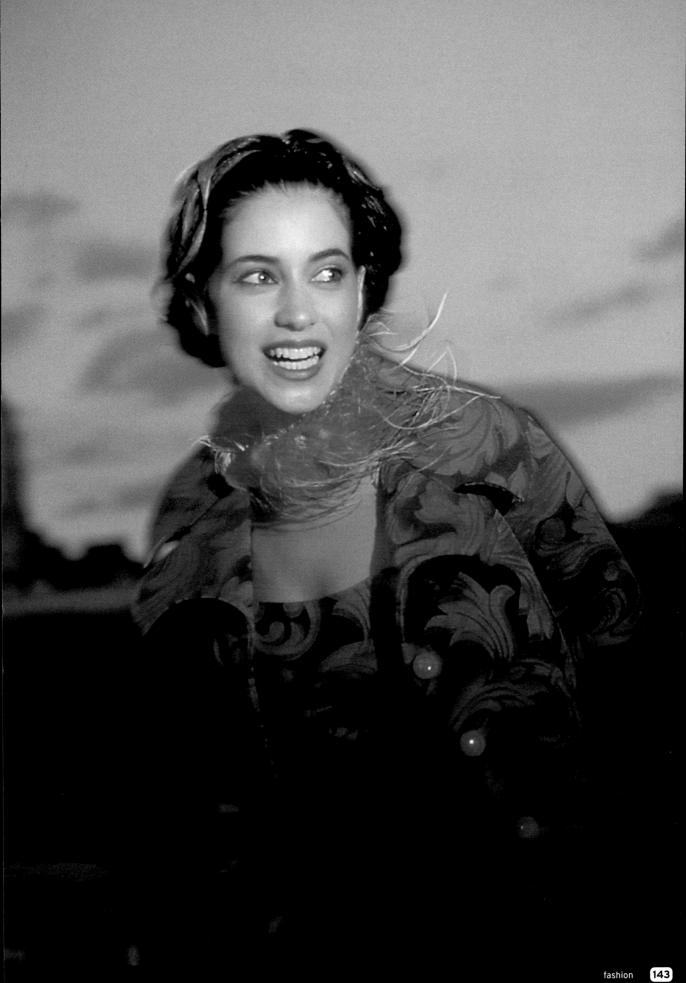

girl on box

photographer Wolfgang Freithof

client

Mardome Collection

use model Promotion

Jewel Turner

art director

Jewel Turner Jimmell Mardome

make-up

Nikki Wang

camera

35mm

lens film 105mm Fuji RDP

exposure

1/60 second at f/5.6

lighting

Electronic flash

props and background

Yellow paper backdrop, box

plan view

key points

- Polyboard wedges can be multipurpose, throwing light forwards and backwards and also flagging the camera from lens flare
- Light shot through a translucent silk umbrella has a different quality from light reflected off one that is non-translucent

It is a common accusation that a picture of a fashion model must have been distorted for her to look quite so tall, thin and elegant.

"They do it with mirrors" or "they do it with lenses," say the sceptics. Well, "they do it with boxes," as the title gives away, would uncover the trick in this particular case. The model, tall, thin and elegant as she is, is standing on a pedestal for extra height in order to show off the long designer dress in all its splendour; the effect on the proportions in the final shot is superb.

The hair design is tall, too, and is lit specifically by a dedicated spot from behind. The main light from the front is high up and behind the camera and shoots through a silk umbrella.

Two standard heads shooting into a wedge of white reflectors are positioned on both sides to give diffused fill to the sides and to light the background.

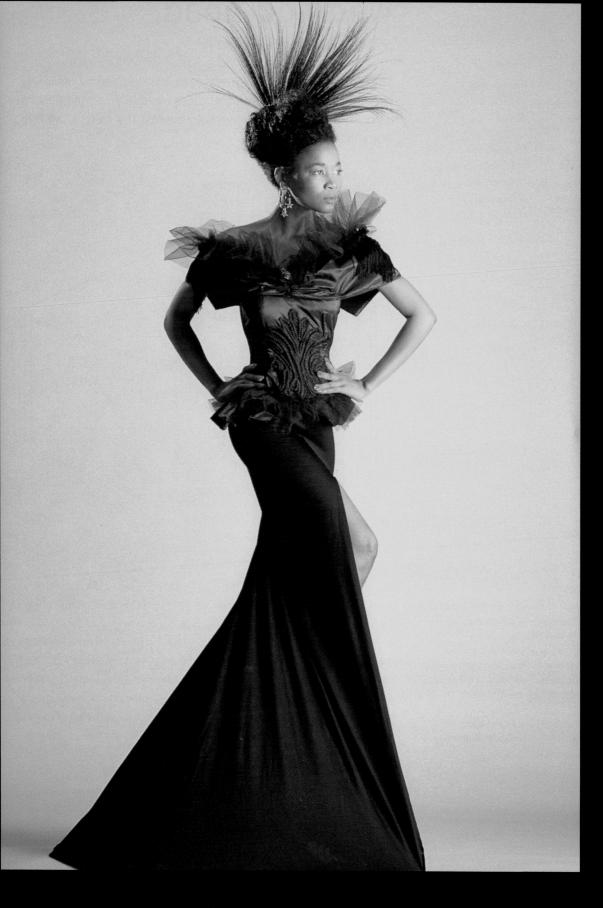

wedding head

photographer Renata Ratajczyk

Use

Personal work

Model

Joa

Camera

35mm 135mm

Lens Film

35mm

Exposure

Fuji Provia 100 1/60 second at f/11

Lighting

Electronic flash

Props and background

White background

key points

- Never under-estimate the importance of the make-up artists and stylists − no amount of soft lighting or petroleum jelly will give a romantic final image if the styling (make-up, hair, expression, pose) of the subject is not right in the first place
- ➤ A small reflector can be just as important as a very large soft box

The model's large, dark velvety eyes, emphasised by make-up, her carefully dressed dark hair and exquisitely painted lips, have a very dramatic impact when set amongst the froth of wedding white lace and net.

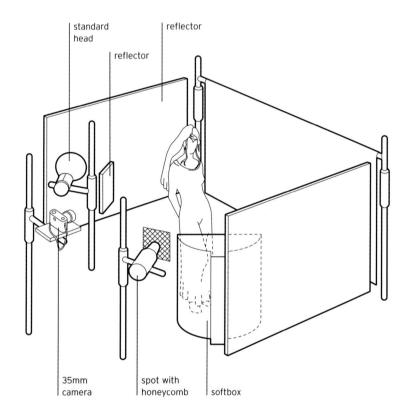

The model's face and the bulk of the dress are lit separately. To the far right there is a medium soft box on the whole of the model. Also to the right there is a standard head with a snoot, honeycomb and diffuser keying the right side of the face. To the left of the camera, a standard head with barn doors bounces off the large white

reflector panel to the left of the model. This lights the dress on that side, and givies a lower level of light than on the face. Diagonally opposite the soft box there is a standard head with honeycomb and barn doors to light the veil from the rear. Finally, there is a small reflector to the left of the model to lighten the shadows on her face.

photographer's comment

Strobes were used. I wanted to create soft romantic light with some dramatic highlights.

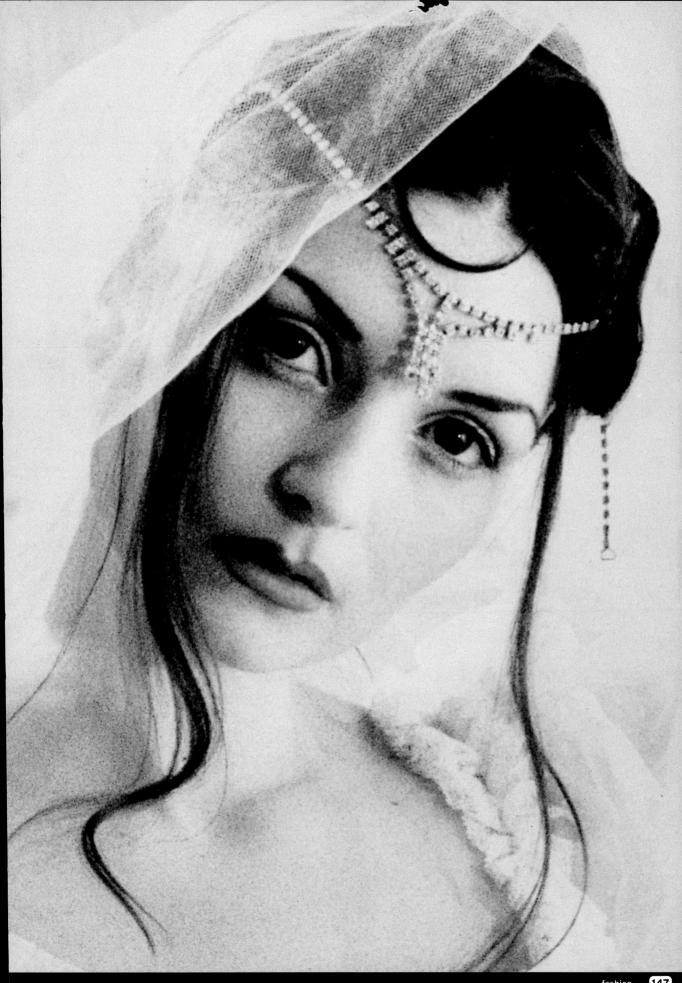

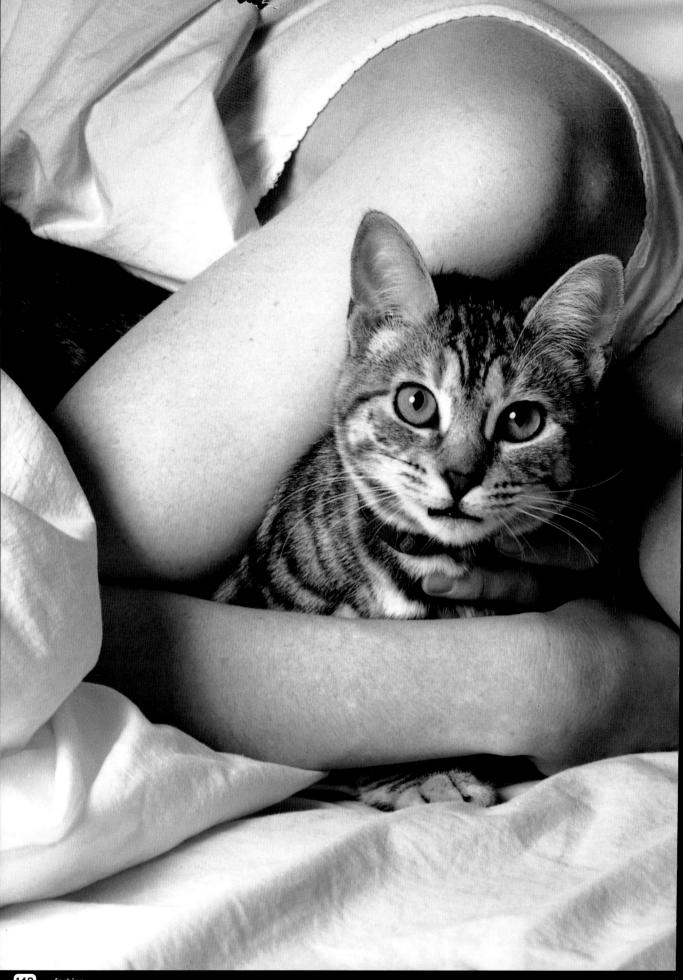

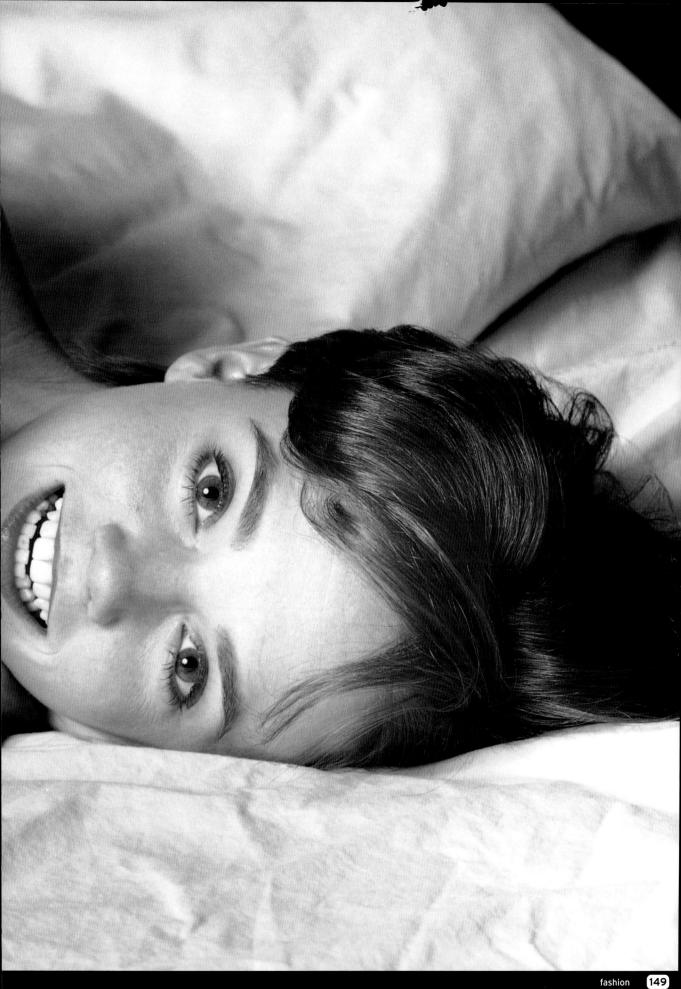

girl with cat

photographer Gordon Trice

client

Agfa

.....

Convention display

camera lens Fuji 680 (6x8cm) 100mm

film

Agfapan 100

exposure

Not recorded

lighting Electronic flash

plan view

key points

- Using reflective light eliminates "red-eye", which in animals usually appears as a blue colour
- Make sure that any potential problems such as model phobias or allergies to cats have been investigated well before the shoot!

Good rapport between model and animal is essential for this kind of shot to succeed. The bond (or lack of it) will be immediately apparent in a final shot.

When working with animals, you should be prepared to shoot plenty of film and to take time to get the moment that you want.

In this superb shot, Gordon Trice has captured the direct gaze of the cat in the perfect face-on position for an appealing and natural-looking moment. The shot was lit with a single standard head set at 1200 watts, shooting into a large soft white 52in umbrella positioned some 10ft from the subject, to the left and just above the camera. This gives the good catchlights in the eyes and pleasant gradation of light and shade across the model's arm, throat and face and highlights on the glossy hair.

underground

photographer Wher Law

The predominant ambient light in this scene is from the fluorescent tubes under the handrails of the escalator.

Wher Law has not tried to detract from this eerie hue. Instead, he has supplemented frontal light in the form of a battery-operated sun gun and modified this with a green gel. A shutter speed of 1/60 second was used to freeze the models and their reflections while

still recording background movement that occurs as they travel along on the escalator. The camera is stationary in relation to the models, though not in relation to the surroundings. This is the equivalent of "panning" to follow a speeding racing car.

 camera
 35mm

 lens
 105mm

 film
 Fuji G800

stylist

exposure 1/60 second at f/1.8
lighting Tungsten, available light
location Underground escalator

Eric Lau

plan view

key points

- ► A fluorescent to daylight filter can be used to correct fluorescent lighting. It is coloured purple to compensate for the green
- Reflections can be controlled by using a polarising filter. Use a circular polariser with auto-focusing cameras

photographer's comment

I wanted to capture the models' feeling, presenting their urban chic. The main light is one stop brighter than the ambient fluorescent light.

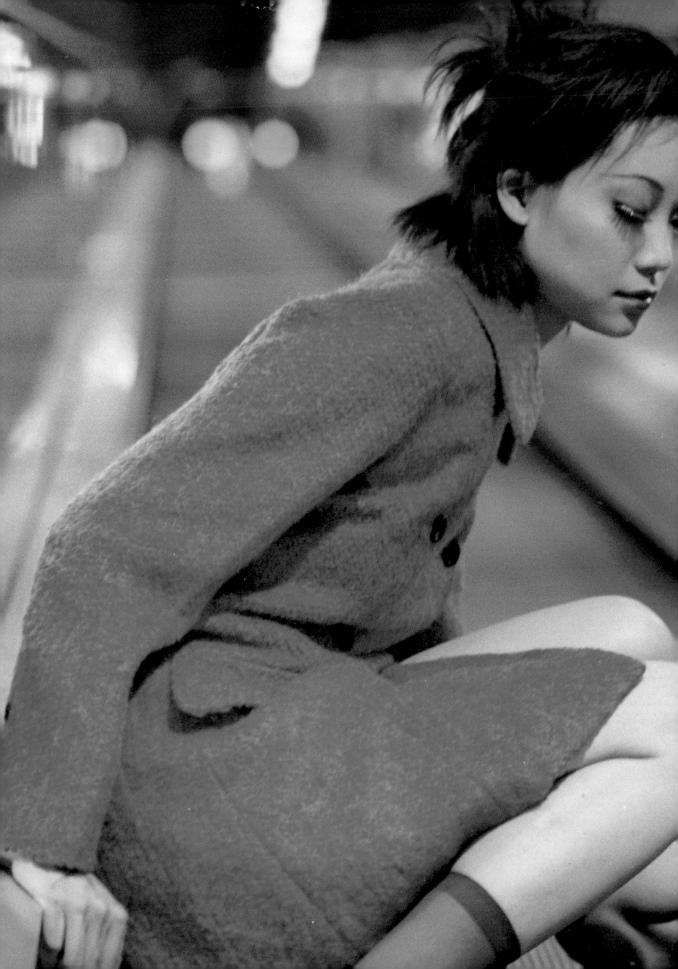

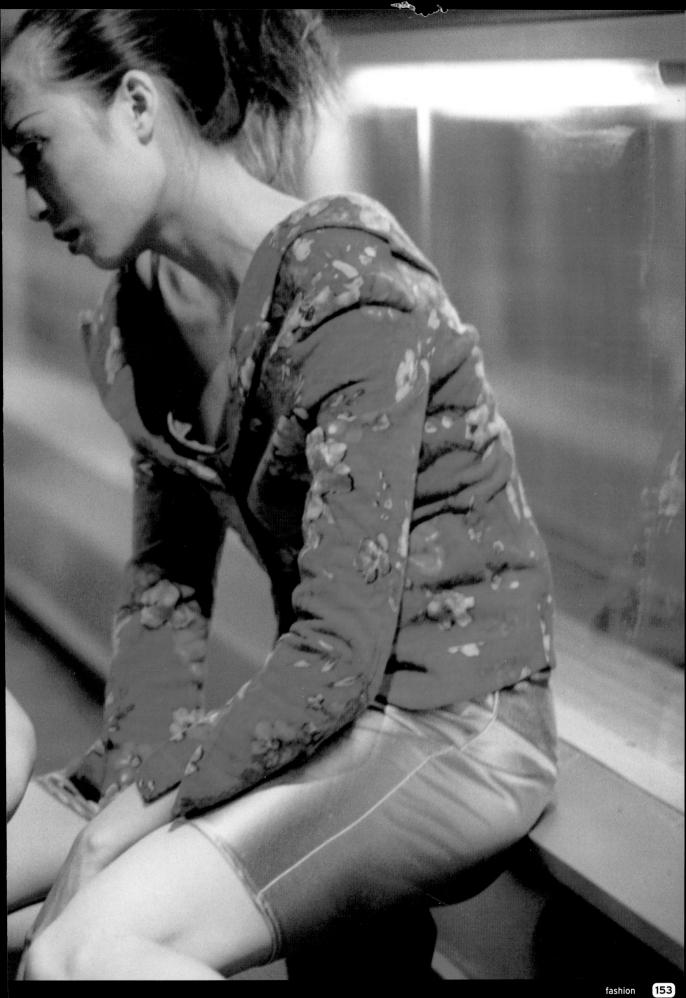

fearful glance

shot in a studio with a basic lighting set-up.

This striking and somewhat disturbing image was created in

several stages by Kazuo Sakai. The image of the woman was

photographer Kazuo Sakai

client

Personal work

camera lens 35mm 85mm

...

Kodak E100SW

exposure

1/125 second at f/5.6

lighting

Electronic flash

plan view

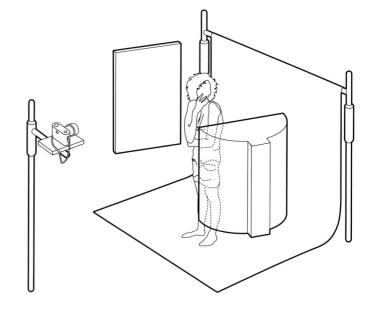

key points

- You should plan out an image carefully when electronic manipulation is to be introduced
- Continuity of contrast is important when different elements are being used to construct a shot

There is a large full-length soft box to the right of the camera and a white reflector slightly to the left of camera. The model is standing against a plain off-white textured canvas background. This canvas allows the photographer to place a more appropriate backdrop onto this canvas, using a computer paint package.

The model was directed by the photographer to look fearful, hence the body language and self-embracing pose. The lighting also reflects this, being somewhat stark and contrasty.

Adobe Photoshop on the Macintosh was used to add a chaotic background to achieve the result that the photographer had in mind.

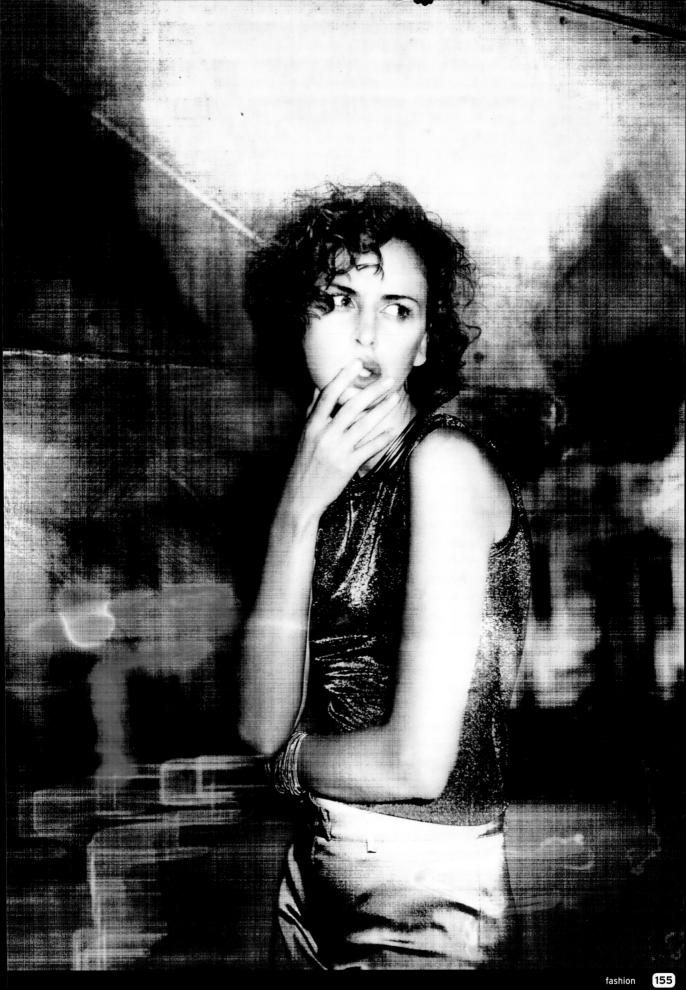

suit

photographer Simon Clemenger

photographer - "go out in the midday sun"...

"Mad dogs and Englishmen" – or, in this case, a model and a

use stylist Model portfolio

designer

Steven Young Steven Young

camera

35mm

lens

28mm-80mm at 35mm

film

Ilford XP2

exposure lighting Not recorded Available light

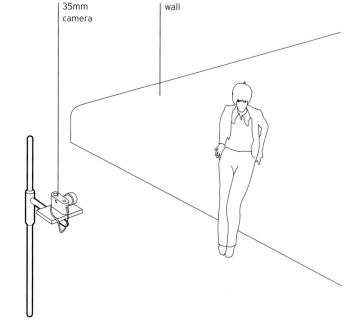

plan view

key points

- This graphic high-key effect is the result of bright midday sunlight and carefully considered printing
- A simple unobtrusive background is often preferable when showing off a full-length outfit

The extreme shortness of the shadows indicate the approximate time of the shoot as noon, while the position of the shadows show that the model is almost directly face-on into the bright sunshine. This gives good detail in both the white shirt and the dark fabric of the suit. The dark sunglasses not only complete the 'look' and complement the fashion styling of the shot, but are

also an absolute necessity for a model who is required to look straight ahead into strong sunlight.

Even in black-and-white, the viewer can almost feel the heat and power of the dazzling sun reflecting off the page. The model's pose - as if pinned to the wall by the sheer force of the sunlight - is an excellent choice to convey and emphasise this feeling.

photographer's comment

This is very interesting film. This shoot was the first time that I ever used it.

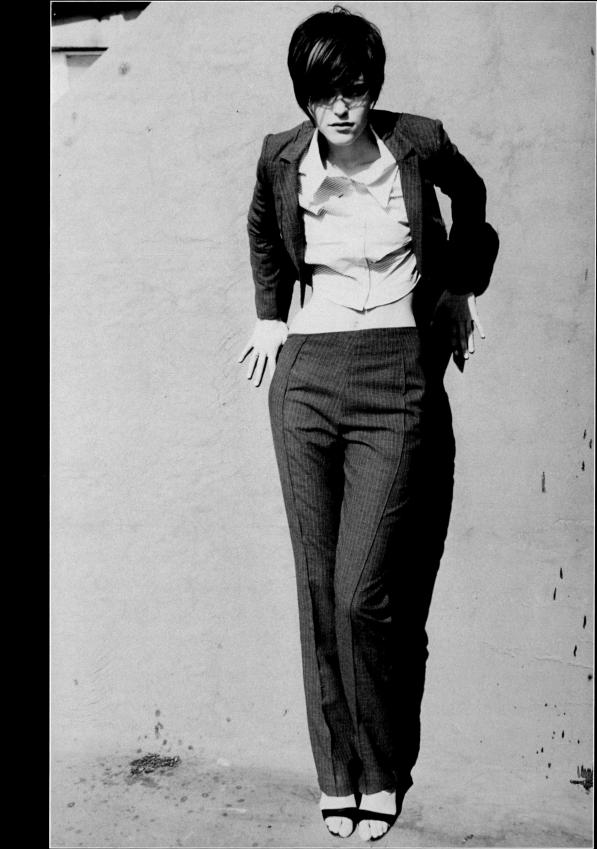

renée

photographer Jörgen Ahlström

6x7cm camera

allows the pattern of the blinds to register.

client

Tatler

use

editorial

model

Renée

camera

6x7cm 35mm

lens film

Kodak GPH

exposure

not recorded

lighting

available light, daylight fluorescent tube

props and

white blinds

background

plan view

key points

- ► When daylight falls into shadow, for instance under the shoe, the colour temperature dramatically increases, which is why there is a blue tint in the shadowy areas on the sole
- ► Colour negative stock is far more suited to high-contrast imagery like this. Transparency stock probably could not hold such a contrast ratio

window with white blinds

Daylight is coming in through window blinds directly ahead of the

model and is diffused by a fine background that nevertheless

A second window to the right, again modified by blinds, is to camera right and introduces side light on the shoes. A fluorescent daylight tube is horizontal to the ground not far off the floor, between the camera and the model. This lifts the shadow detail of

light strip

the floor. Careful directing of the model ensures that the left silvery shoe stiletto picks up a bright highlight from this source, while the right stiletto is tilted to avoid it. A further reflection of the tube is visible in the black supporting part of the right shoe heel.

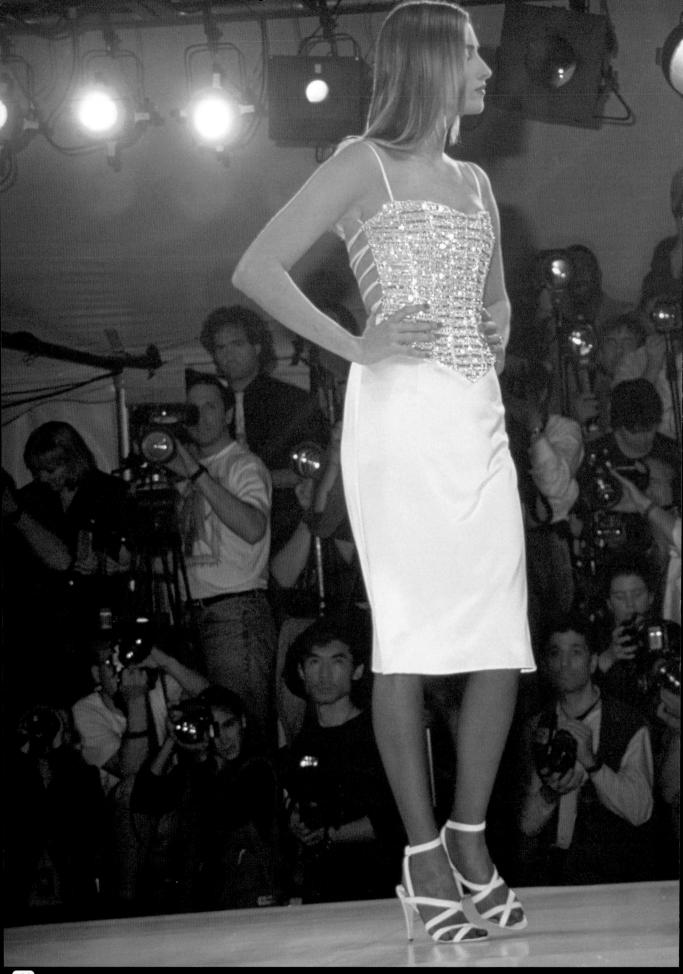

new york fashion show

This is a situation where the photographer had to work with the

lighting that was already in place. For a catwalk fashion show a

multiplicity of stage lights surround the runway, and are visible

photographer André Maier

in the shot.

use

Portfolio exhibition

camera

35mm 50mm

lens film

Fuji Velvia

exposure liahtina Not recorded Available light.

fill-in flash

props and background Live catwalk show

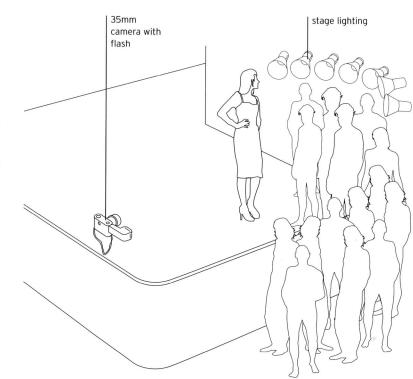

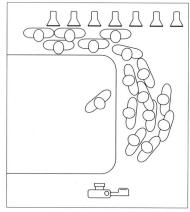

plan view

key points

- In a situation like this, it is worth considering utilising flare as a creative aid to composition
- It is always a challenge to find an unusual 'take' on a commonly photographed subject.
- Spot metering is an invaluable aid for catwalk photography

These banks of tungsten lights give the deep golden warm glow to the picture. Only the model's dress and shoes show up as a bright clear white, because of the on-camera electronic flash used by André Maier for fill-in, which outshines the tungsten ambient light.

It is of course more common at a fashion show for a photographer to

concentrate on the model and the clothing that is being displayed, but this shot is more of a documentary-style image than a traditional catwalk shot. André Maier wanted to illustrate the extended wall of photographers with their array of vastly expensive camera equipment and lenses surrounding the stage.

photographer's comment

I wanted to catch the excitement of what was going on in a general sense, rather than just what was happening on the catwalk.

lisa

nearby building.

photographer Jörgen Ahlström

The photographer was 15m above this stunning

paved square, shooting from the balcony of a

client

LC

use

Editorial

model

Lisa

camera

6x7cm

lens

75mm

film

Kodak TriX 400

exposure

Not recorded

lighting

Available light

plan view

key points

- Some locations offer a background that simply cannot be emulated
- It may be necessary to get police permission and co-operation in order to ensure a clear view of a large expanse of public space

Only available light was used, which in this case was bright sun on the far side of the model. The location and angle of view are what make this shot so visually exciting. The geometric patterns of the cobblestones form an expansive mosaic background, and there is a gradient from light to dark from the top to the bottom of the picture because of the angle of sunlight

and plane of the surface in relation to the photographer's position. The position of the sun gives fairly even light on the surfaces of the cobbles while allowing the recessed mortar areas between to stay deep black.

The upper surfaces of the model just catch the light directly, and the paved surface acts as a reflector to provide fill on the rest of the body.

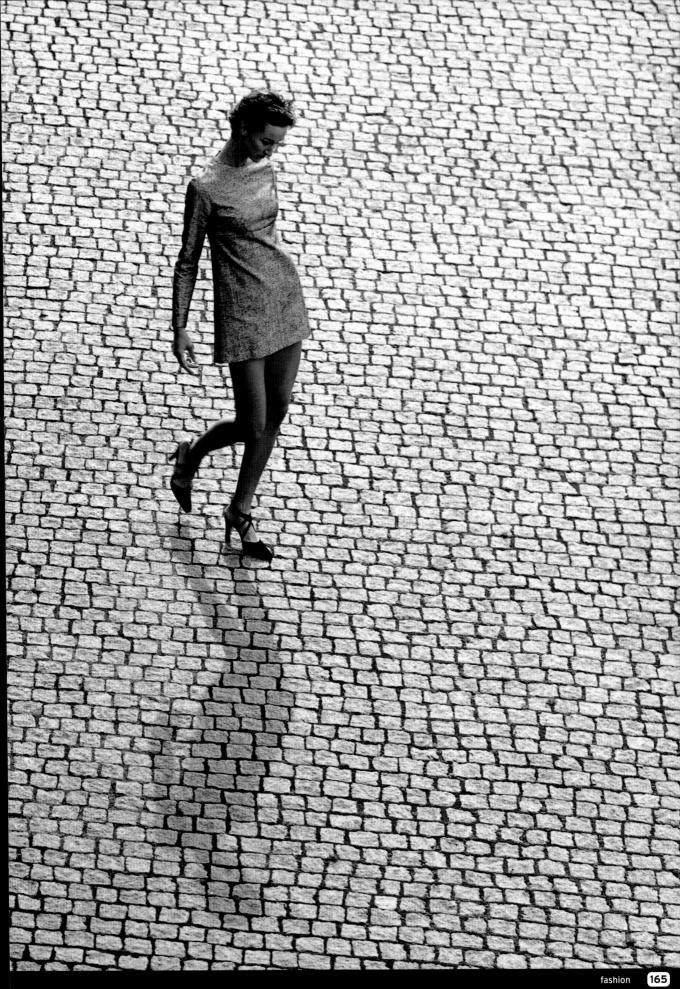

atelière

camera right.

photographer Ben Lagunas and Alex Kuri

client

Claudio Designer

use

Editorial

assistant

Isak, Christian,

art director

Paulina, Janice Ben Lagunas

stylist

Leonardo 6x6cm

camera lens

210mm

film

Kodak Tmax CN

exposure

1/250 second at f/11

lighting

plan view

Three-quarters behind the model is a focusing spot directed at her. This gives a back light that shines through the length of gauzy dress fabric she is holding up and adds rim light to the edge of her arm.

The only other source is the crystal chandelier that is visible at the top of the image, basking in a bright pool of its own light. Everything about this shot shines. The fantastic costume, the stylish fashion workshop setting, the beautiful and immaculately made-up model, the theatrical pose and the sparkling quality of light all combine to condense the glamorous appeal of the world of fashion into a single stunning image. The effect is reminiscent of the work of Cecil Beaton combined with the surrealist work of Angus McBean.

key points

- ➤ When lighting for theatrical effect, traditional rules, such as the back light being opposite the key light, need not always apply
- ► Prop lights can double up as sources

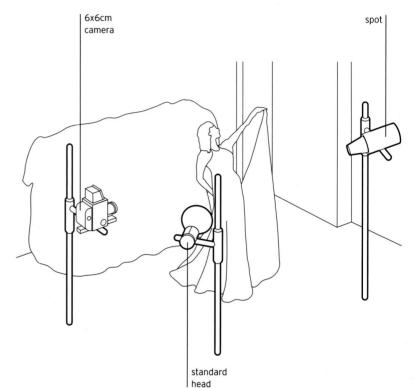

The camera is straight-on to the model, with a standard head to

photographer's comment

Using toners with this kind of film produced warm 'colours'.

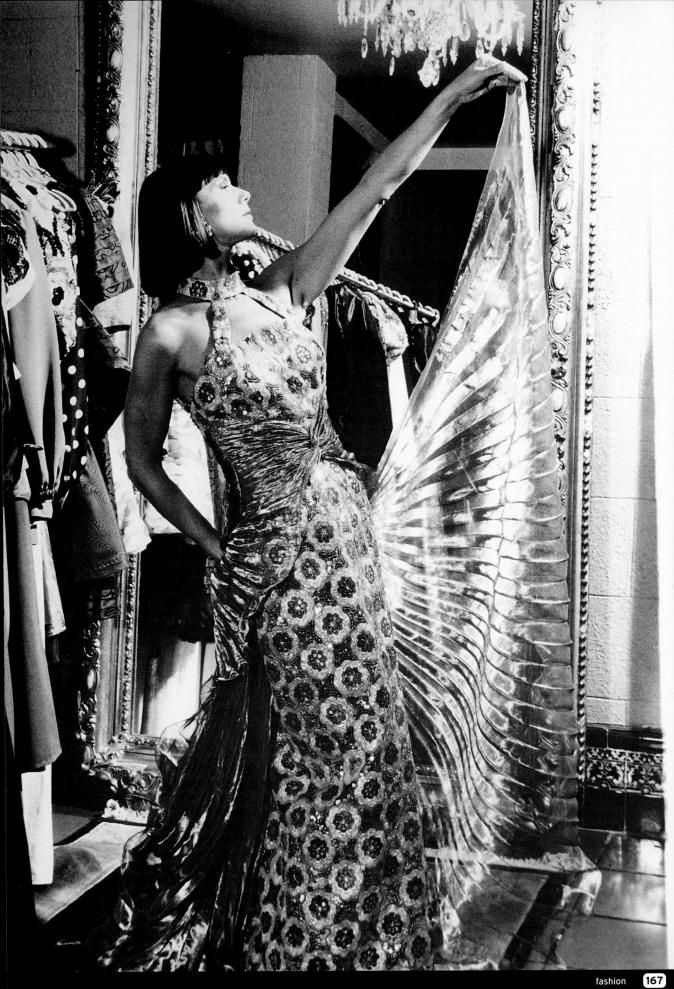

girl on rooftop

photographer Wolfgang Freithof

Wolfgang Freithof has positioned the bare bulb flash head in the Editorial same direction, in relation to the model, as the sun at the time of

Kevin Sharpiro

hair and make-up

BFIA

Irasema Rivera

client

art director

use

camera 35mm

35mm light bulb lens 85mm camera

this shot.

Ilford XP2 film 1/60 second at f/4 exposure

lighting Available light, electronic flash

plan view

key points

- ► Constant exposures combined with an initial clip test is important to determine correct development time when cross-processing
- ► Different hues, blueish, greenish or brownish, can be achieved with XP2 by printing onto colour paper and varying the filtration

It combines with and complements the ambient light available and emphasises its directionality to give strong highlights along the model's back and side nearest the camera. Her front is in the fall-off shade area away from both the sun and the flash. The blue-green hue of the shot is appropriate for this

spotlessly white lingerie shot. The cool, crisp, clean look is ideal to convey just such qualities about the garments being modelled. The choice of a fairskinned, blonde model, in combination with the film stock and processing method used, keeps the emphasis on lightness and brightness.

photographer's comment

The film was rated at ISO 50 and processed E6, pushed two stops to get the washed-out skin tones.

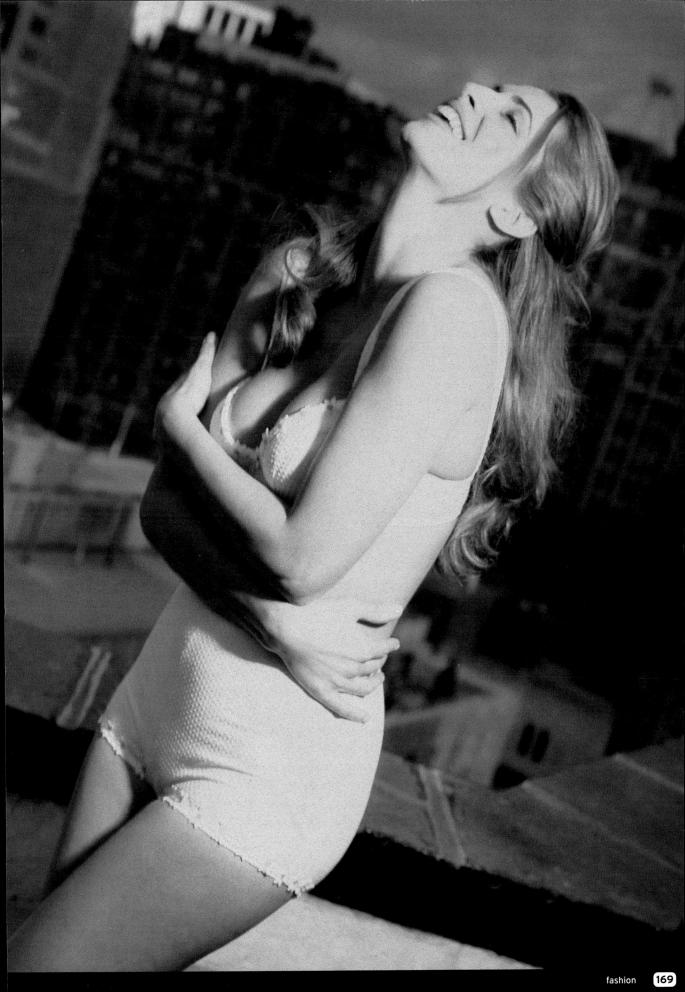

calligraphy face

photographer Marc Joye

Not everyone would think of using Japanese calligraphy as a fashion make-up accessory, but Marc Joye uses this interesting visual element with subtlety and style.

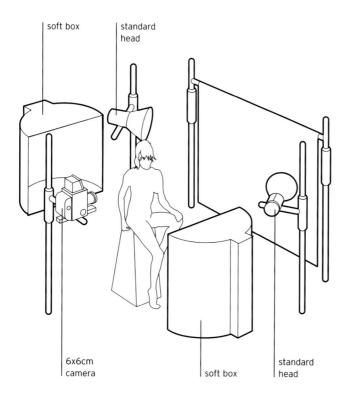

Joye has experimented with various styles of body painting, and sometimes adds calligraphy or ink-design decoration to slides after the shoot. This shot shows his fascination with the idea in close-up. "By setting some more light on the background we created a contre-jour effect, bright light!" he says. "An aperture of f/11 was chosen as we liked a lot of unsharpness, with only the eye and calligraphy sharp." Two

flash heads brightly and evenly illuminate the background. The model is quite close to the camera and is standing between two one-metre square soft boxes, one in front of her face and the other aimed at her back. The background is overexposed by one and a half stops to render it light and gleaming. Notice that the catchlight in the eye is a reflection of an entire soft box - an effective finishing detail.

Photographer's comment

Genevieve's body was very light through make-up except for some blue highlights on her eyes, lips and breast.

use

Portfolio

model

Genevieve

stylist

Geni and Mike

camera

6x6cm

lens

150mm EPP 100

film exposure

√60 at f/11

lighting

Electronic flash

key points

► Imaginative use of make-up can make for an imaginative subject and inspire an imaginative composition.

Depth of field depends on several factors: the focal length of the lens, the distance of the subject from the camera, and the amount of light available, so in this shot f/11 is a relatively shallow depth of field

plan view

crouching man

photographer Frank Wartenberg

use

Publicity

camera

6x7cm

lens

105mm

film exposure Fuii Velvia Not recorded

lighting

Electronic flash

plan view

The key to this shot is a very shallow depth of field to make the model's head appear separate from the body.

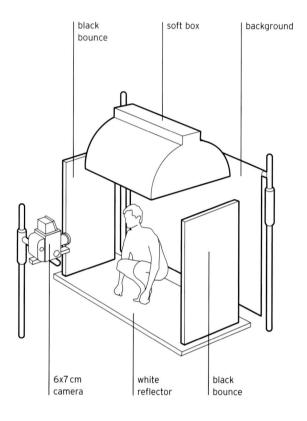

key points

- ► Controlling a model's pose is not purely a compositional consideration - it involves lighting control as well
- Depth of field is dependent upon the distance of the subject from the lens, the aperture and consequently the amount of light

The more one looks at it, the more surreal, and even disturbing, the shot seems to become. The lighting adds to the disembodied effect by emphasising graphic areas of light and shade. The pose is highly contrived; the lines on the forehead are there to create distinctive forms and the braced

muscles also highlight the landscapelike undulations of the limbs.

The purpose of all this careful posing and composition is of course to establish the perfect crest of bristlelike hair at the point of focus, both in terms of the lens and in terms of the viewer's interest.

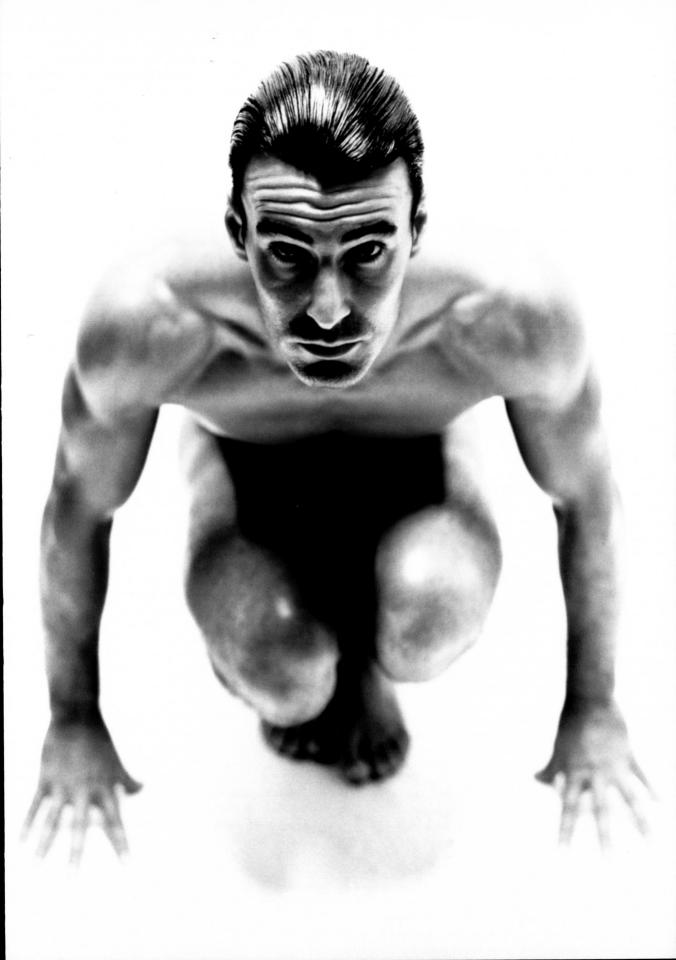

chinese hair

photographer Frank Wartenberg

use

Self-promotion

camera

6x7cm

lens film 127mm

exposure

Fuji Velvia Not recorded

lighting

Tungsten

plan view

There is no shortage of lighting equipment here. Frank

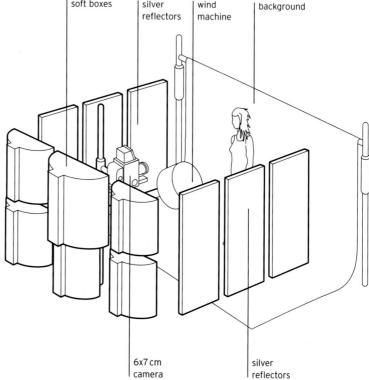

key points

- Modelling lights are normally tungsten, so bear this in mind when balancing sources
- Silver reflectors will produce more focussed light than white reflectors

The main light is a large soft box (used with the modelling light only) positioned behind the camera. Six smaller soft boxes are arranged on either side and below this, again using only the tungsten modelling light. These combine to give an even sheet of light across the subject.

On both sides is a selection of silver reflectors, effectively forming a wall to either side.

The resulting bright and even background provides a foil against which the strands of the model's hair, tousled by a wind machine, stand out in stark silhouette.

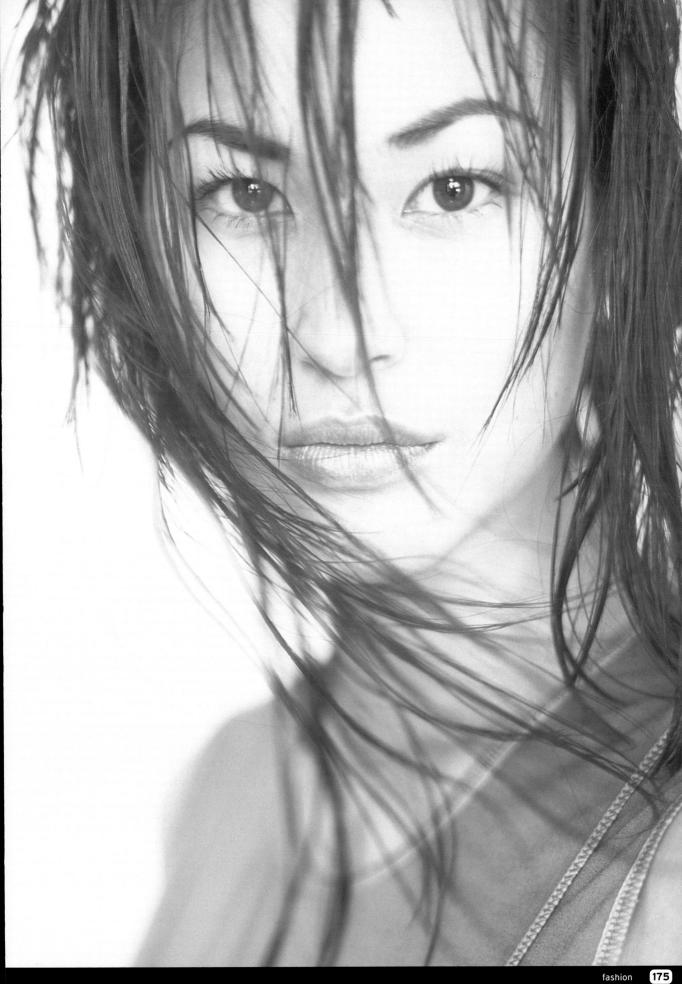

face

client

Eurowoman

use

Editorial

model

Kati Tartet

assistant

Helene Elfsberg Louise Simony

make-up stylist

Bjorne Lindgreen

camera

Pentax 67

lens

90mm

film

Fuji Provia 400 ISO 1/2 second at f/2.8

exposure lighting

Tungsten

plan view

key points

- Symmetry of composition used in conjunction with symmetry of lighting can double the impact of a shot
- ► Domestic tungsten lighting has a colour temperature of around 2800° Kelvin, which gives a warm glow

Framing and punctuating the face are the all-important shadows below the chin, nose and brows, adding a strongly graphic and even geometric element to the composition. These shadows are achieved by the use of a single light source (in fact, a single domestic tungsten light bulb) positioned high above the model's head.

The model seems disarmingly close to the viewer and the resulting shallow depth of field flattens out all but the most important of her features. The evenness on the forehead and nose arise partly from this flattening-out effect, but also from the expert application of make-up to give a perfectly smooth and even skin surface.

The striking symmetry of this shot is part of what makes it so compelling. Equally arresting is the model's gaze, enhanced by bold make-up lines.

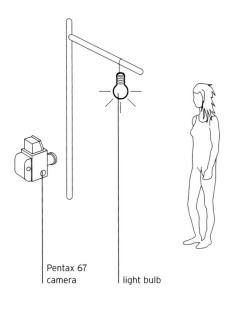

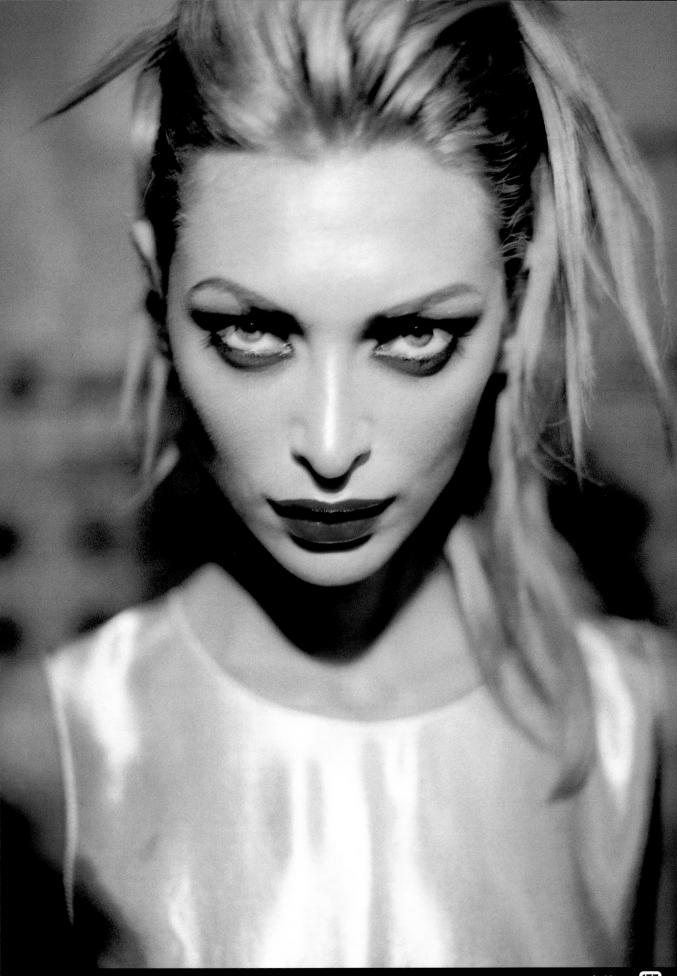

biba cover

photographer Jeff Manzetti

diffusion

material

umbrellas

In this shot, the photographer has used a highly controlled pool

of soft light. The key modelling is provided by one direct source.

Pentax 67

camera

black

bounce

light strip

Biba magazine client

Cover IISA

Estella Warren model hair Karim Mytha Brigitte Hymans make-up

Nathalie Marshall stylist

Pentax 67 camera lens 135mm film EPT 120/160

lighting Flash

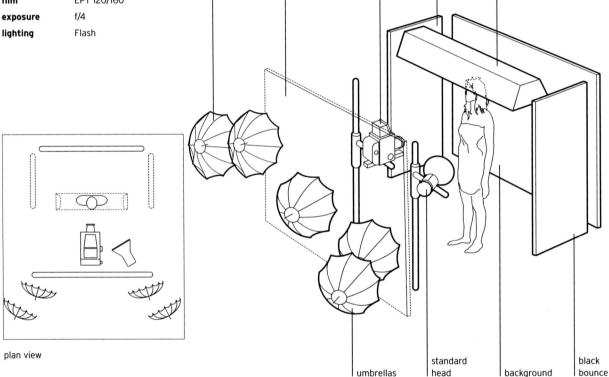

key points

- ► Black panels will dramatically increase the fall-off within a composition
- ► Catchlights are an important consideration and should not be left to chance

Two pairs of heads shooting into brollies are evenly placed either side behind the camera and come through a wall of diffusion material to provide overall illumination and light the background. A strip light is positioned directly above the model to pick out every single lock and wisp of hair. The placing of the key light is evident from the dual catchlight in the eyes. The leftmost catchlight is from the brollies, whereas the righthand-side one is the key light. A standard head with a fresnel lens, to the right of the camera, is set to give just enough modelling under the chin, but the pool of soft light keeps the depth of the shadows to a minimum.

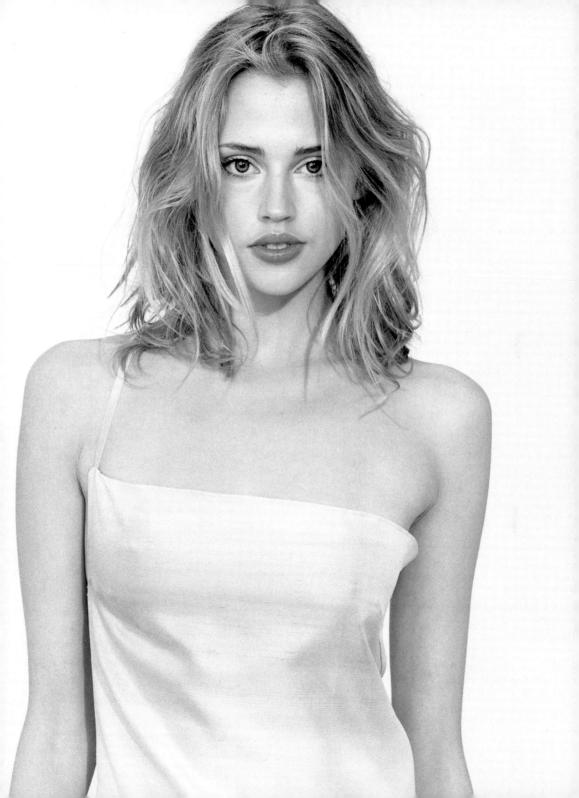

linda

cover-shot image.

photographer Jörgen Ahlström

client Elle
use Editorial
model Linda

camera 6x7cm lens 90mm

film Kodak GPY 400
exposure Not recorded
lighting Daylight tubes

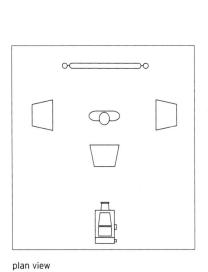

Jörgen Ahlström used Kino Flo daylight tubes - fluorescent tubes balanced to a colour temperature of 5600° Kelvin, equivalent to that of a standard flash head and daylight. The one that is reflected in the eyes is above the camera and horizontal to the ground. In this position it provides the catchlights in the eyes, emphasises the eyeshadow and lips and adds general lighting across the front of the model. Two more daylight tubes are positioned upright, one either side of the model, in close proximity to her. These give the bright glare on the sides of the arms and highlights on the cheeks. The slight halo effect occurs because these tubes are just behind the model.

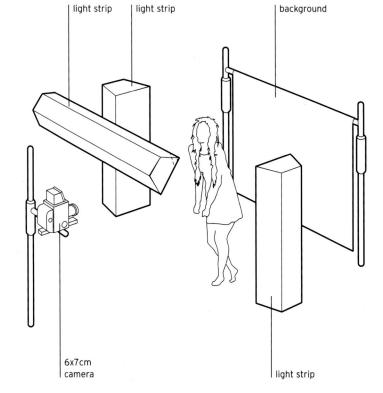

The straight line catchlights in the eyes reveal something of

the lighting set-up that the photographer used for this classic

key points

- Using a fluorescent tube rather than a strip light gives more concentrated light
- Standard fluorescent tubes can be corrected to daylight by using a specific purple gel

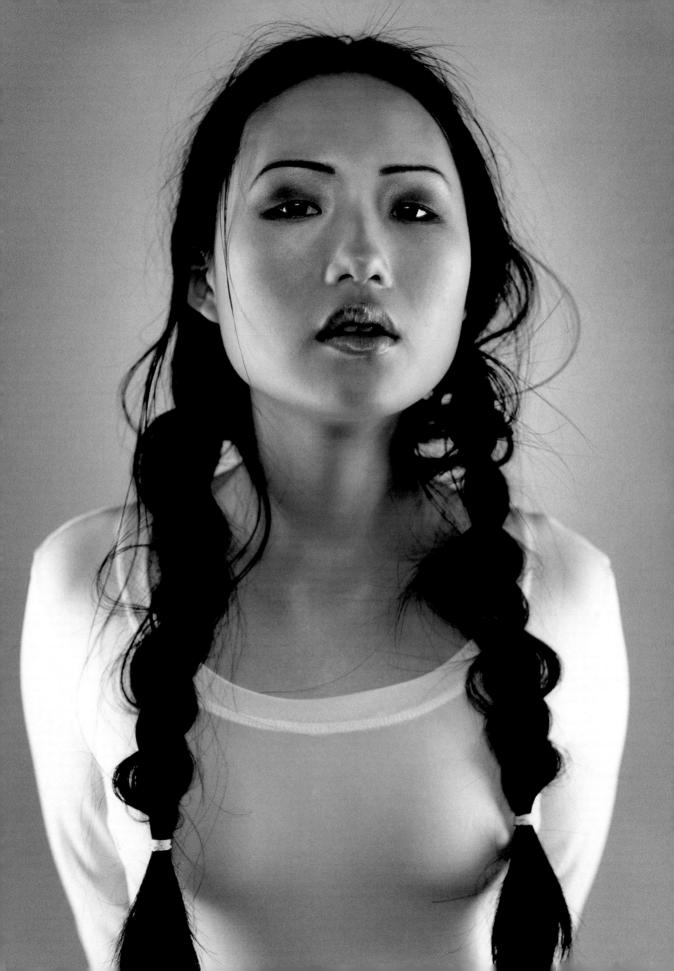

bouche suave

photographer Jeff Manzetti

DS Magazine Editorial

model Karine Saby
hair Bruno Wepp
make-up Thibault Fabre

client

use

stylist Nathalie Baumgartner camera 6x7cm

lens 135mm
film Fuji EPL 160
exposure 1/30 second at f/4
lighting Electronic flash

Even though it is quite clear that this is a photograph of lips, there is a way of looking at this image as though it were an abstract study.

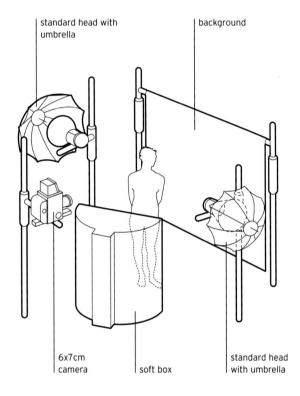

plan view

key points

- When composing tight close-up images remember that space is required to place lights appropriately
- Sometimes deliberately degrading an image (i.e. not shooting it ultra-sharp) can give a more interesting look

The effect of being so close in to the subject, with such a smooth, even expanse of pale colour in the areas of the face and the background, gives a sense of disembodiment and lack of context for the lips. It is simultaneously a very rounded rendering of the three-dimensional full pouting lips and also a flat, abstract, two-dimensional image of an area of shiny red against a pale background. It all depends how you

look at it. From a practical lighting point of view, it is desirable to have a long macro or long close-focusing lens to allow for optimum positioning of lighting.

This shot is lit by an Elinchrom octabox (an octagonal soft box) placed to the right of camera. The background is lit by two symmetrically positioned standard heads shooting into umbrellas.

black slip/lace dress

photographer Wolfgang Freithof

client Fernando Sanchez

use Editorial

models Claudia Schiffer (Black slip)

and Naomi Campbell (Lace

dress)

art director Quintin Yearby

make-up Sam Fine

hair Ron Capozzoli camera 6x6cm

lens 150mm

film Kodak Tri-X

exposure 1/60 second at f/8 lighting Electronic flash

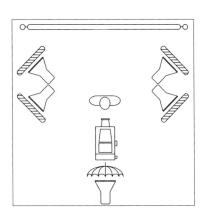

plan view

key points

- Before buying expensive computer equipment, make sure you know what you want to do with it.
- Images can put into a computer via a scanner or can be originated on a digital format.

On this shoot, Wolfgang Freithof was working with the two great supermodels, Naomi Campbell and Claudia Schiffer.

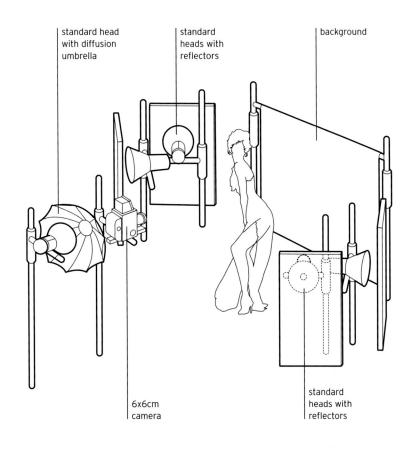

The poses of the two shots and the fact that they were created in the same shoot using the same lighting set-up and modelling fashions from the same collection seem to mark the images a natural pair. Yet for all their similarities, the two pictures give some insight into the personal qualities that professional models can bring to their work. It is tempting to say that the poses are similar, but a closer look reveals that

they are not: Naomi Campbell's trademark striding style is evident in the still, just as Claudia Schiffer's vampish, dramatic style comes through in her shot with equal strength.

The lighting used is straightforward. Two pairs of standard heads bounce out of a polyboard wedge on each side, and the key light is a standard head shooting through an umbrella above the camera.

photographer's comment

Retouched and coloured on an Apple 9600/300 with 320MB of RAM, 22 GB hard drive, using Adobe Photoshop 5.0

belly

photographer Frank Wartenberg

use

Publicity

camera

6x7 cm

lens film 90mm

exposure

Fuji Velvia Not recorded

lighting

Electronic flash

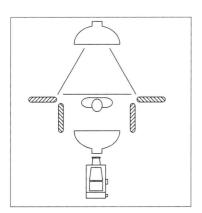

plan view

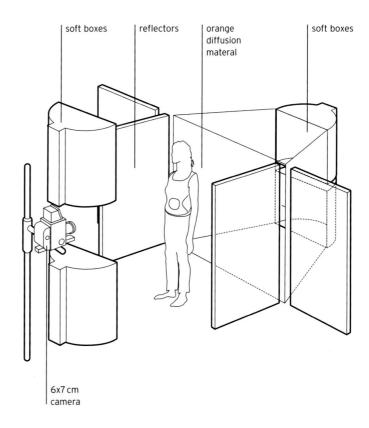

Ever one to use an innovative and imaginative lighting set-up,

effect, and demonstrates the superb results that he gets.

this shot shows Frank Wartenberg's individual approach to good

key points

- Back light traditionally is a hard source, but of course rules are there to be broken
- Experiment with different lighting set-ups - you may find that something unexpected is very effective

There are two soft boxes behind the model, one above the other, directed towards the camera to back light the model. A large pair of diffuser panels painted orange provide a background behind her and the soft boxes are

behind these. Face on to the model are two more soft boxes, one above the camera and one below. These give an even spread of light along the length of the model. Two styro wedges act as reflectors to the sides.

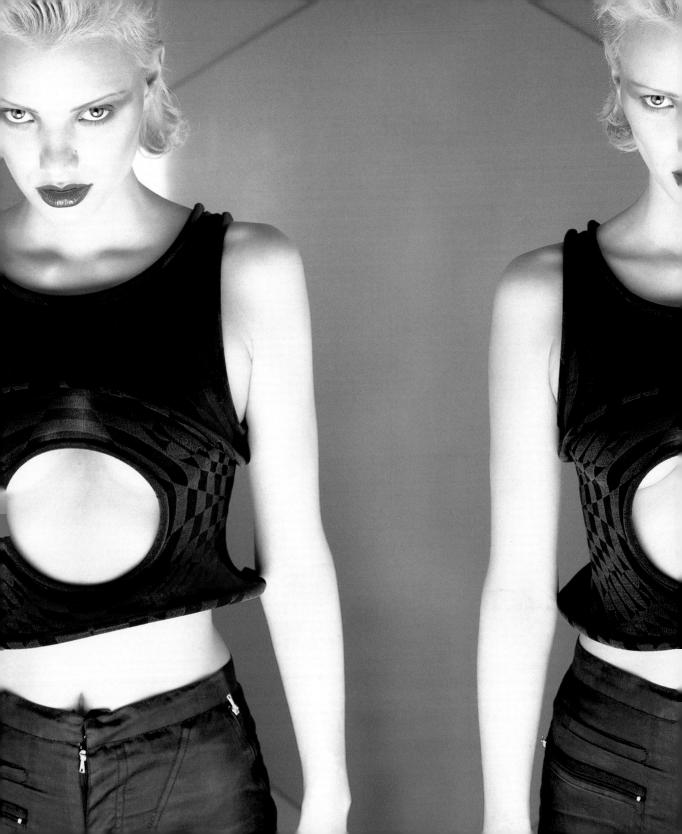

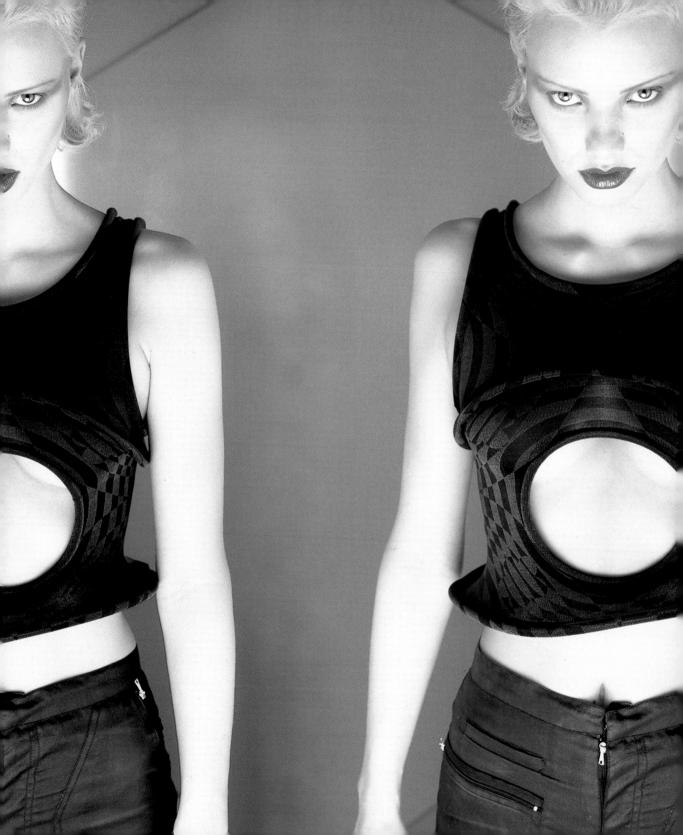

miami fashion

Michael Grecco made good use of this mirror-tiled wall to create

a piecemeal-effect image that is reminiscent of some of the

6x7cm

camera

photographer Michael Grecco

collage work of David Hockney.

standard

head

client

Raygun Publishing

IISA

Editorial

models

Luna and Michael Grecco

assistant

Jason Hill

camera

6x7cm

lens

50mm

film

Kodak EPZ 100 1/60 second at f/8

exposure lighting

Electronic flash

props and background Shot on location at Diesel Jeans Penthouse at the Pelican Hotel, Miami

Beach, Florida

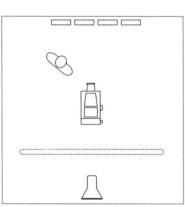

plan view

When working in close proximity to mirrors, the photographer can either try very hard not to be seen and to hide lighting equipment, or can choose to make a feature of allowing all these things to be clearly visible in the final shot and play a part in the composition.

diffusion material

The lighting is provided by a standard head, which is bouncing off a white wall at the opposite end of the room to the mirror. To diffuse the light, reduce the contrast and to produce a 'sheet' of light, a literal sheet of white silk is draped in between the model(s) and the light.

The mirror gives some frontal light and also enables the viewer to see the strong back light.

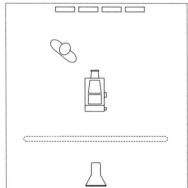

key points

- ► Location features can provide a stimulus for a composition
- ► If it is impossible to work around a feature that is a problem, try incorporating it into the shot instead

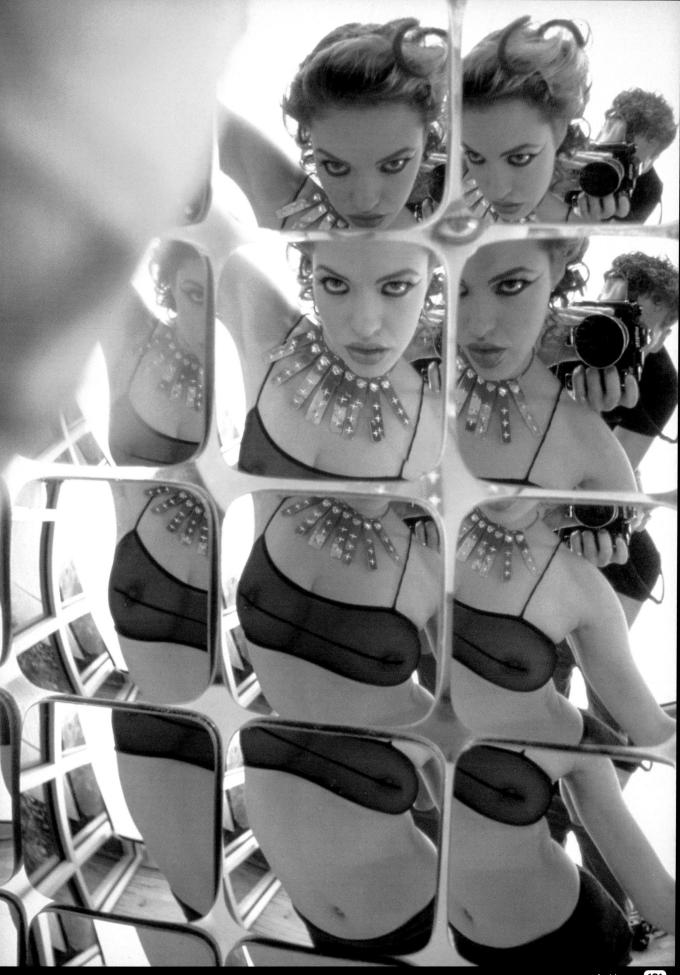

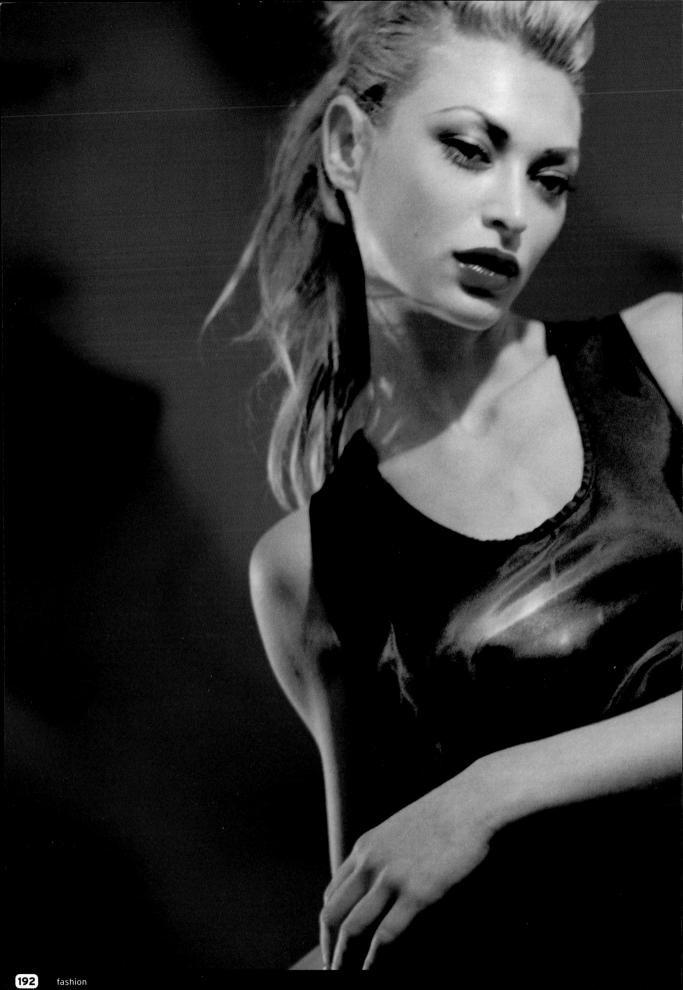

black dress

photographer Isak Hoffmeyer

Effective lighting does not have to be expensive and difficult. For this shot, the lighting set-up consisted of nothing more than what Isak Hoffmeyer describes as "a lightbulb on a stick!"

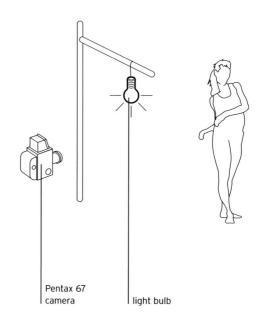

client Eurowoman
use Editorial
model Kati Tartet
assistant Helene Elfsberg
make-up Louise Simony
stylist Bjorne Lindgreen

camera Pentax 67 lens 90mm

film Fuji Provia 400 ISO cross-

1/2 second at f/2.8

processed in C-41

lighting Tungsten

props and Painted backdrop

background

exposure

plan view

key points

- When cross-processing film stocks, it is essential to perform extensive tests to establish film speed rating and development time
- Different types of lighting are affected in different ways by cross-processing, but generally there will be an increase in contrast

Of course, it is not so much what you've got as what you do with it that counts - in other words, the use to which the lighting is put indicates the skill of the photographer, rather than the grandeur (or otherwise) of his equipment.

In this case, Isak has got a great deal out of very little. The bulb is suspended high above the camera and slightly to the side to give a degree of directionality to the light. (The angle of the shadow on the throat indicates the height and position of the bulb clearly.)
The model is some distance from the backdrop, which is adequately illuminated by the same source. The choice of costume, pose, glossy makeup and positioning of light and camera make the most of specular highlights at various points, for interest. Notice the slight softness that is evident in the shot, inevitable with a half-second exposure. It, too, is a carefully considered element and adds to the image's sense of dynamic movement.

white dress twice

photographer Corrado Dalcò

useful technique to keep in mind.

client Bruno's Knitwear art director Vignali Augusto

assistant Daniele Ferrari

Olivia stylist hair Matteo

Editorial use 35mm camera

24mm lens

film Ektachrome 64 1/60 second at f/2.8 exposure

liahtina Available light

plan view

The use of two shots adds interest and a sense of experiencing a "double take" on the subject photographed.

This pair of images has the same cross-processing technique applied -E6 film has been processed in C41 chemistry. Notice the contemporary compositional technique used. The cropping halfway through the head might be misconstrued: in other

circumstances it could be the signature of an unskilled amateur, but it is quite deliberate here. It is surprisingly difficult to compose and frame so precisely in this way.

There is a vogue for framing of this kind in current fashion imagery in order to emphasise the clothing and give a stark, harsh "street" grittiness to the shots.

key points

- Rules are there to be broken, in terms of composition as much as in lighting
- Experiment with different methods of presentation to enhance the impact of an image

The impact and effectiveness of using a pair of shots for a single

fashion feature comes across clearly. It is an interesting and

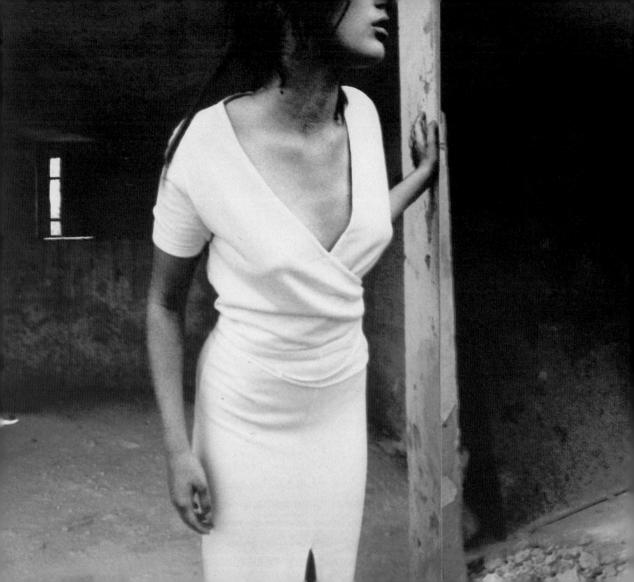

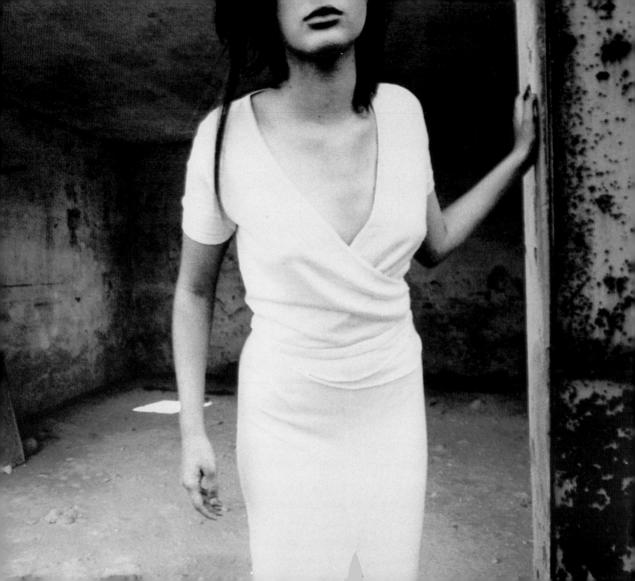

high kick

photographer Simon Clemenger

soft box

IISA

Model portfolio

model

Sophie

make-up stylist

Caroline Siobhan

camera

RZ67

lens

50mm

film

Kodak GPH

exposure

Not recorded

lighting

Electronic flash Infinity cove

props and background

plan view

key points

- ► This is a classic example of a background acting as a reflector.
- ► Colour negative stock has far more latitude than transparency stock

In effect, the model is in a pool of direct and bounced soft light, since the positioning of the soft boxes means that the cove itself acts a reflector and doubles up the two sources into four (i.e. two direct sources and two bounced sources simultaneously).

This results in a very even spread of light right across the subject, with a

minimum of modelling. The effect is to make the model look free in space, with a strong sense of her dynamic movement and very little sense of place or space around her to distract from this core idea. Although not handtrimmed, the image has the same crispness and lack of context as the neatest of cutouts.

"infinity cove" background 6x7cm camera soft box

The model is in the heart of an infinity cove, with a soft box at

either side of her angled into the curvature of the cove.

photographer's comment

I wanted to capture a sense of freedom of movement.

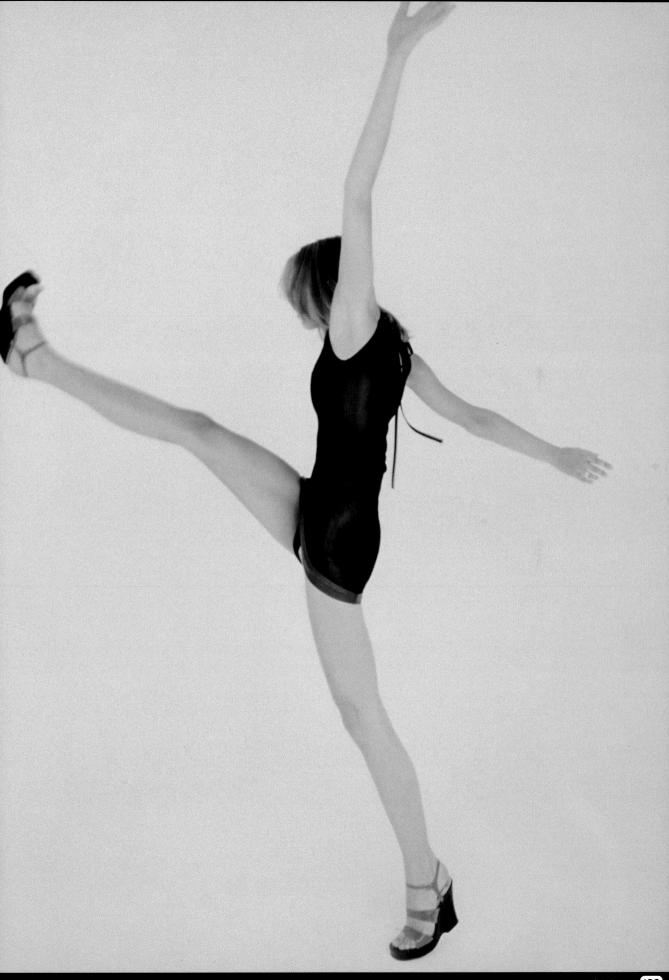

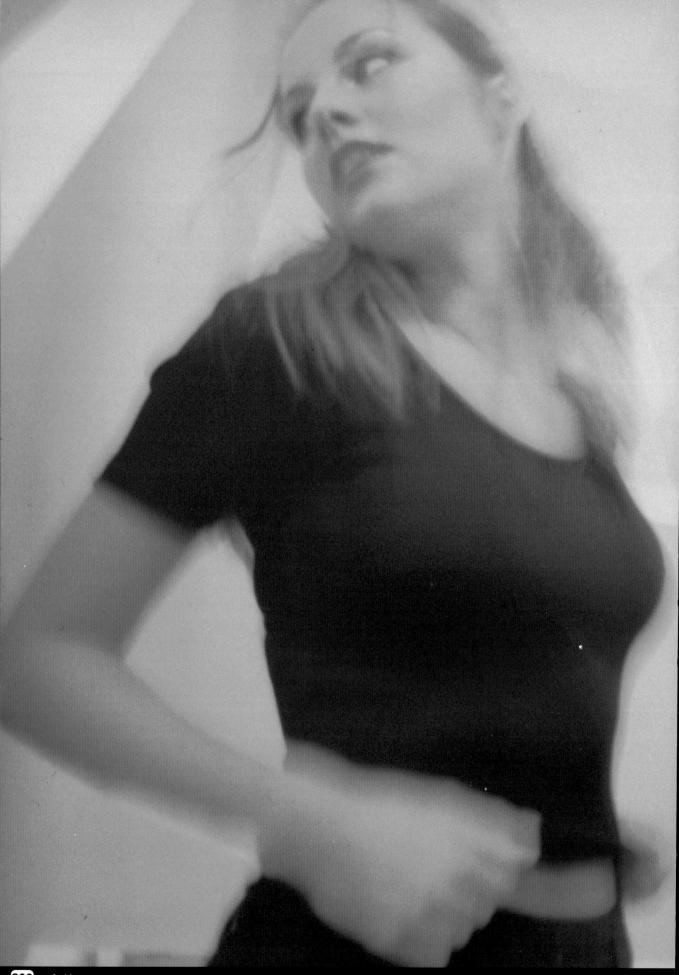

architecture

The unusual background for a shot is, in fact, the decor of the

35mm

camera

house of a friend of photographer Corrado Dalcò.

standard

head

photographer Corrado Dalcò

use

Personal work

model

Reka

assistant

Francesca Passeri

art director

Corrado Dalcò

hair camera Caterina

35mm 24mm

lens film

Fuji Realla 100

exposure

1/8 second at f/2.8

lighting

Tungsten

The background gives the effect of rays of light as if streaming down from the sun in a child's painting, whereas in actual fact the effect stems from the architectural element of the title.

standard

head

Of the three tungsten standard heads used to light this pair of shots, only one is used as a direct source. That is positioned well back to the left of the camera and acts as a source of illumination on the background. The other two tungsten heads are one directly behind and one to the right of the photographer and bounce off the walls of the building.

standard

head

The cross-processing lends the unusual colour rendition associated with the technique.

key points

- ► It is worth keeping a log of unusual location settings that you come across for future reference
- ► Lighting effects can be achieved by background paintwork and setdressing rather than by actual lights

futuristic

photographer Frank Wartenberg

use

Publicity

camera

6x7cm

lens

90mm

film

Fuji Velvia

exposure

Not recorded

lighting

Electronic flash

plan view

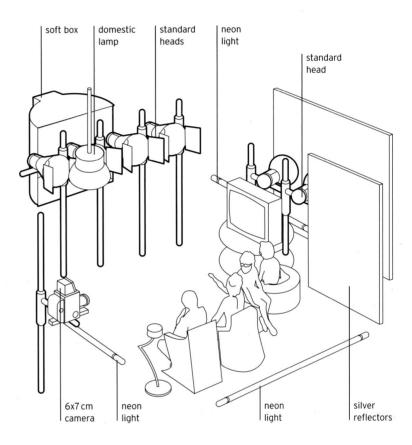

To handle a set-up of this complexity successfully, you need to

cumulative effect and the inter-relations of all the sources.

consider each element individually, and then take account of the

key points

- The mix of unmatched light source types can be actively embraced for a particular look
- It is a good idea to keep a range of higher output domestic lamps to help balance exposure

The lights within the shot come first and the other elements have to be arranged to accommodate them. Within frame here are an overhead domestic tungsten lamp, an illuminated TV screen and various neon strips, some of which are blocked from direct view of the

camera. These set the parameters, and then Frank Wartenberg has added an array of spots, one per model, and a large soft box for broader model illumination. The variety of source types and positions create the eerie futuristic look.

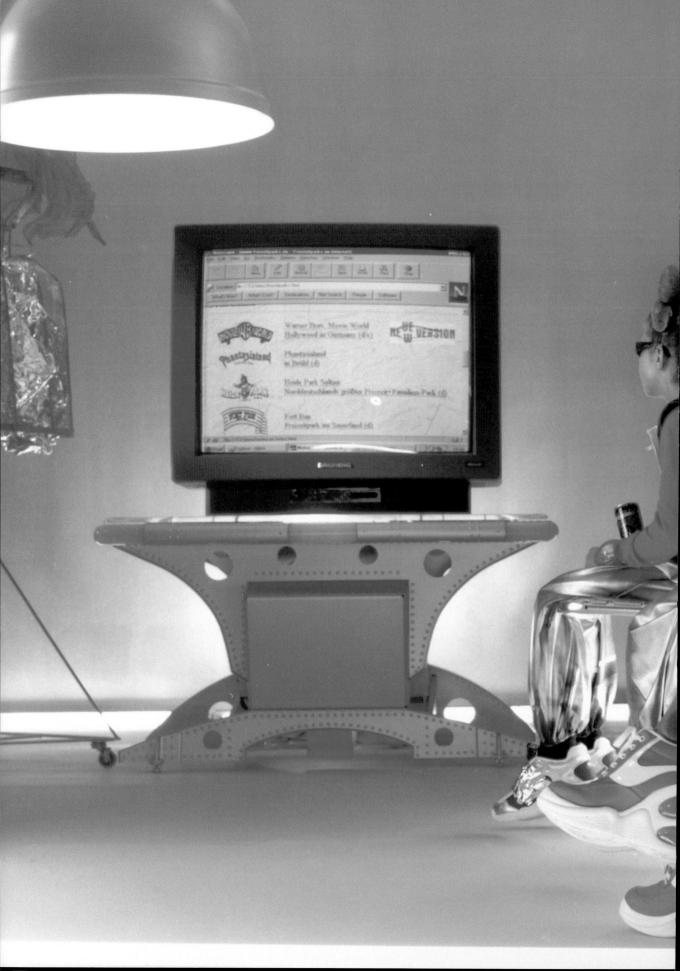

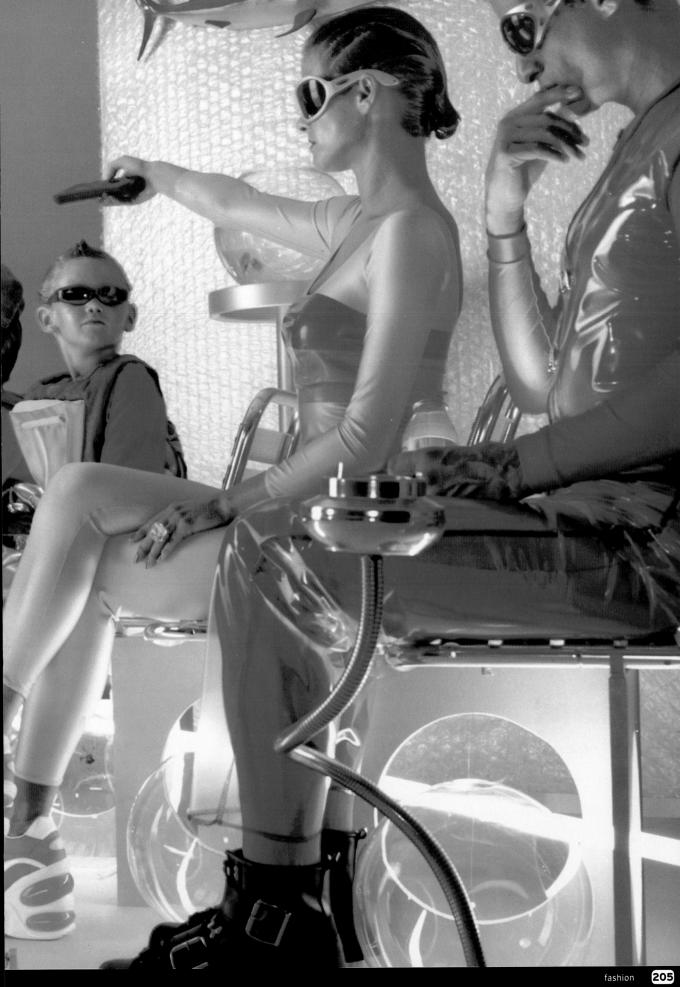

girl and mask

photographer Wolfgang Freithof

Sophia Lee for Ann Taylor Loft

models Marcella and Zoli Sidney Jamilla make-up

client

camera

Doug Chess mask by

lens 50mm film Kodak EPL

exposure 1/15 second at f/8 Electronic flash lighting

6x6cm

props and White cove background

plan view

key points

- ► Working in heavy or cumbersome masks and costumes can be very hot work - bear this in mind and give the models frequent breaks
- Cut-outs can be managed digitally or manually, but can be tricky to do well either way

A standard head is high on a boom in the centre near the camera. The background light is one stop brighter than the front light, the effect of which is strong side lighting and background light. The evenness of the light on the background is a deliberate choice in order to minimise the setting behind

the models and give them an out-ofcontext, almost flying, look. From a practical point of view, if it is desired to cut out the image of the models and place them onto an alternative background later, this is easier if the original background is plain and does not interfere with the process.

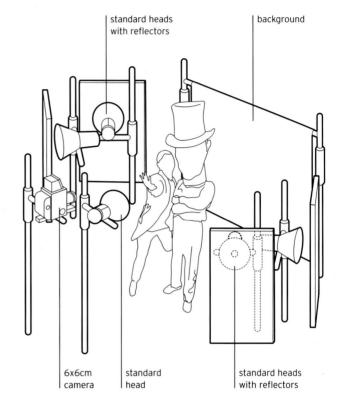

Two standard heads pointing into two flats on either side of the

models illuminate the background and the side of the models.

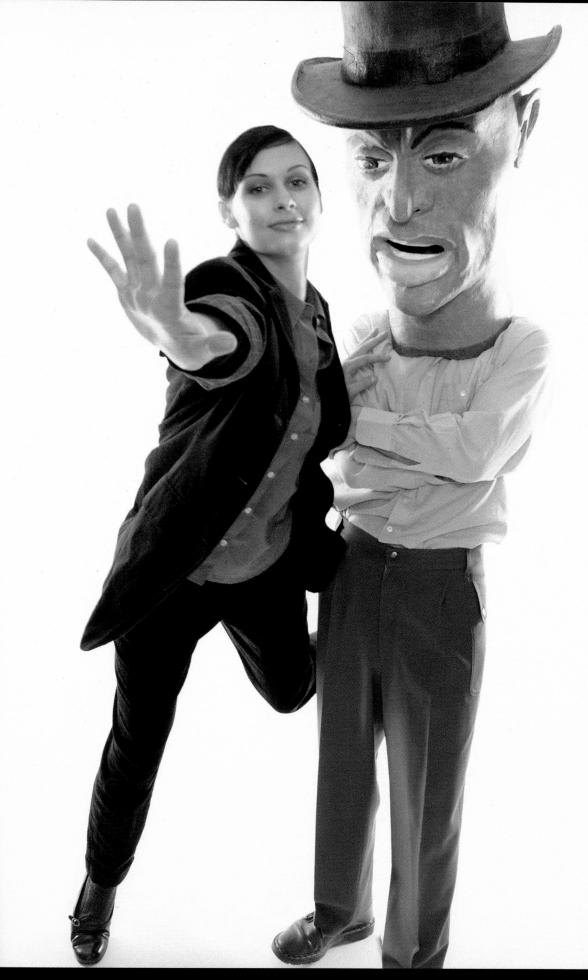

elena and fish

photographer Wolfgang Freithof

use

Editorial

model

Elena /Jan Alpert Models

art director

Sophia Lee Nikki Wang

make-up

35mm

lens film

50mm Fuii RDP

exposure

1/15 second at f/2.8

liahtina

Available light, electronic flash

location

Jake's Fish Store

The choice of situation within the fish store location is important

in order to capture the fish logo in the window in the background

as a counterpoint to the actual fish in the model's hands.

plan view

key points

- When working with unknown light sources such as neon or argon lights, it is wise to make test exposures to determine how the colour records
- Ring flashes can be used to produce direct, virtually shadowless lighting.
 Both portable and mains-operated models are available

The blue bar and lines of the counter contribute an important graphic element, coupled with the diamond floor tiles that reflect in the rest of the counter.

The neon lights in the background provide some separation. The fluorescent lights that light the fish store generally have the usual green hue. Wolfgang Freithof has chosen not to compensate for this tinge, but rather to embrace the look, which contributes to the somewhat surreal feel of the

image. The ring flash on the camera lens lights the model and the fish and this flash overrides the fluorescent lighting. The redness of the dress, lips and fish body and eyes are thus untainted by the green tinge but sing above the background tones in a startling and eye-catching way. They alone in the shot have the daylight quality of lighting and colour, and this looks quite unearthly set against the fluorescent ambient light of the rest of the image.

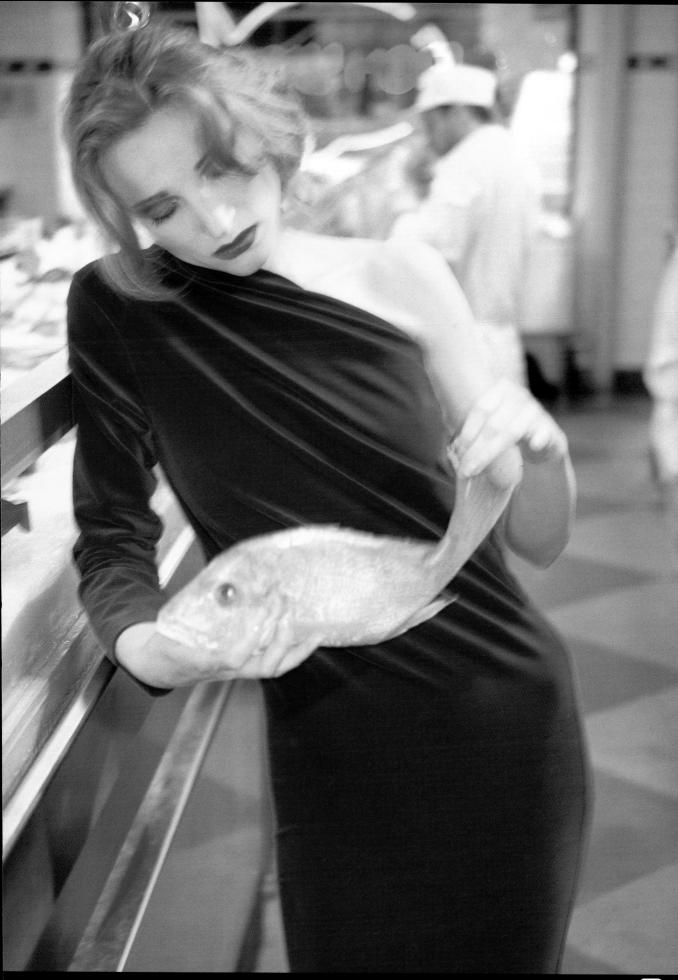

gold boots

photographer Frank Wartenberg

use

Publicity 6x7cm

camera lens

105mm

film

Fuji Velvia Not recorded

exposure lighting

Electronic flash

props and background Golden background

plan view

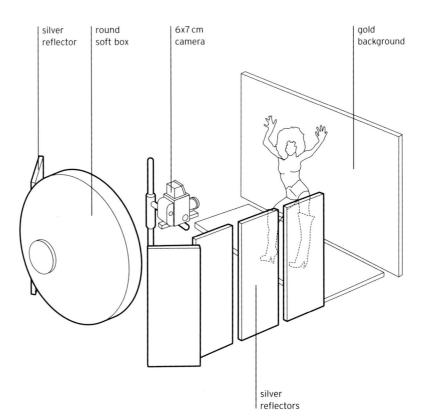

This shot draws on many different inspirations. The hair is

Medusa, the hands and arms are Hindu deity and the gold

boots and shorts are a Midas touch of pure kitsch.

key points

- When using a separate light meter, remember to take into account light lost by using a filter
- Some reflectors focus light, some disperse light and others reduce light

The material and contours of the gold boots are great for introducing a playful element into the lighting, which is sourced simply by a large circular soft box positioned directly behind the camera. To provide a degree of modelling, a series of silver reflectors placed on the right of the camera focus the spill light in to key the shot. As if the gold background, gold floor and gold costume and make-up weren't enough to make an impact, Frank Wartenberg really presses the point home by using an 81B warm-up filter.

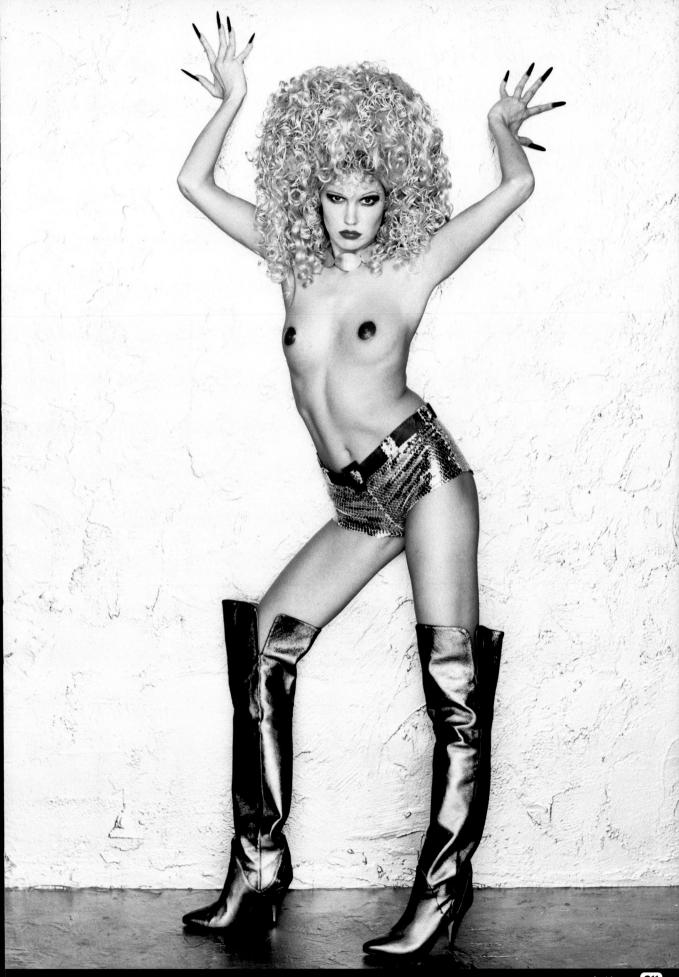

glamour

A wide range of photographs is included in this section, demonstrating the use of such elements as setting and costume and looking at the creation of different moods, from the romantic to the raunchy. Glamour images produced for commercial, editorial, personal and fine art work are featured. Whatever the shot, the key element is the lighting.

Glamour is an age-old theme, and creative artists are forever looking for new approaches to familiar territory. What was once considered too strong for widespread consumption has now become more commonplace. Audiences also have become more sophisticated and are no longer satisfied with all-too-accessible, unsubtle imagery. A trend has developed for a more visually literate approach, where there is room for artistic presentation that has strong powers of suggestion.

Glamour imagery is used in a far more widespread way than ever before. No longer the province exclusively of the top shelf, bold glamour work now features in magazines, bill-hoardings, greetings cards and poster shops. The photographs here demonstrate how creative, world-class photographers are rising to the challenge of providing appropriate imagery for this market.

One indication of the close relationship between photography and other visual arts is the extent to which many of the photographers featured treat the glamour subject matter as fine art material, an opportunity to explore the range of composition and subject, sometimes in a surprisingly detached and impersonal way.

A noticeable feature of many of the images in this section is the lack of passivity of the models. Women now tend to be portrayed in a less demeaning way - in the world of commercial and art photography at least. The market demands a more sophisticated approach.

The glamour imagination

Glamour is a subject area that is very prone to changes of fashion. What is glamorous, sophisticated or outrageous at one time can seem amusingly dated, tame and gauche when viewed with some years' perspective. The photographer should be aware of current tastes and produce images that either chime with the popular imagination of the moment or pushes public taste a step further.

Keeping up with the times necessitates keen observation. The photographer must always be collecting ideas, noticing details and interesting effects, to build up a stock of inspiration to draw on for a shoot.

The flip side of this is to use the imagination to envisage what "might be" rather than what has been witnessed at first hand. Glamour photography is an imaginative, fantasy area, and it is important to experiment.

Cameras, lenses and films

Medium format has been used by many of the photographers featured here, as it gives good definition while allowing quick working in an area where close detail in the final image will be essential and spontaneity during the shoot will be paramount. Many photographers have also used 35mm. for convenience or to achieve the "look" they require. The 35mm negative or transparency inherently requires more enlargement in the reproduction process and thus gives larger grain and adds to the texture of the final image. However, with modern film stock technology, grain is finer on certain films so a photographer needs to know the whole range of stocks available to choose the right one. Polaroid 35mm instant stocks have been used quite widely. They give instant results, useful for checking "work in progress" during what might be a relatively "free", experimental session. Polaroid stocks are also popular for glamour shoots because

of the graphic, contrasty image that they can give. More and more, Polaroid film is used for the end result, not just as an interim stage.

Very few of the photographers featured in this book have used 10x8 plate cameras, which used to be more widely used. The relatively small, lightweight, modern electronic cameras have obvious appeal and versatility.

Lighting equipment

A range of equipment is needed for the glamour shoot. The basic kit used most frequently by the photographers featured here consists of soft boxes, standard heads and silver, gold, white and black reflectors, and the occasional ring flash. A plethora of devices for modifying light is always useful, for example, honeycombs, diffusing screens, coloured gels, umbrellas and filters.

Since glamour work frequently features bare skin, it is important to know how different filters and gels can enhance the range of skin tones, especially as Polaroid tests cannot be relied upon for giving an indication of colour, but only for exposure and contrast. Many of the shots here include warm-up orange filters to give tanned-looking skin, while contrast filters to give more graphic body forms are also frequently used.

The texture and colour of the subject's skin will influence the lighting set-up chosen. For bright, burnt-out skin, a close-in light source will be appropriate. For more graduation and fall-off of light on curved surfaces, carefully placed black panels are useful. Different types of light (focusing spots, reflectors, soft boxes, ring flashes) all give different kinds of catchlights in eyes, and choice of lighting on specific details can make all the difference.

The team

The team for a glamour shoot may be large or small. At the absolute minimum there may be only the photographer, doubling up as the model in order to make spontaneous use of the light of the moment. More usually, though, a good make-up artist and stylist are needed, as well as an assistant or two. If a client is involved, there may well also be an agency art director present at the shoot, representatives of the client and other marketing and publicity staff.

The professional model will take all this in his or her stride, but it is true to say that for the intimate work that glamour photography entails, a rapport between photographer and model(s), (and between the models themselves. if a couple or group are involved) will often be established most naturally and effectively without an audience of onlookers. For this reason the photographer may want and need to establish a comfortable, sympathetic atmosphere before the actual shoot starts. It is important that the model should know exactly what is required from the shoot beforehand to avoid any misunderstandings or awkward refusals at a crucial stage of a shoot, though an element of improvisation may also be important. The choice of a natural, imaginative, spontaneous and responsive model will help enormously.

Location and setting

There are two main considerations with regard to settings. The initial choices are whether the shoot is to take place on location or in the studio.

Within the location option there are thousands of variables to weigh up. Is the setting what is being advertised? Is the setting an essential context for the use of the product? Is the choice of an

exact setting (for example, the Bahamas) an essential prerequisite, or will a generic brief (for example, a sunny beach) be adequate? Whose decision is it? Who will research the exact location? If it is not the photographer, then it must be someone with a good awareness of the lighting considerations (direction of the sun, shadow-casting buildings and trees, for example) as well as an eve for a photogenic spot. Who has to approve the final choice of location? Are there any release considerations for shoots on private property or of particular sites? Could the location be simulated more conveniently and costeffectively in the studio instead? Who will pay for what?

Using a studio set gives infinitely more control over the variables. The set can be built to facilitate the ideal viewpoint; for example, a room setting for an interior shot can be constructed without all the walls of a real interior. Even the weather is available on demand: wind can be simulated to order, as can mist, fog, rain, snow, angle and intensity of sunshine.

The drawback can be the cost and time involved in building a very elaborate, detailed or difficult set. While for some sets the basic studio props can be adequately arranged by the photographer and/or stylist, for others a large set-construction team is required, consisting of a construction manager co-ordinating a team of carpenters, electricians, painters, and others. Props may have to be hired, which then involves the administration and co-ordination skills and time of a production manager, liaising with outof-house suppliers. The budget for all this needs to be calculated accurately beforehand and then watched closely when the shoot goes ahead.

Mood, styling and lighting

Obviously a primary concern for a glamour shoot is the mood created by both the styling (costume, setting, model posing) and by the lighting, whether from artificial sources or natural available light. Whatever the initial source of light favoured, it will probably have to be modified to obtain the required quality, ranging from as hard as possible to very soft.

Colour is a major factor in creating a particular mood or feel, as is widely recognized in everyday life. Think of the common associations of colour with mood: red for anger, blue for coolness, green as a soothing, relaxing hue. From a practical point of view, remember, too, that certain colours are also thought by some people to be unlucky and can engender a great deal of superstition (something to be aware of if any member of the team turns out to be particularly superstitious about the presence of the colour green on set, for example).

Although the photographer may have in mind the exact look that he or she wants, there have to be practical considerations too. Sometimes there are unexpected intrinsic limitations to the location of the shoot, for example, little space for positioning of lamps, problems of proximity in terms of focal lengths, difficulty with feeling comfortable for the photographer, assistants and, most importantly, the model. All of these can demand some guick solutions on the part of the photographer. The mood, styling and lighting may have to be adapted to accommodate the unforeseen. You can minimize the possibility of surprises on the day by preparing for the shoot as much as possible. Nevertheless, it is necessary to keep an open mind and to be prepared for anything!

cover girl

photographer Frank Wartenberg

setting such as the studio used here.

With the benefit of a window at the right height, of the right

brightly and purely with the available light, even in an interior

35mm camera

size and facing in the right direction, it is possible to light a shot

client

Foto Magazine

use model Editorial - cover shot Jacqueline

assistant

Jan

stylists

Karin and Matina

camera

35mm Nikon F4

lens film

105mm Agfa Scala

exposure lighting

Not recorded Available light

props and background Studio

Plan View

The model faces a large window that provides bright (but not harsh) light, which is spread evenly across the body. The pose creates opportunities for gentle shadows to give subtle modelling outlines to the figure.

Compositionally, it is significant that some of the fingers and part of a foot should be visible. If you cover the bottom edge of the shot to conceal these, their importance is obvious: the

shot looks unbalanced and the limbs of the model seem to disappear out of frame all too abruptly, giving a disconcerting lack of "geography" to the body.

The directness of the expression engages the viewer and the minimal clothing and careful pose combine, partly to reveal, partly to conceal the body, adding immeasurably to the allure and intimacy of the shot.

key points

- ► This shot demonstrates how effectively natural daylight flooding through a window can take the place of a soft box in a studio
- ► It is essential with sunlight to work quickly: the lighting conditions are always changing

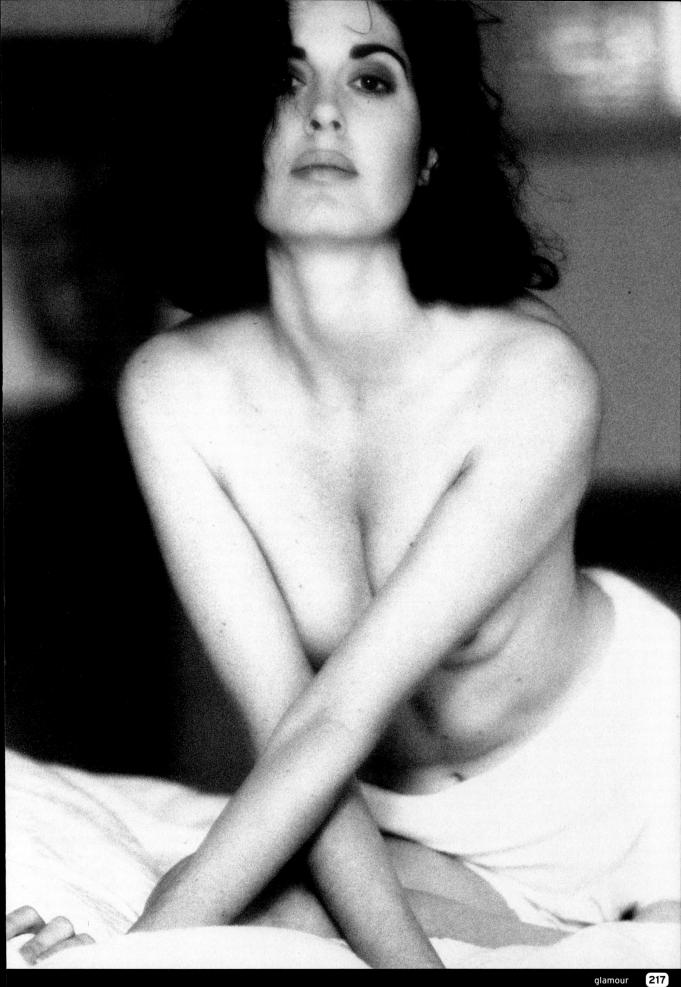

Caroline

photographer Juan Manuel Garcia

Use of a light brush allows close control of the illumination on La Agencia - Miami client Advertising every part of the frame, enabling the photographer to create USA Caroline Gómez model the exact type of light needed. However, it requires a lengthy assistants Carlos Barrera, Carlos exposure, and the stillness of the model is very important. For Bayora this reason, Juan Manuel García placed a steadying apparatus Alejandro Ortíz stylist

behind the model for her to lean on.

camera 6x6cm
lens 150mm
film Ektachrome 100
exposure 90 seconds
lighting Light brush

props and Blue velvet background, support for model to

lean on

key points

- To complement the effect of light brushing, diffusion can be used on the camera lens
- Light intensity and balance can also be altered by changing the power and aperture or by making multiple exposures

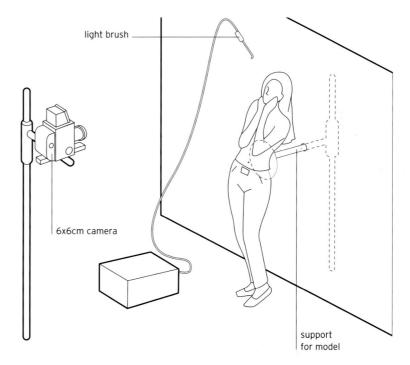

The light brush was held only 50cm from the model, so for the duration of the exposure the photographer was in the frame, wielding the lightbrush. He is not visible in the final image as there was no light falling on him.

The light brush was applied with smooth movements. Then a blue filter was used on the point of the light, to increase the small size of the light and to record the background area around the model. The main factors when using the light brush are the accessories used, the direction of the light, the movement of the light brush, the distance between the light brush and the model and the length of exposure. The model's stillness is very important, hence the support system used here.

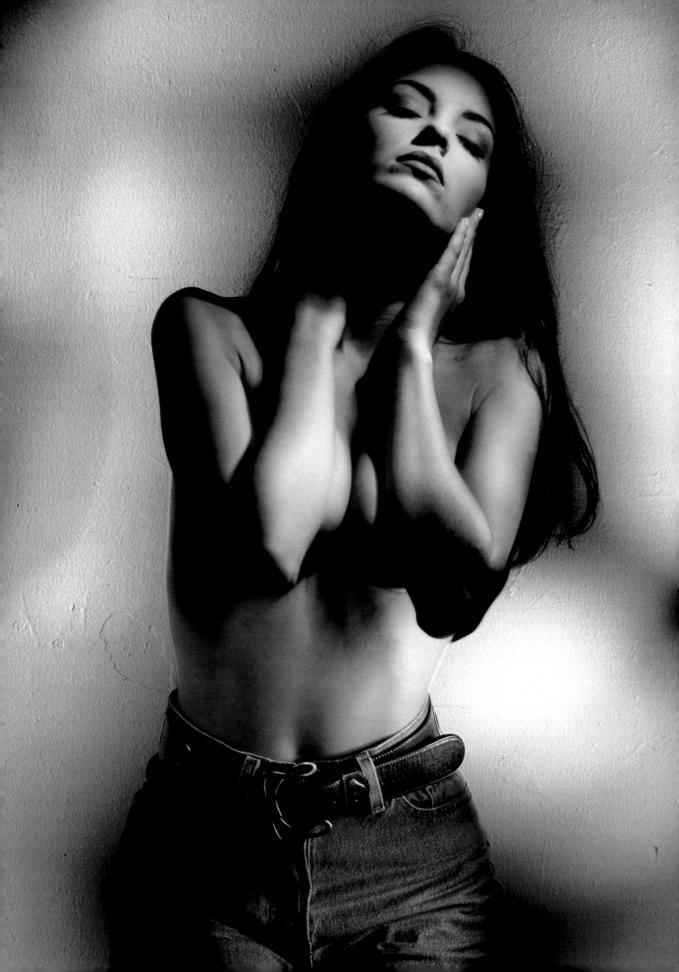

Touch

in the photograph.

photographer Holly Stewart

client

Self-promotion

use

Portfolio

models

Cynthia and Phillip at Mitchell

camera

35mm

lens film 60mm

Kodak 100SW

exposure

1/60 second at f/5.6

lighting

Electronic flash and tungsten

props and background Painted canvas

Plan View

soft box white reflector white reflector white reflector

This shot emanates much warmth of tone. The choice of film,

Kodak 100SW, gives good colour saturation and a warm look.

The painted canvas backdrop complements the skin colour of

the models, but does not compete with them for prominence

key points

- Black hair absorbs a lot of light and a large amount of light is needed to register a high level of detail
- Positioning one model further away from the camera than the other raises considerations of depth of field

The background to this shot is not lit independently, so although the colour tone is in a similar hue, it is not as brightly lit as the models are. The background area therefore remains firmly in the background.

The models themselves are lit by a single central soft box, causing highlights on the upturned face and shoulders, and three reflectors, giving an amount of fill. The placing of the models results in areas of deep shadows where they both flag each other (on the far shoulder and chest in each case), and the woman's head is tilted away from the light to give an area of dark tones at the back of the head.

Series

photographer Terry Ryan

client Model and picture library

use Self-promotion

model Suzi

assistant Nicolas Hawke

camera 35mm lens 105mm

film Polaroid Polagraph

exposure f/16

lighting Electronic flash: 2 heads

props and background White scoop

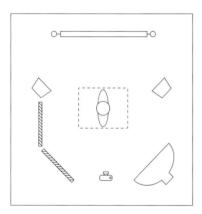

Plan View

key points

- Polagraph film can be developed instantly, enabling the photographer to check the lighting "on the hoof" as the shoot progresses
- Low-contrast lighting is essential if you want a good tonal range with high-contrast material

The lighting consists of two 5-foot strip lights lighting the background, two soft boxes aimed at the model (one to the side in front, and one overhead) and two white reflectors bouncing light in on the shadow side of the model. The set-up, camera settings and model were the same for the whole shoot.

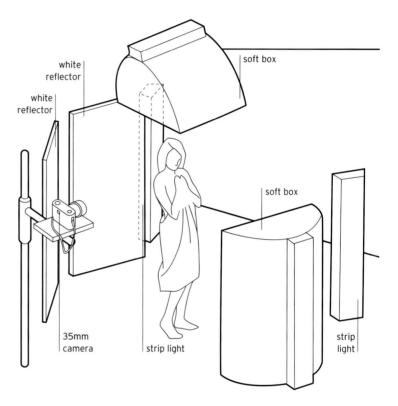

In any shoot, some shots will prove to be more successful than others, and the enlarged shot from this series is among Terry Ryan's preferred results from the session.

It is instructive to observe how different the mood and feel of the shots can be, solely as a result of the pose of the model; whether she is looking out at the viewer or averting her eyes; and her expression. While some shots verge on the territory of art photography, recalling draped classical statues, others would not be out of place in any glamour setting.

The choice of Polagraph film, which is a high-contrast stock, means that a tight lighting ratio is required to achieve a good tonal range. Hence the choice of a soft box, which gives an even, diffused light, and the reflectors, which reduce the ratio even more.

Innocence

photographer Julia Martinez

use

Personal work

camera

Mamiya 645

lens

90mm

film exposure Tmax 100 f/11

lighting

Electronic flash

This shot demonstrates the importance of always being aware and alert and on the look-out for a potential shot. Julia Martinez had finished the main session of a shoot and the model was dressing and re-arranging her hair after the main business of the day was over.

Plan View

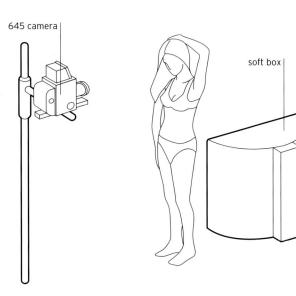

key points

- ► There isn't time to set up lighting with opportunistic shots. The "experimental" element that this introduces can give interesting results
- ► Using a diffuser under the enlarger at the printing stage causes the shadow areas to 'bleed' into the highlights the opposite effect to using it oncamera

As the model swept back her hair, Julia noticed the potential for another interesting shot and, as she had one last frame left on the film, she quickly called "Hold it!". She swiftly took the shot as the model paused for a moment, standing in the light of just one soft box. In the circumstances there was no time

to set up reflectors, so this is lit purely by the soft box. The side of the face is in almost complete shade, but there is enough light to give the impression of the face. The model's colouring and clothing combine to give a strong chiaroscuro effect. The result is a stylish look and a balanced picture.

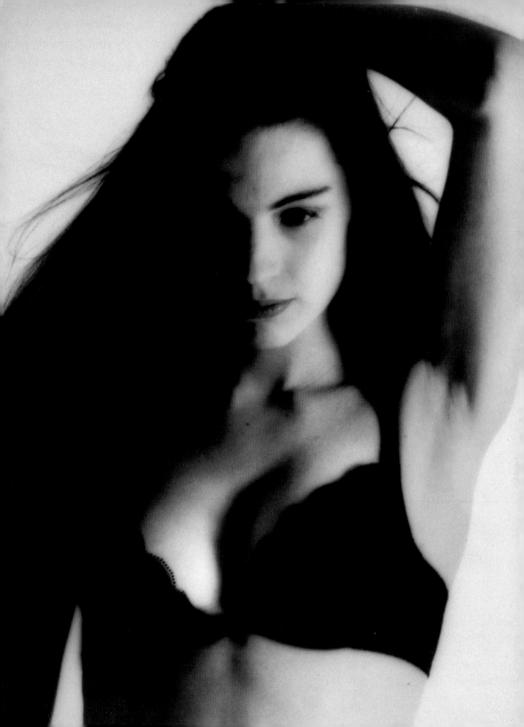

Rock dancing

photographer Tim Orden

use

Personal work

model

Sasha

assistant

Donna Orden

camera

35mm

lens

60mm

film

Fuji Velvia rated at 100 ISO cross-processed

exposure

1/250 second at f/5.6

lighting

Electronic flash, available

liaht

background

Hawaiian beach

Plan View

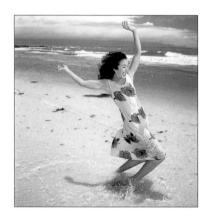

key points

- Informal moments can be as interesting as the more posed moments
- Notice the difference that the presence of the sand makes to the look: it acts as a reflector
- The background is very saturated colour, because of the choice of film and processing

"I wanted a different feel for this" says photographer Tim Orden. "A cross-processed look would lend a surreal element, adding to the idea of the wild and wacky antics of Sasha, my model."

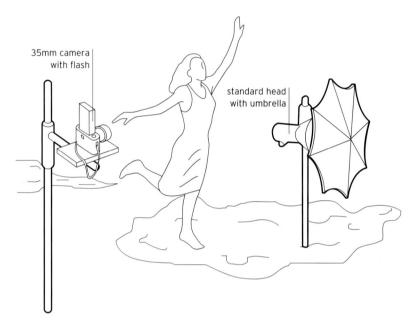

"It was a bright sunny day and I had my assistant keep the remotely triggered light on the shadow side of the model at all times. As we moved around the scene my assistant ran to stay in position."

Tim used a polarizing filter with Fuji Velvia film rated at 100 ISO, crossprocessed it in a C41 negative process, and finally made a print from the resulting negative. Since there was bright sunlight, the shutter speed was determined by the meter reading of the sky. To keep the bright, high-key look, the flash was used to fill on the front of the model's body.

Photographer's comment

It is necessary to shoot plenty of film when the subject is moving spontaneously.

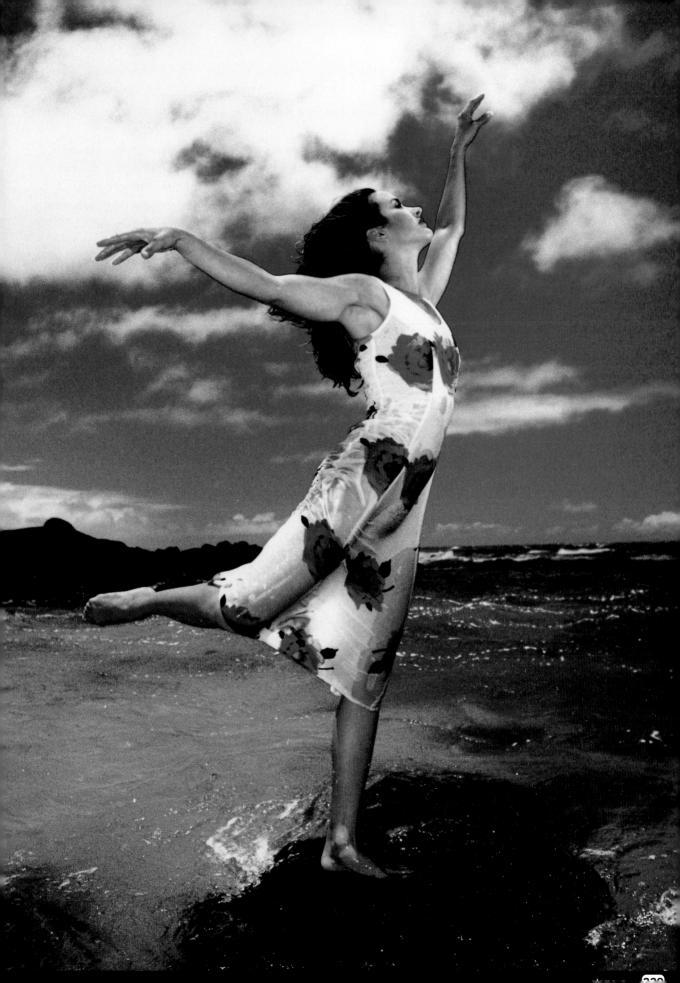

Camila

photographer Patricia Novoa

client

Personal work

use

Portfolio

model

Camila

camera

35mm

lens

80-200mm Kodak infra-red

film exposure

f/11

lighting

Electronic flash: 2 soft boxes

Infra-red film often produces a very distinctive graininess and characteristically lends an almost ghostly, pearly glow to skin tones. This is ideal for creating an out-of-the-ordinary feel, whether to emphasize tenderness, soulful innocence or ethereal spirituality, or to introduce a more unnerving and unearthly element of surrealism.

Plan View

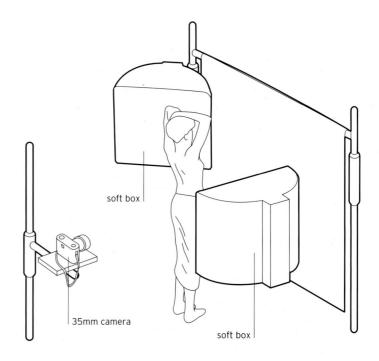

key points

- Infra-red film is normally used with a deep-red filter over the lens, although it is worth experimenting with less intense contrast filters, or even none at all
- Infra-red colour film is also available. Its main uses are for medical, aerial and forensic applications, where the colour displacements can make possible the interpretation of otherwise unseen factors

Here, the delicacy of the model's back is emphasized by the apparent fragility of the image, which breaks up into grains and virtually fades away before the eyes.

Two soft boxes only 1m and 1.5m from the model, burn out the skin texture on the areas closest to the

lights, while the pearly effect of the infra-red film makes the outer arms seem to glow as if with their own inner light, as though they were the source rather than the recipients of light. Only the hair and areas of slight shading and modelling on the back confirm any sense of the solidity of the subject.

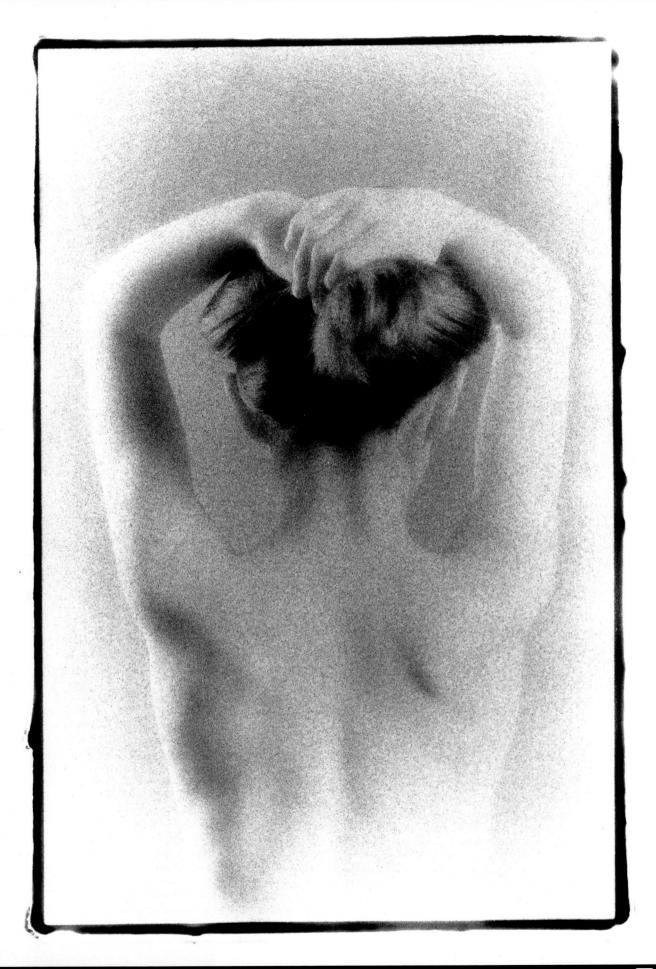

Draped nude

photographer Gérard de Saint Maxent

The abstract composition is characteristic of Gérard de Saint Maxent's work. The stylized composition is very distinctive.

client Personal work
use Postcard
camera 645
lens 200mm
film Kodak Tmax 400

exposure 1/60 second at f/11 Electronic flash

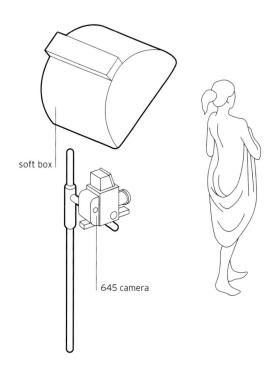

This shot has a historical resonance. The drapery and curves are like those of classical statues, with the soft folds of fabric and flesh combined as a single entity. The choice of fabric is important in this respect: the cloth and the skin need to be virtually indistinguishable from one another for the statue imagery to work, with the same even,

sculpted, marble-like texture across all areas.

This shot uses a single keylight in the form of a soft box to one side, and a reflector on the opposite side. This serves the function of adding a slight touch of detail in the deeper areas of the folds of cloth and in the extreme lower-right corner of the frame.

key points

- Tight lighting ratios are required for higher-contrast films otherwise detail will be lost in either the highlights or shadows
- ► Black and white can be a good choice when an emphasis primarily on form is required. (Black and white prints can of course be made from colour negatives, if the photographer wishes to shoot in colour to keep his or her options open)

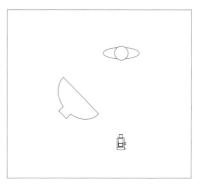

Plan View

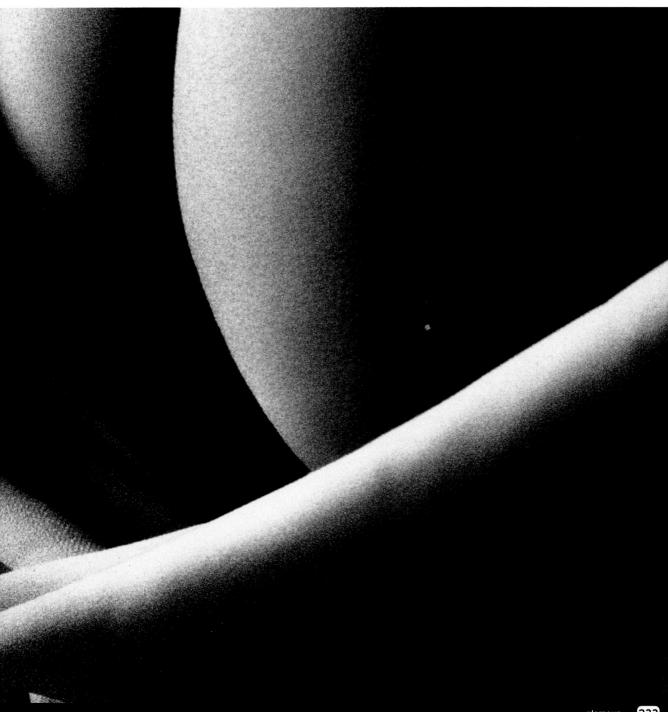

Back pain

photographer Ron McMillan

photographer Ron McMillan.

client

PBB Agency

use

Brochure cover

model

Emma Noble

assistant

David Grover

art director

Claire

camera

Hasselblad 210mm

lens film

Ektachrome 100

exposure

f/16

lighting

Electronic flash

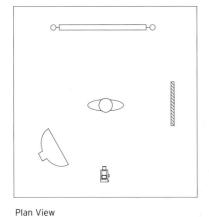

key points

- ► It is better to shoot the image "clean" without filtration, since various types of manipulation can then be tried out at the printing stage
- To avoid too stark a final image when cross-processing, it is important to have a very tight lighting ratio

"The object of the exercise was to make the shot look 'different' and 'more dramatic' than usual. We shot on transparency film but processed it in C41 negative chemicals. The resulting negatives are more contrasty and the colour balance is affected. From the negatives, prints were made altering the colour balance even more, plus

adding a grain screen in the enlarger to achieve the end result. A great deal of experimenting was necessary to produce a final image that satisfied everyone concerned, since one of the problems with this kind of exercise is that you can create a wide variety of quite different results from the same original shot."

reflector

soft box 6x6cm camera

"This is one of a series of shots for Royal College of Nursing

Insurance Services. This one is for medical insurance - featuring

back pain particularly, as it is common among nurses," explains

Photographer's comment

Photographers must be careful not to make the original film too contrasty, as the cross-processing, etc. will increase the contrast anyway, so a fairly softly-lit original is required.

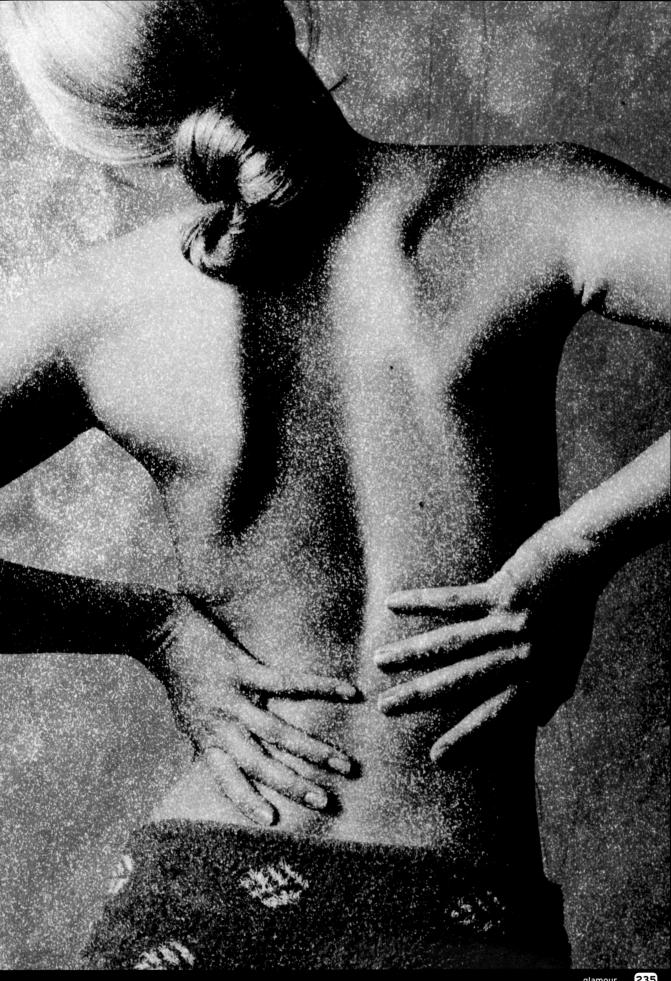

Nude

photographer Frank Wartenberg

client Stern Magazine use Editorial Stern Cover

Bert assistant

art director Frankie Backer Mamiya RZ67 camera

lens 185mm

film Agfa 25 exposure Not recorded

lighting Electronic flash: 5 heads

props and Grey backdrop material,

background box to sit on

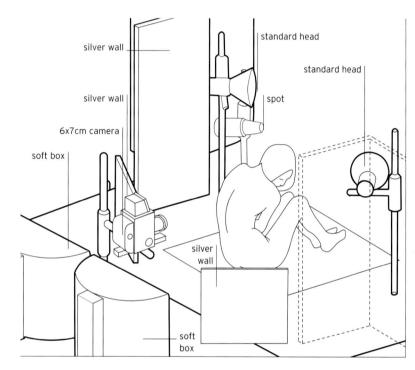

This is a superb example of how something seen in its entirety

can also look like an abstract. It is obvious that this picture is a

of the hair and sympathetic use of lighting, the shot has been

made into both a classical study and an abstract work of art.

back view of a nude, but with careful posing of the model, styling

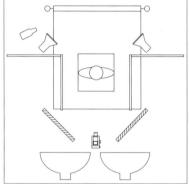

Plan View

key points

- ► Even the most familiar subject can be given an abstract form
- ► Abstract presentation of a familiar form reveals new qualities and a new way of looking at things for the viewer

Two large soft boxes some distance behind and above the camera give a blanket of soft light, which is in turn reflected off the model's back and hair, giving skilfully crafted highlights, complementing these sculpturally perfect features of the body. Two silver reflectors, one either side of the camera and at the same proximity, brighten the highlights even further. The hair is styled to display an array of alternating tones.

Compositionally, the considered fashioning of the coiffure and position of the head and the upper part of the body create an extraordinary, abstract effect.

The two standard heads on the background are supplemented by a spot to the left, which gives a pool of slightly brighter light to ensure separation. Finally, notice how the positioning of the model gives a deliberate low-light rim down the left side of the torso.

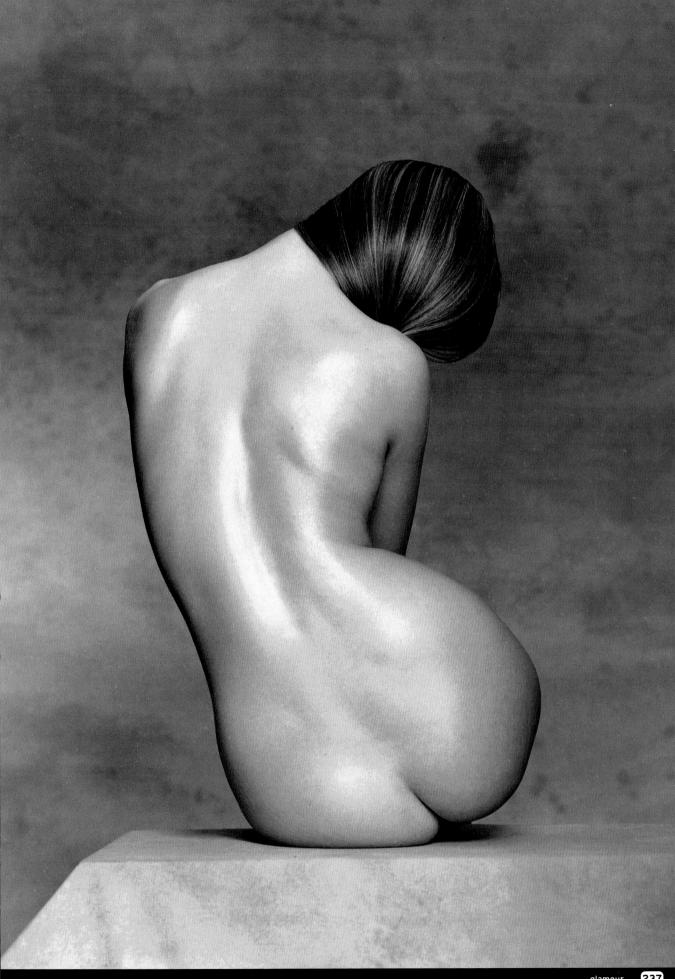

fotomagazin cover

photographer Frank Wartenberg

use

Cover/advertising

camera

Nikon F4

lens

105mm Kodak EPR

film exposure

1/60 second at f/4

lighting

Electronic flash: 5 heads

props and background

White paper background

This startling shot makes good use of all the factors available. The model poses provocatively, the costume gives interesting plays of light against her form, the props (black beads) are used to add another shock element by creating a bondage look and add visual interest by adding pinprick highlights, the colour is bold and graphic, and the strong lighting is stark and voyeuristic.

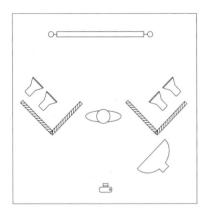

Plan View

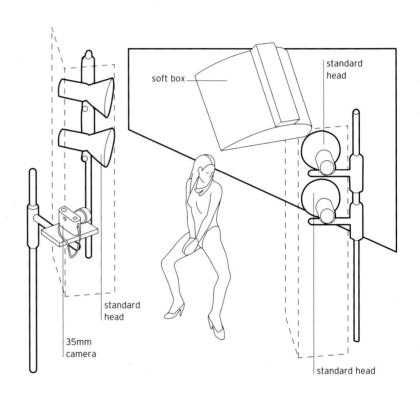

key points

The positioning of the two pairs of black panels effectively make a tunnel, giving good fall-off at the sides of the model Much of the starkness of this image derives from the fact that the model is set almost like a cut-out against the high-key background, with not a hint or trace of shadow behind. Because the model is on a podium with the soft box angled down at her, and because she is some distance from the background,

any shadow is likely to fall on the floor and not on the white backdrop.

The fact that there are four standard heads directed at the background also contributes to making sure that no shadow will be visible, as these lights would burn out any stray unwanted shadow falling on the backdrop.

Photographer's comment

The girl is standing on a podium 40cm high.

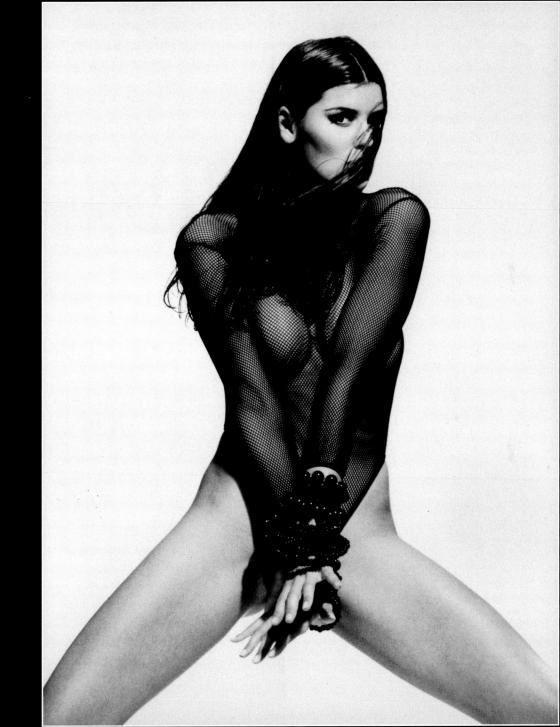

Moda Kit

photographer Ben Lagunas and Alex Kuri

black bounce

When producing images for advertising, photographers often

need to allow space in the image for copy to be added. The large,

dark, even areas that frame this shot are ideal for this purpose.

client Arouesty Asociados
use Advertising campaign for

Moda Kit

Moda Ki

assistants Patricia and Gabrielle
art director Carlos Arquesty

stylist Elvia Orrco

lighting

camera 6x6cm Hasselblad 205TCC

lens180mm CF SonnarfilmKodak Tmax 100exposure1/125 second at f/16

Electronic flash: 1 soft box

Plan View

The soft box lights the outline of the the model. The image achieved is

key points

- ► It may be necessary to build in space around the subject, depending on how the image is to be used. Shooting and supplying a full frame image does not always mean that you have to fill the available frame with the subject
- Working within the parameters of a brief can be inspiring
- Even when using plain black as a background, there are endless materials, textures, types of reflectivity and finishes to choose from.

The soft box lights the outline of the model and enough of the product for identification. The black bounce prevents any accidental fill from reflecting-in, ensuring both the smooth blackness of the background and side, and the essential modest shading of

striking, attractive, provocatively sensual yet also tastefully discreet. It also puts across the product strongly and is a practical, flexible image for advertising purposes. In other words, it fits the client's brief exactly.

Photographer's comment

The product is in the bag - inexpensive clothes. This was an original and controversial campaign. We had to show nudes, but not as pin-ups or pornography. We didn't want to offend the buyers. The art director looked for an intimate but unusual moment. He loved the final result, with the light modelling of the body.

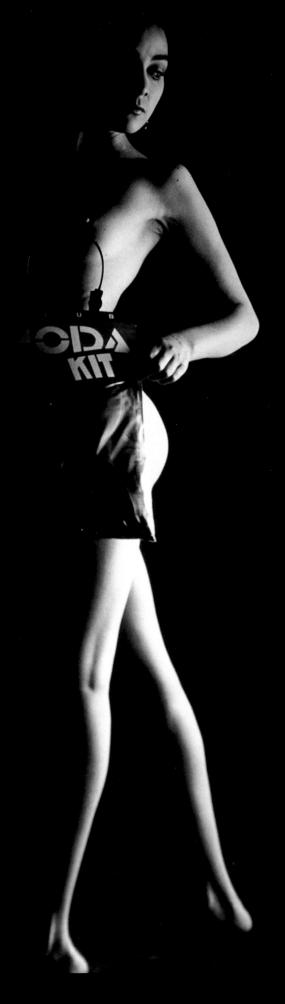

Helen

photographer Terry Ryan

client

Couture

use

Point of sale and packs

model

Helen

assistant

Nicolas Hawke

make-up

Alli Williams

camera

6x6cm

lens

120mm macro

film

Kodak Ektachrome

tiim

100 Plus

exposure

f/22

lighting

Electronic flash: 3 heads

props and background Large cotton backdrop

Plan View

Since this is a product pack-shot image, it is essential that the tights should be foremost in the final image. The graphic qualities of the pose draw attention to the product effectively, and the high-key look is a subtle way of emphasizing the smoothness of the hosiery.

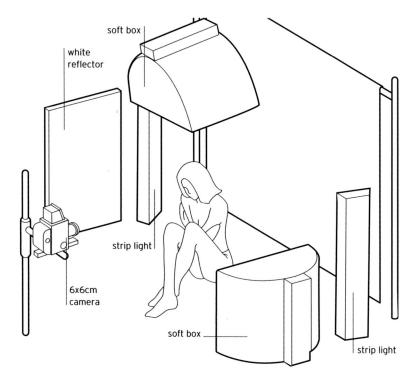

key points

- Directional lighting helps to differentiate areas of a subject when that subject consists largely of white against white, but careful exposure control is required
- With a uniformly-coloured subject, details such as the hair colour of the model become important to lend contrast and "substance" to the shot

The swimming pool light to camera right gives evenly distributed light over the whole subject. However, the pose provides contrasting areas of relative shade on the upper part of the legs, though the shot is basically a low-contrast image. The reflector to the

left and choice of colour of the product, background and model's skin tones combine to ensure this.

The hair, the only area of remarkably different tone, is lit separately from above by an overhead soft box. This gives detail and texture to the coiffure.

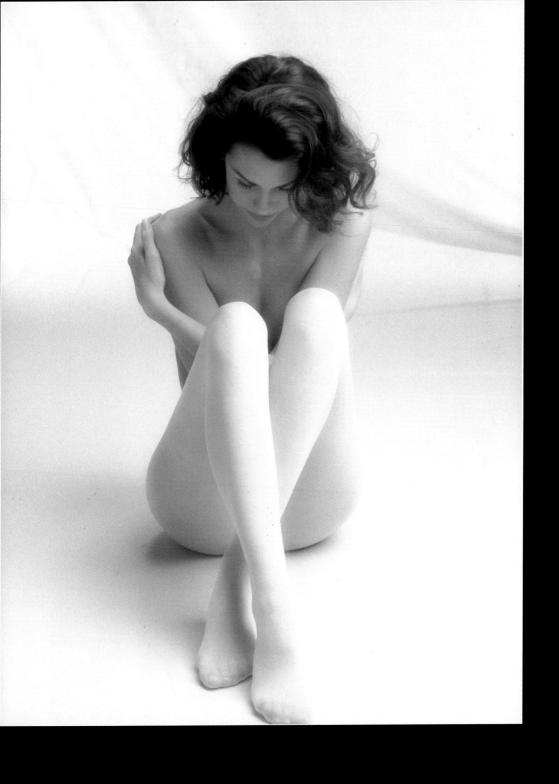

"Brinco" Advertising

photographer Ben Lagunas and Alex Kuri

The product on display is the material covering the model, so that has to be the main focus of attention - and of lighting - in the shot. The model is in effect a living piece of apparatus, used to hold and display the fabric and to add interest to what is basically a product shot.

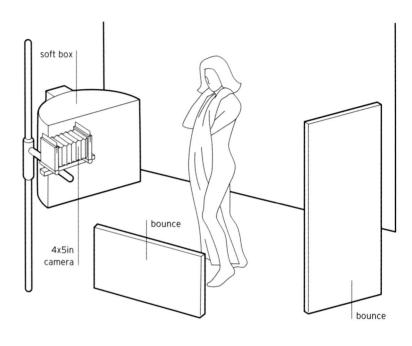

Everything shines out from the picture centre. The 2m-square soft box to the left and two reflectors provide bright light on the fabric, while the positioning of the material gives some shadows on the model's body. The bounce to the front is directed on to the material rather than the model. and the relative darkness of her face and arms gives some detail. The light falling on the background (which is spill light from the soft box plus the bounce

on the right) seems to radiate from the centre of the material.

The composition owes more to Botticelli's "Birth of Venus" than it does to a typical pack shot. As in the famous painting Venus rises from the waves and modestly clutches her long hair partially to hide her nakedness, her head inclined away from the viewer's gaze, so the model here discreetly holds the material to herself and averts her eyes from the camera.

Entreteias Brinco client use Advertising Jacqueline Robinson model assistants Suzanne, Natasha, Victoria art director Cory Rice stylist Elvia Orozco Sinar 4x5 inch camera lane Schneider 180mm film Kodak Tmax exposure 1/60 second at f/8

Electronic flash

The model was covered by

the product, Buckram

key points

- ► The qualities of the product that come across from an image should be the qualities that the client wants to emphasize. This, in turn, will dictate the quality of light required
- ► When balancing varying amounts of light to deliberately "burn out" selective areas of the shot, it is essential to know how the film stock reacts to the relative light intensities used, and to expose accordingly

Photographer's comment

The light on the front helps to enhance the product. The back light shows the model's silhouette.

Plan View

lighting

props and

background

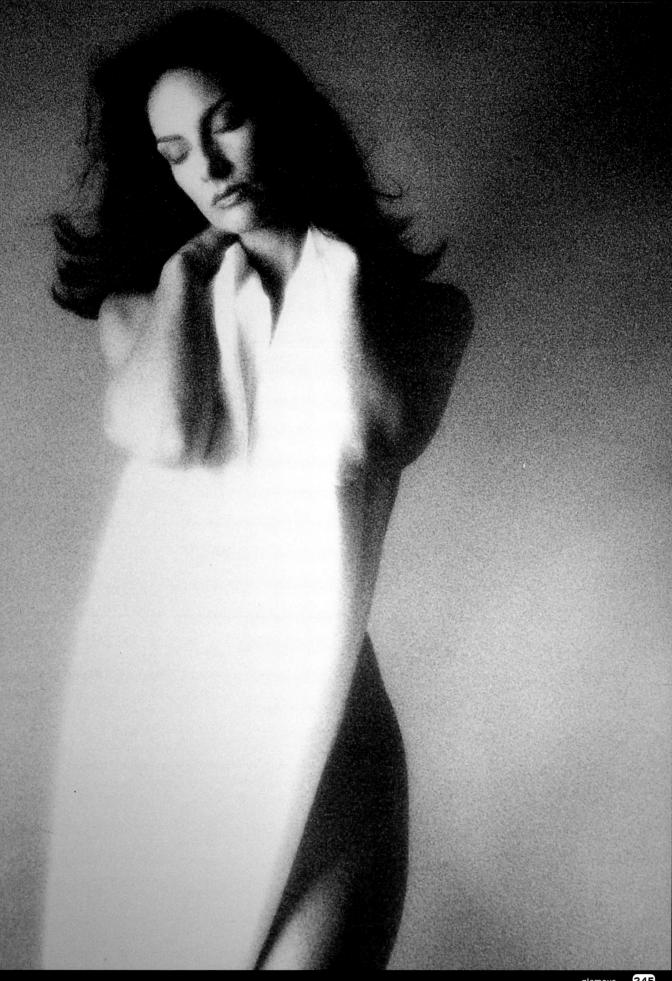

Gabriella and dog

photographer Frank Wartenberg

client Self-promotion use Portfolio

model Gabriella

assistant Bert Spangemacher

stylist **Uta Sorst** camera Mamiya RZ67

lens 110mm

film Kodak EPR 64 exposure Not recorded

lighting Electronic ring flash

props and Golden painted wall background and ground

Plan View

The resulting catchlights in the eyes are a compelling aspect of the photograph. The eyes of the dog have a fiendish, unearthly glint, echoed by the shine on the nose and the studs of the collar, and the piercing pin-pricks of red in the eyes of the model are a small but significant detail in defining the mood of the shot.

The pose ensures that the faces of the model and of the dog are equidistant from the camera, so that

the plane of focus is exactly the same for both pairs of eyes.

The flash simultaneously back lights the shot, inasmuch as it is reflected by the gold paint on the wall, giving interesting shadow-cum-reflections on the floor. The depth of field reduces the separation that might otherwise be expected; there is little or no rim-light defining the edge of the model, but instead, fine but dark fall-off shadow areas that "ink in" her outline.

key points

- ➤ Note the difference in resulting colour between the gold-painted area that is facing the light directly (i.e. the wall), and that lying at 90 degrees to it (i.e. the floor)
- ► The orange 81A warm-up filter used here deepens the skin tones

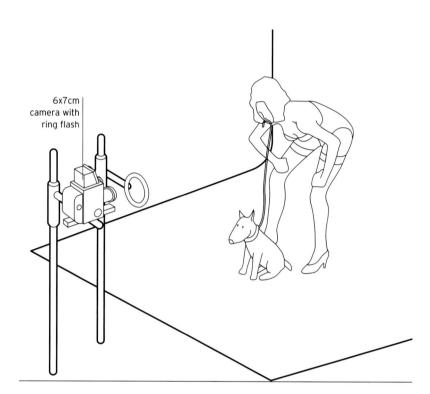

The choice and positioning of the electronic ring flash is crucial.

It is set directly face-on to the model and the dog, and is large

enough to burn out the gold background over a large area.

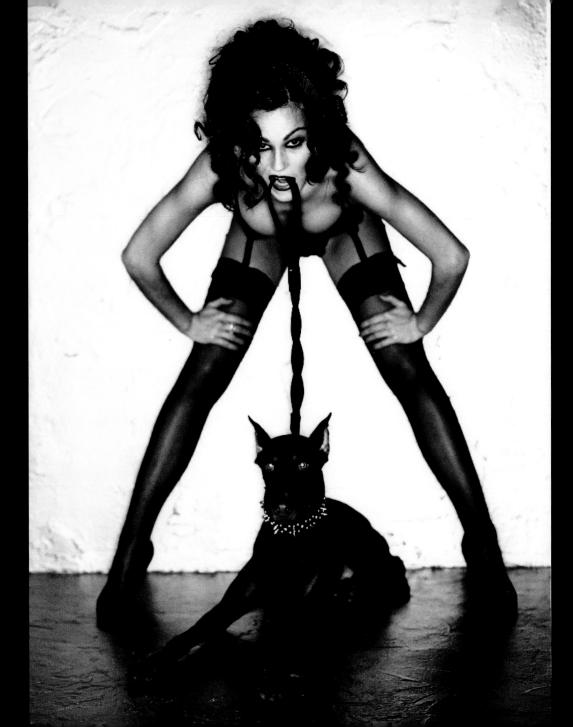

Flower Hat

photographer Holly Stewart

client

Self-promotion

use

Book

model

Cindra

make-up

Dawn Sutti

stylist and hair Victor Hutching

camera

6x6cm

lens

140mm

film

Tmax 100

exposure

1/125 second at f/11

lighting

Electronic flash

props and background Painted background

Plan View

The styling, make-up and hair, clothing and props has helped to create an attractive "period" look.

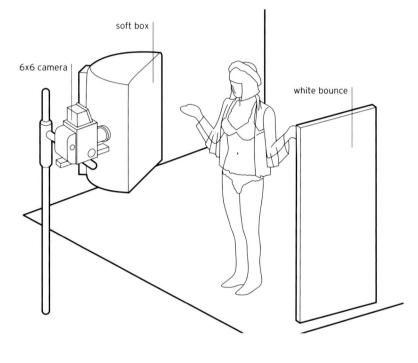

key points

- ► A versatile lighting set-up can give substantially different results with different subjects
- ► The best models have excellent control over their every feature and can give just the expression and mood that is wanted - as long as the directing is good

This shot features a busily-textured costume, smooth coiffure and expanses of bare skin in place of material. The sheen on the torso gives a strong sense of modelling, while the gleam on the hair has the opposite effect, flattening out the shape to

exaggerate its stark brilliance. The eyes are clear and sparkling, with a well-defined catchlight; a dark-eyed model would not have given the same effect. There is an openness and freshness of pose, expression and costume.

Skin to Skin Collection I

photographer Ben Lagunas and Alex Kuri

use assistant Fine art personal work Natasha, Victoria, Suzanne

art director stylist Ben Lagunas Charle

camera Iens Mamiya RZ67 250mm

film

Tmax 100

exposure lighting 1/60 second at f/16

Available light

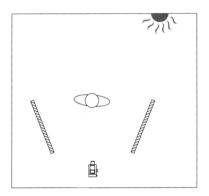

Plan View

black bounce 6x7cm camera black bounce

The model is lying in a barren sandy landscape. The green filter

makes the yellow sand areas just in front of the model record as

light grey, while the shadier areas, which to the eye would have

had a more orange appearance, record as darker grey.

key points

- ► Black and white contrast filters pass light of their own colour
- It is important to take account of the fact that deeply coloured contrast filters absorb a great deal of light and are best used in bright conditions

The impression created is of a high-key pool of apparent light in front of the model, emphasizing the power of the blazing sun beating down on both the desert landscape and on the model's back. The use of black panels gives just adequate fill on the near side of the model's body.

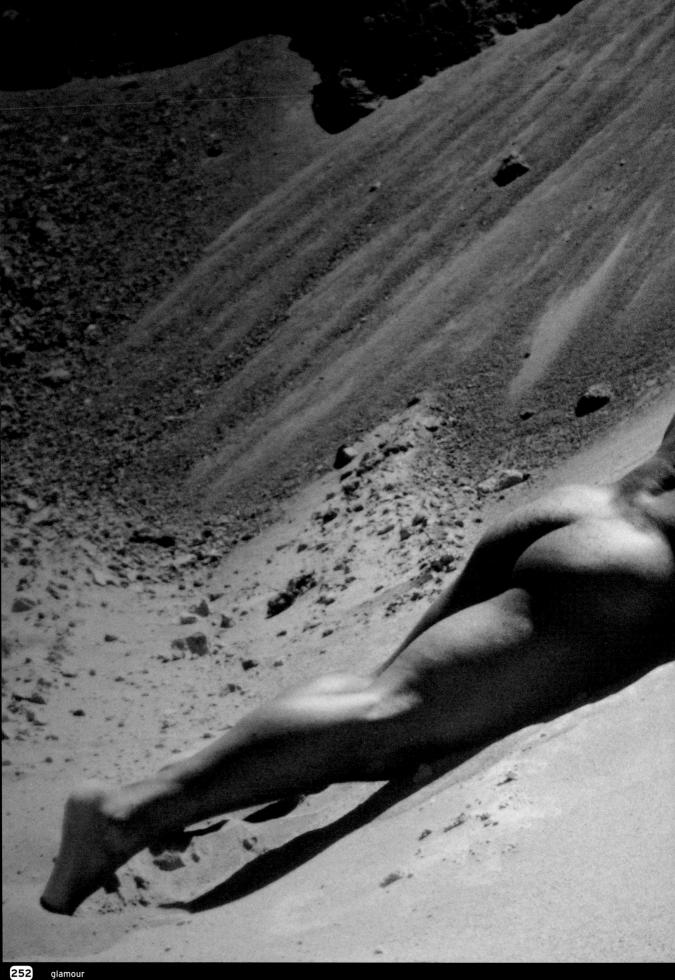

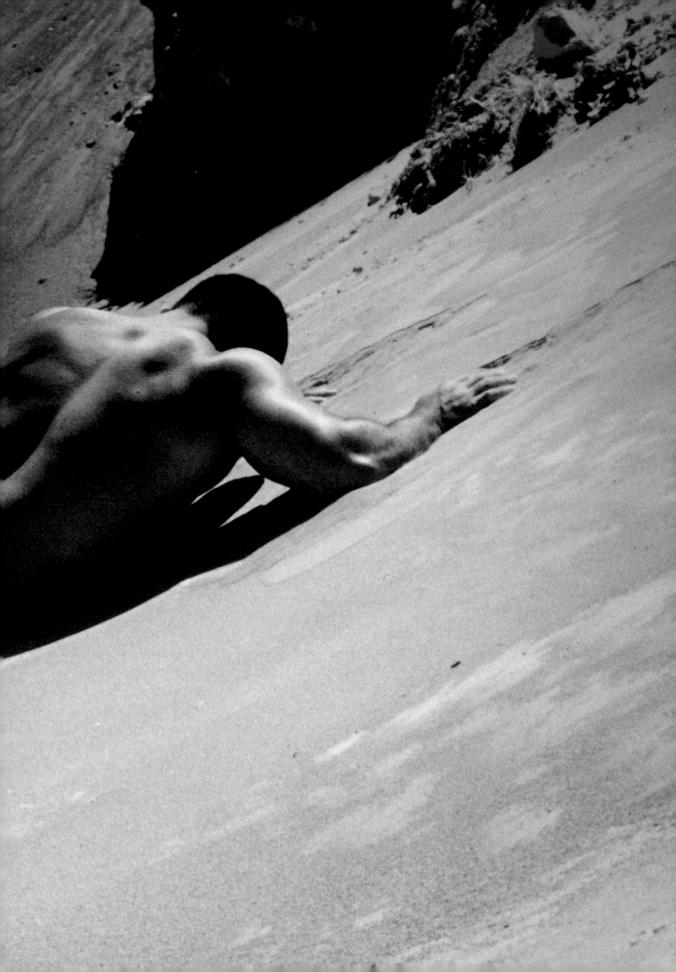

Skin to Skin Collection II

photographer Ben Lagunas and Alex Kuri

the foliage and provide more detail.

The background for this outdoor shot consists of trees and

grass, so a green filter was used to lift these areas, lighten

Fine art personal work Natasha, Victoria, Suzanne

art director Ben Lagunas

stylist Charle

use

assistants

lighting

Mamiya RZ67 camera

lens 250mm

film Kodak Tmax 100

exposure 1/30 second at f/16

Available light

Plan View

key points

► Careful positioning of black panels can substantially increase the directionality of available light

The models are positioned between two black panels, and natural bright sunshine is the only source of light. The result is a tunnel of darkness with very strong overhead lighting - the panels ensure that absolutely no reflected fill can bounce in from the sides.

The long lens, which was used from a distance of about 6m, means that the bodies of the entwined models fill the frame almost completely. The shine from the sunlight reflected on the models' bodies emphasizes their form exquisitely.

black bounce

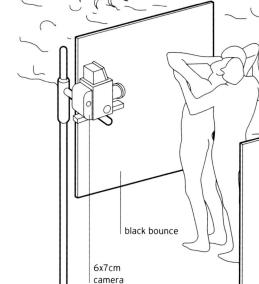

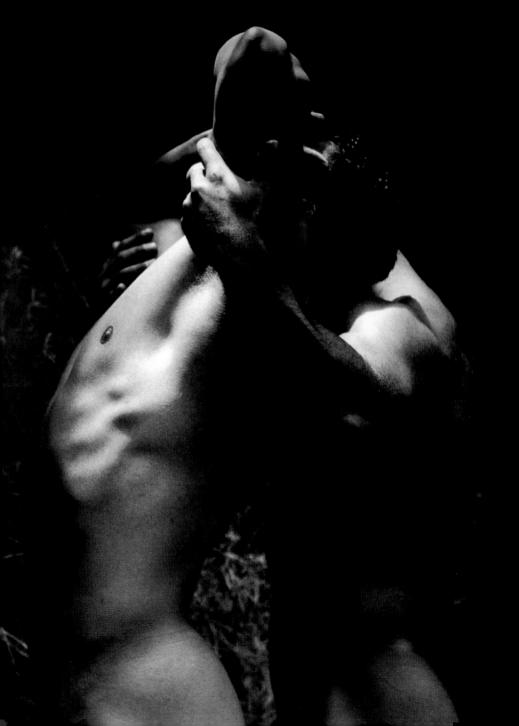

Underwear

photographer Frank Wartenberg

This is an archetypal image of male beauty. It was used in an

men's underwear-buying female partner contingent.

advertising context to promote underwear and was thus targeted

partly at the potential male consumer, but also, of course, at the

reflector

use

Presentation/underwear

model

Nic

assistant

Jan

stylist

Laurent, Uta

camera

Nikon F4

lens film 105mm

lighting

Polaroid Polagraph

Available light plus reflector

props and background Grey background

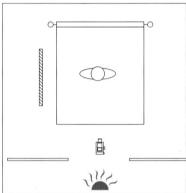

Plan View

The appeal therefore has to be doubleedged. On the one hand, it is important that men should be able to relate to the image, to create a desire for them to purchase the product. At the same time the image must appeal to women, who may well be the purchasers of gifts for partners. The glamour and eroticism of the shot have an important function in this respect. The contextualizing is therefore an important aspect of the

35mm camera

> image's capacity to compel the viewer. The model is lit by a reflector, which bounces daylight from a window on to the body, giving more directionality and intensity to the available ambient light. The sunny aspect lends an air of romanticized idealism, without undermining the masculinity of the image. This quality is assured by the choice of idealized model and the strong, graphic styling.

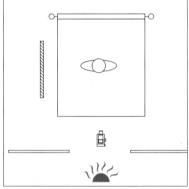

key points

► Daylight can be controlled to a certain extent by the use of bounces and flags

Augustus as Ancient Hawaiian

photographer Tim Orden

"Nude shots can sometimes be awkward if any member of the team is ill at ease," Tim Orden comments.

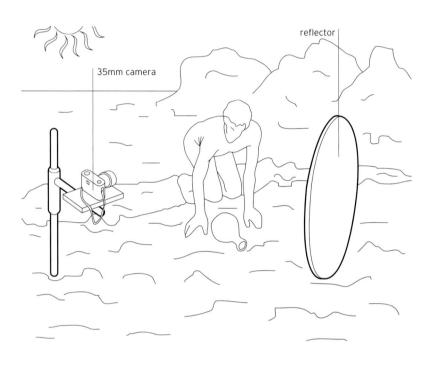

The same and the s

Personal work

Donna Orden

Kodak Tri-X rated at

Available light, reflector

Sandy beach, Hawaii,

Augustus

35mm

60mm

100 ISO

Not recorded

gourd pot

Plan View

model

assistant

exposure lighting

props and

background

camera

lens

film

key points

- On an overcast day a reflector can distort the impression of the location of the sun (the true main light source)
- Down-rating a film, combined with pull-processing, will generally give more shadow detail

"Shooting dudes without clothing is easy for me. However, Augustus was shy about being totally exposed with my wife, Donna, around. Donna's job was to do the make-up and help with the reflector. So, I convinced my model that we should just 'get on with it' and 'Do what we're trying to do.'

"Donna showed no outward signs of titillation by Augustus's walking around nude. However, during a break, she went over by the shoreline and sat down. I asked her, 'Are you okay?' Her answer was, 'Yeah, I'm just a little hot.' 'What do you mean, hot?', I blurted. 'Well, what do you think I mean?' I guess she was looking cooler during the shoot than she actually was."

There are no additional lights in this shot, just a 1-metre-square silver reflector on the shadow side of the model. The photographer used a 400 ISO film rated at 100 ISO and underdeveloped the result by 2 stops.

Photographer's comment

I had Augustus roll in the sand to give him a body texture.

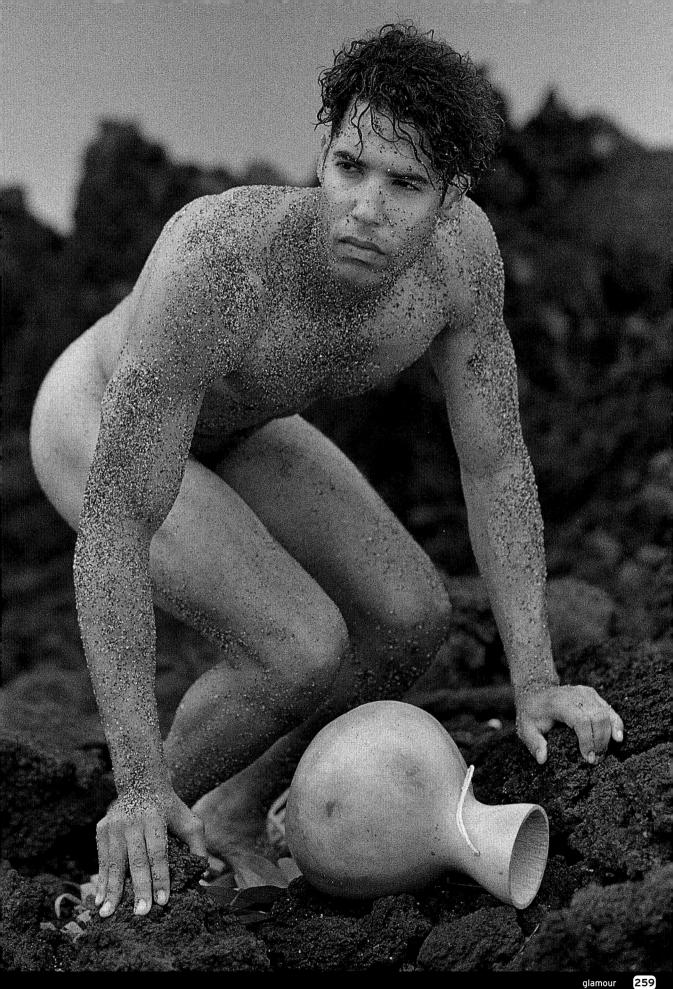

Rosari

photographer Julia Martinez

has produced a fascinating image.

model

Rosari

camera

MF Mamiya 645

lens

300mm

film

Tmax 400

exposure

f/11

lighting

Available light

Plan View

With just the simplest of lighting - late afternoon Spanish sun -

and some imaginative finishing experimentation, Julia Martinez

key points

 A wide range of tissue paper is available, from coarser, disposable paper handkerchiefs to the finest craft paper Perhaps "icon" would be a better term. The religious resonances are obvious, from the centrally-placed crucifix pendant and ghostly Turin shroud effect, to the very pose, features and expression of the model, which recall many depictions of Jesus Christ, or, perhaps, of Saint Sebastian, with torso exposed and vulnerable.

There is little to say about the lighting except that, although the model was positioned side-on to the sun, the immediate impression is not that of strongly directional side

lighting. This is because the bounce, strategically placed, evens out the lighting on the body.

More unusual is the unconventional textile-like finish and obscuring texture of the picture. This was achieved at the printing stage by projecting through an overlay of tissue paper, which accounts for the woven-fibre quality of the image. Finally, hand colouring with crayons completed the post-production.

The final twist to this image is that the model is actually a woman.

Golden Man

photographer Frank Wartenberg

client

Foto Magazine

use

Cover Kirk Smith

model assistant

Bert

stylist

Ruth Vale

camera

Mamiya RZ67

lens

110mm

film

Kodak EPR 64

exposure

Not recorded

lighting

Electronic ring flash

plus 1 head

props and background

Golden wall

Plan View

key points

- Choice of background is a key part of a picture. Here the texture creates highlights in the upper part, and lowlights in the lower part
- A shutter speed of 1/125 second or less is essential if you want to 'freeze' a moving subject

It is not often that the subsidiary light in a set-up is of more importance than the main keylight. But in this extraordinary shot, there is little to say about the straightforward keylight, a spot that is simply placed overhead to give directional downlighting. Instead, it is Frank Wartenberg's subtle use of a fill-in ring flash that commands more attention and creates the main areas of interest.

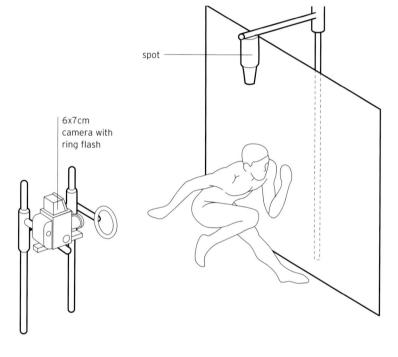

The purpose of the front ring flash here is not to provide light so much as to provide shadow. Behind the hands and outstretched arm it throws a slim shadow on the background, which creates both an amount of separation and a sense of movement.

The positioning of the ring flash, lower than the model and pointing up at him, means that the legs throw further shadow areas on to the torso and the bent arm, adding to the high-contrast film noir (or perhaps we should say "film d'or") look.

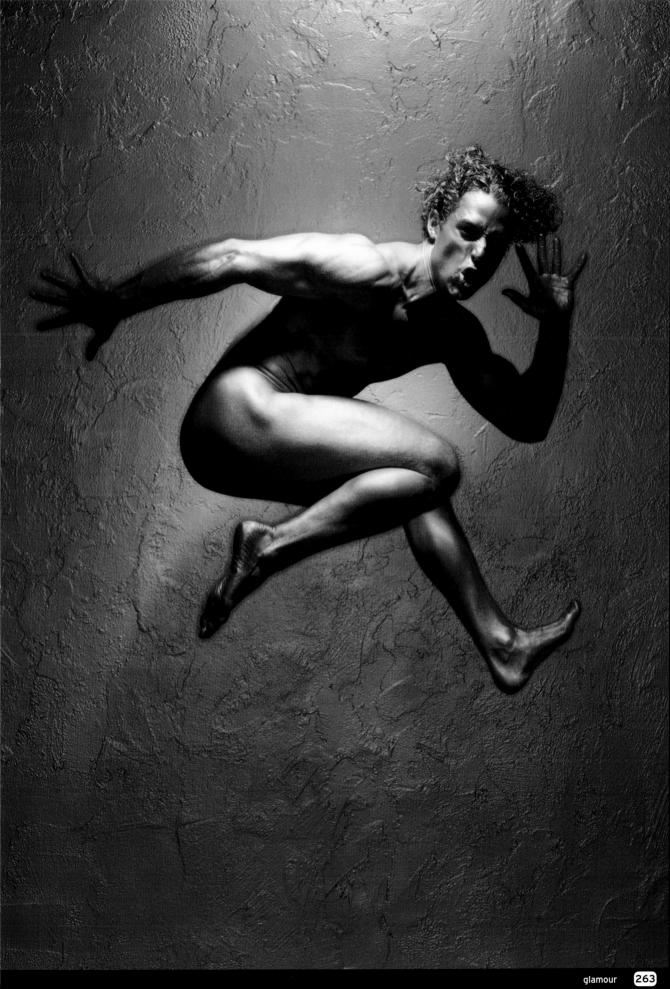

Lingerie

photographer Frank Wartenberg

clearly within the busy setting.

spot with

The lighting in this shot is dual-purpose. It establishes a time

of day and thus contributes to the narrative implicit in the shot,

and it contributes to the practicalities of illustrating the model

client use Brigitte Magazine

---!-4--4

Editorial

assistant

Jan

camera

Nikon F4 105mm

lens film

10311111

exposure

Polaroid Polagraph Not recorded

lighting

HMI spot

props and

Artist's studio (location)

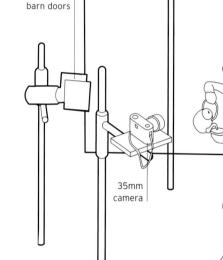

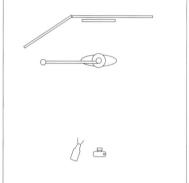

Plan View

key points

- The choice of lighting can establish a motivation and internal logic for the other facets of a shot (props, costume, and so on)
- ► It is important for the photographer to be aware of "tones and zones"

The stark spot emulates bright, latemorning sunlight streaming through a window. All the details conspire to create the eroticism that the photographer wanted: the morning sunshine and suggestive "morning after" coffee, the model's sensual lingerie, the wittily-placed painting leaning against the wall so that the figure in it seems to avert his gaze, with a troubled expression, from the

part of the model that is in startling proximity to his eyes.

spot

The spot light is carefully positioned so as to give outline detail in the shadow of the model, but without too much density. It also casts shadows of the items hanging on the clothes line. Since these shadows fall on a darkertoned surface, the shadow is denseressential to make the model's right arm stand out.

Photographer's comment

I wanted a natural but erotic scene.

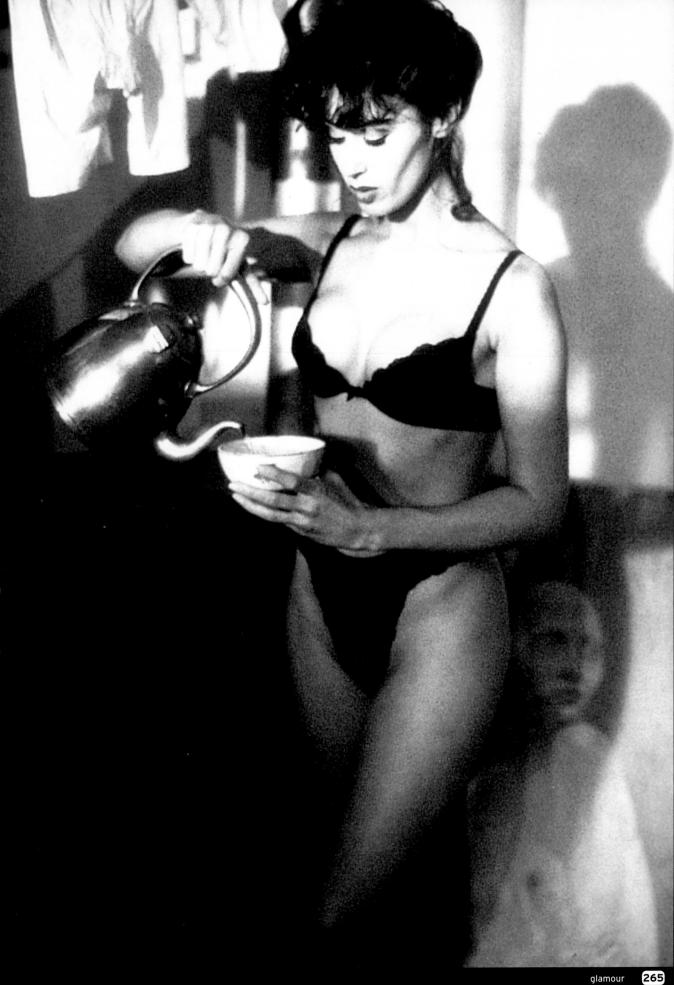

Jacqueline in the box

photographer Michael Grecco

"Skin tones require a surprising amount of additional blue in order to record as neutral", says Michael Grecco. "I am forever adding blue filtration."

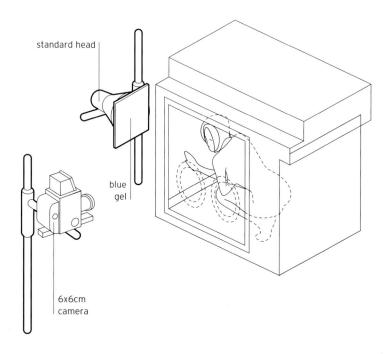

For this particular shot, Michael Grecco used a ½ booster blue filter, resulting in the pale blue-tinged skin that he wanted. Although this was an outdoor daylit shoot, it was an overcast day and the model crouching inside the dark box needed additional flash lighting. This was provided by a Comet 1200

PMT. Since tungsten-balanced film was being used, the box (lit only by the ambient daylight) records as a rich, deep blue, while the skin retains its almost neutral tones and glows in the gloom from within the unnerving location set, giving this extraordinary and haunting look.

Photographer's comment

The sudden rain added an ethereal look to this picture, taken at the Los Alamos nuclear lab's junk yard.

wse Personal work
model Kelly Anderson

camera 6x6cm lens 120mm

film Kodak EPY 64 (tungsten-

balanced)

exposure 1/5 second at f/8 lighting Electronic flash

props and Los Alamos, New Mexico **background** ucclear lab equipment

key points

- ► Full blue filtration results in the loss of two stops of light
- ► When this is used over a flash head the inverse-square law also applies

Plan View

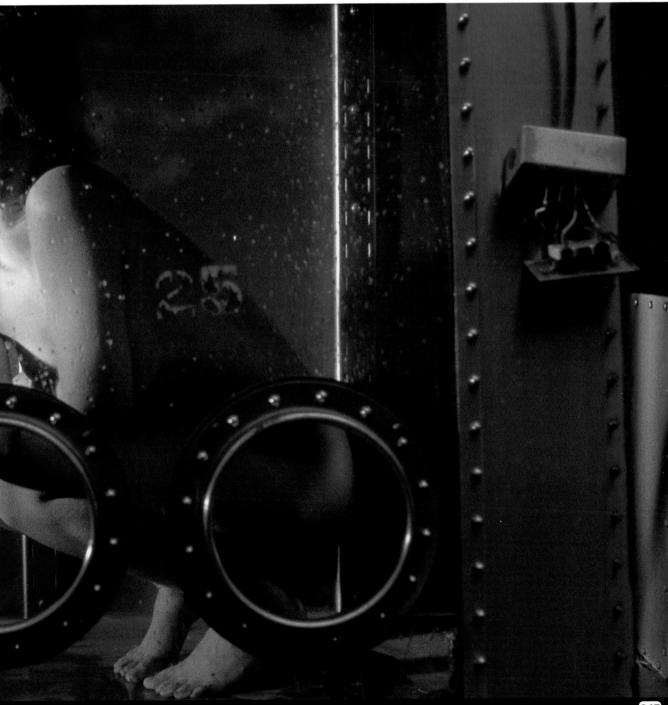

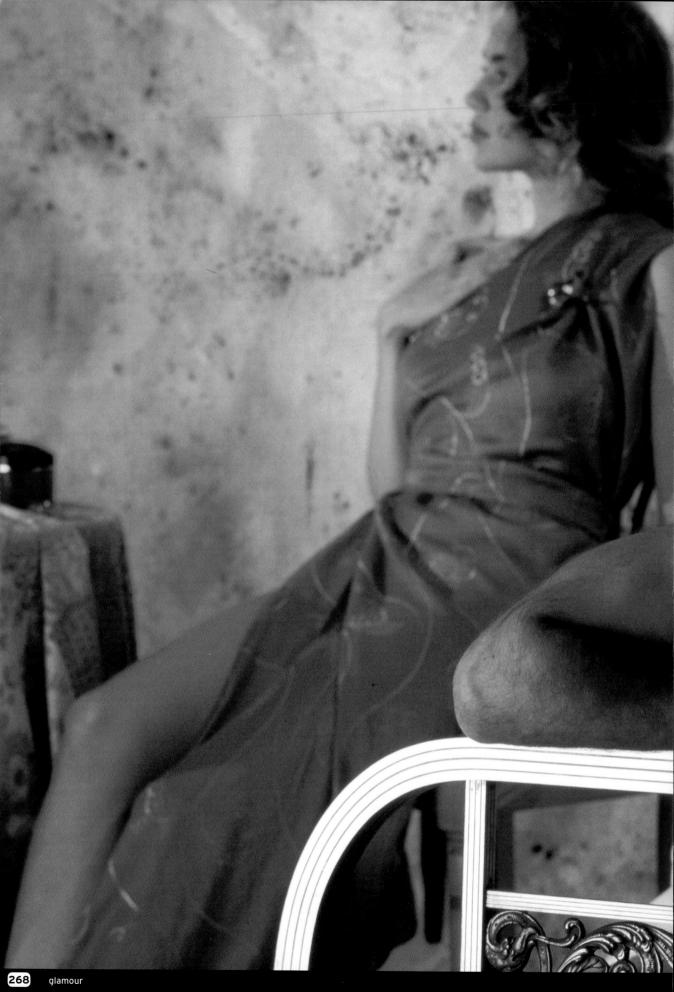

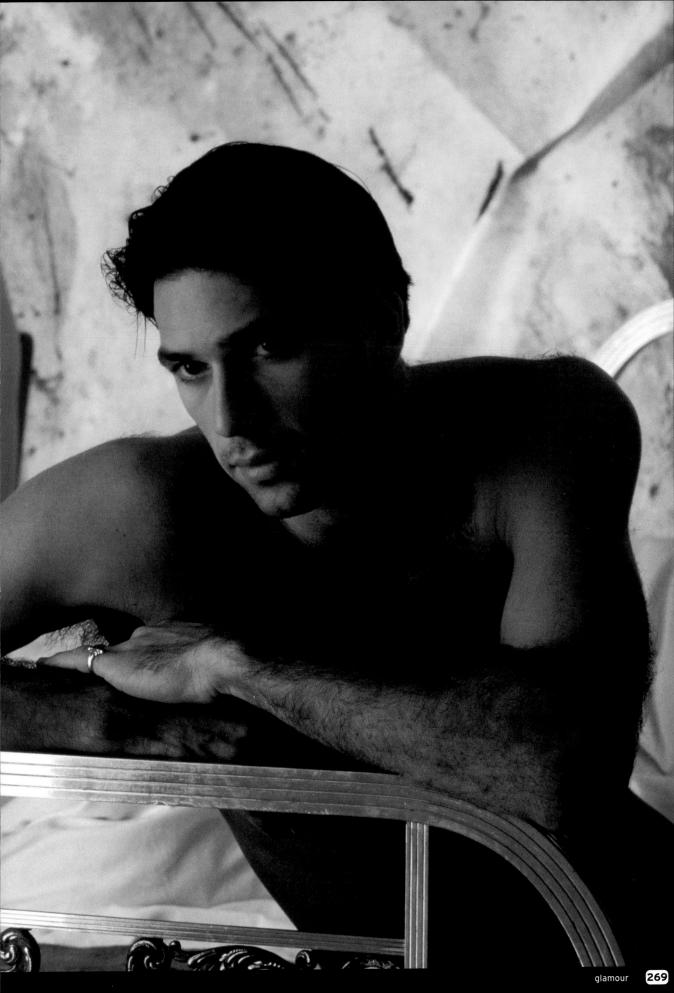

Bedstead

photographer Frank Wartenberg

The voyeuristic quality of this shot derives from the tangible tension conveyed by the two characters featured. This seems to be an intensely private moment, perhaps of friction, uncertainty or attraction – several interpretations are possible.

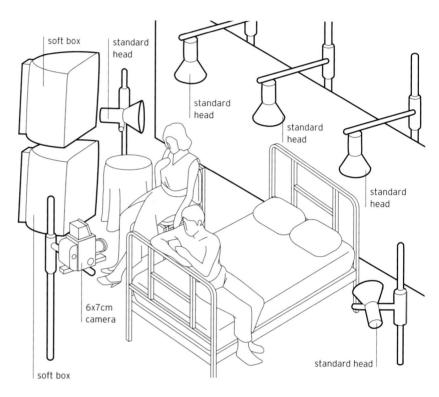

client Select magazine
use Editorial

model Alan and Ludmilla

assistant Jurgen

art director Frank Wartenberg
stylists Susan, Sabine
camera Mamiya RZ67
lens 180mm

film Kodak EPR exposure Not recorded

lighting Electronic flash: 5 heads and 2 soft boxes

props and background Bed, chair, table, painted background

Plan View

key points

- Tensions between contrasting areas of lighting can be suggestive of tensions in the subject matter
- Separation can be achieved by using a long lens to reduce the depth of field instead of using a backlight

The posing and expression of the models play a major part in creating this effect, as do the colour, setting and texture of the subject. The wall, the clothing and the skin are all of similar colour tones, lit to imply the confused connections between them. Five flashes give even light on the woman and the background, and the use of an orange filter over the camera

lens lends relative uniformity to the colour range. Only the bedstead, lit by two soft boxes, has a cold glow of its own, the intensity of light outweighing the effect of the light orange filter on the camera. The male model, lit by the same two soft boxes, is posed to give areas of shadow on the body and face to emphasize the moody atmosphere of the shot.

Photographer's comment

The whole set was built in the studio.

Massage

photographer Frank Wartenberg

Frank Wartenberg photographer

Fit for Fun client Editorial/cosmetic use

Bert assistant

Laurent Boyas stylist

film

Mamiya camera lens 185mm

Fuii Velvia Not recorded exposure liahtina Electronic flash: 6 heads

props and Built set, light orange

background background

Plan View

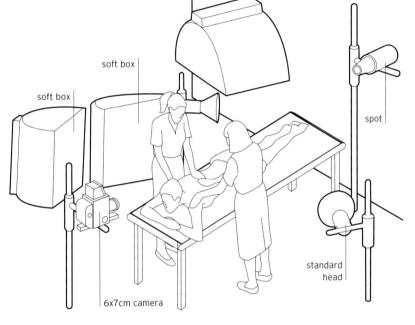

The use of the 81A orange filter contributes a rich, luxurious

warmth to this shot. The overall lighting is quite soft, supplied

by the two front soft boxes, and there are hard highlights on

parts of the model's body her hair, and the masseurs' arms.

key points

- ► You should light the whole of the set from the beginning, even if you plan to frame little of the background. This allows for greater latitude with framing and model-directing, without interruption for re-positioning
- ► Even the smallest amount of rim-light separation can make all the difference in clearly defining a model's features

These areas of contrasting hard light and the shining areas that they produce are significant in three respects. First, the shine on the body is important to establish the idea of a massage oil being applied. Secondly, the shine on the back of the hair and on the arms of the masseurs gives the idea of warm sunlight streaming in

through a rear window. These aspects are achieved by the close-in rear soft box. Its proximity provides apparently harder directional light. Thirdly, the hard light from the focusing spot picks out the back of the hair and gives the outline of light below the ear. This detail provides the essential separation between the face and the shoulder.

The Cat Lady

Photographer Frank Wartenberg

IISA camera Self-promotion

Mamiya RZ67 110mm

lens film

Fuii Velvia rated at

40 ASA

exposure

Not recorded

lighting

Electronic ring flash

props and background Wild cat backdrop

Plan View

key points - A lot can be achieved with even the minimum of lighting

► High-key detail can add to the stark impact of a deliberately startling shot

The positioning of the black material on the floor was an important decision. because it introduces a horizon line where the floor meets the wall, and helps the viewer to make sense of the model's pose. The "geography" of the shot might otherwise have been difficult to understand. The ring flash gives a wall of light on the leopardskin

background. The cloth has texture, movement and tone enough of its own to give the variation and interest required. The white, fetishy stiletto shoes are very evenly lit, giving a highly graphic form. Here, it is the contrast in colour between the highkey shoes and the low-key area of the background that provides separation.

6x7cm camera with ring flash

This is an example of the idea that "enough is plenty". If only a

single ring flash is needed, then just use one. Frank Wartenberg

is not afraid to use a whole host of lights if the occasion

demands it, but in this case only a single source was needed.

Photographer's comment

I wanted a powerful and erotic photo!

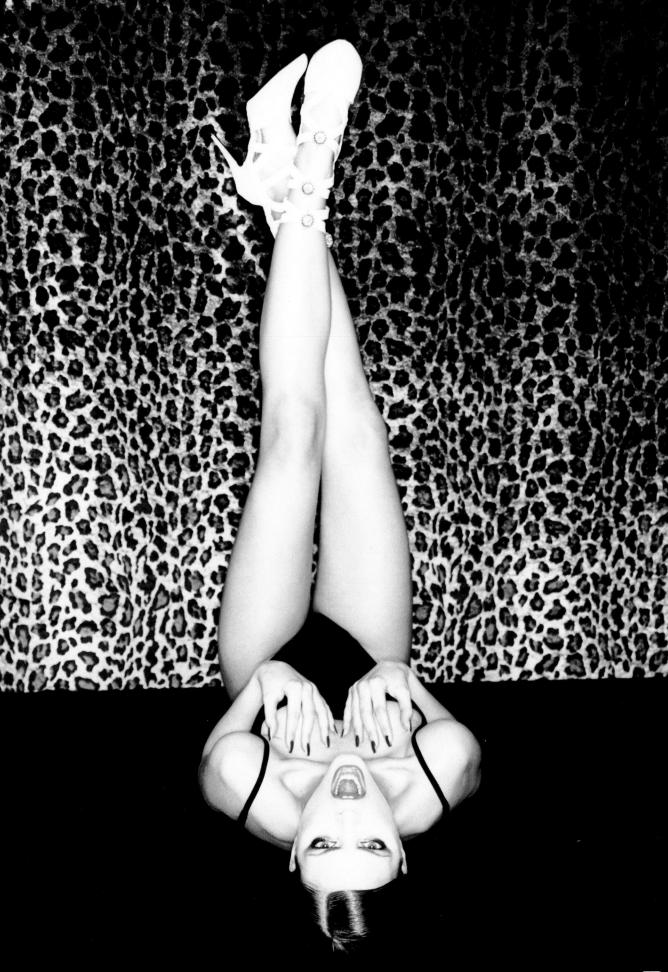

Erotic Art

photographer Frank Wartenberg

Areas of dark are just as important as light in this shot. The blackness of the leather seat and the regular pattern of the black tights give two major areas of visual impact. The large, long soft box running almost the entire length of the couch gives a dazzling highlight along its edges but the fabric of the clothing remains matt in texture and unlifted by catchlights. The reflectors bounce in just enough light to provide some fill.

client Art Buyer's Calendar use Advertising

model Brigitte
assistant Marc

art director Frank Wartenberg stylist Ulrike, Uta

camera Nikon F4

lens 85mm with orange filter film Polaroid Polagraph

lighting Electronic flash:

1 soft box

props and Grey background background old leather furniture

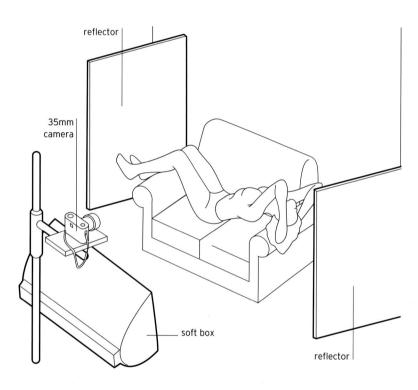

The grey of the background represents the brightest area of the shot and the model's body displays every tone in between, encompassing a highlight on the midriff that is equivalent in brightness to the background, down to a shadowy hand that is almost as dark as the leather. The position of the soft box,

slightly closer to the model on the camera left side, gives some directionality, so the model's front is bathed in light while the head and arms are flung into more shadowy territory. The modelling on the breast (nearest to the camera) displays the gradation of light from one side to the other.

Photographer's comment

Erotic art – the body like a statue.

key points

- ➤ A high-contrast stock, even when modified with an orange contrast filter, can still be lit to give a mediumcontrast look
- Observe the splendid example of graduated light on a perfectly smooth, rounded subject

Plan View

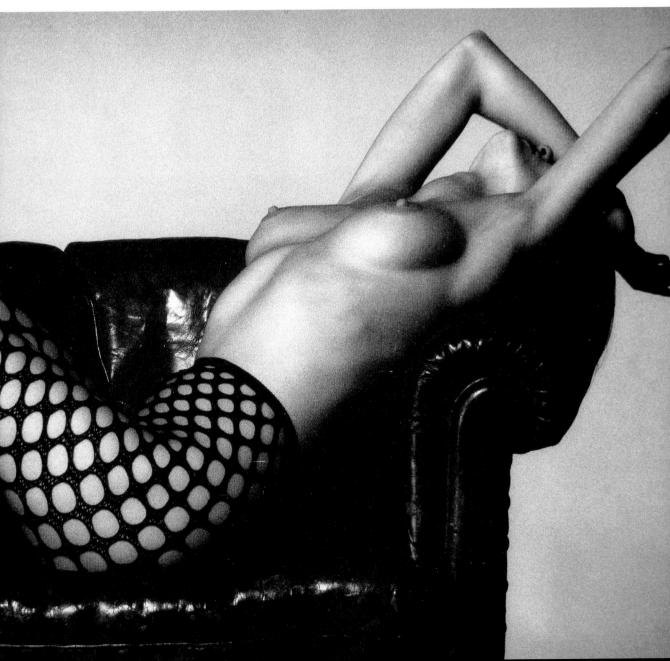

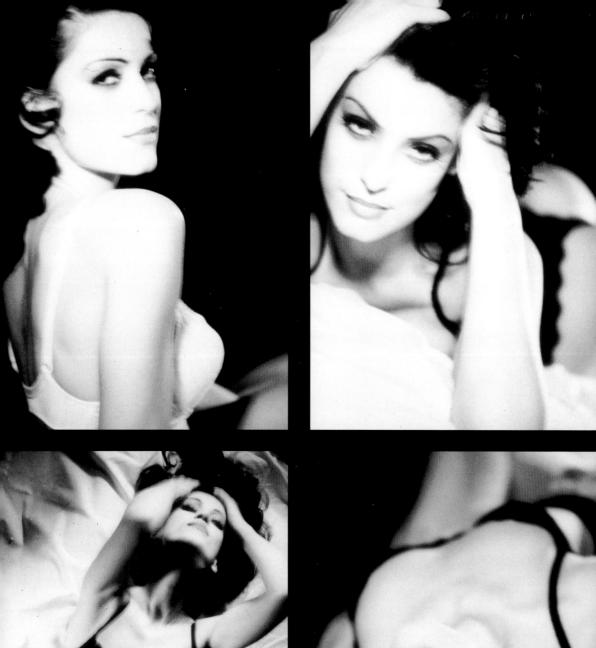

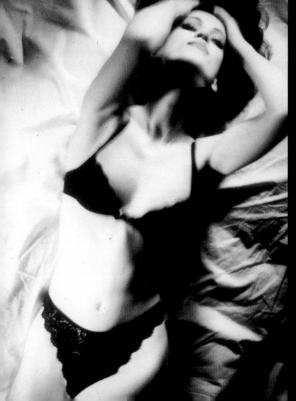

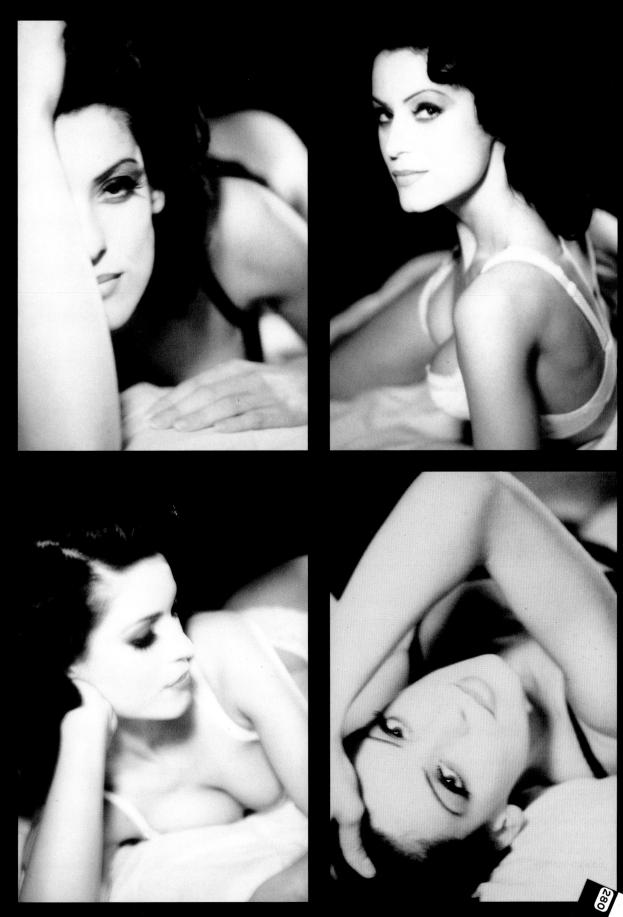

 $gl_{\partial m_t}$

Natasha Series

photographer Günther Uttendorfer

This is another example of a very simple set-up, with just one 500-watt tungsten head with a standard reflector and frost, the only source used throughout the whole sequence.

The head is placed to camera left and its position stays constant for the whole shoot. It is the model and the photographer who move, introducing variations in composition and lighting, and revealing the textures in the fabrics of the model's clothing and the sheets. The model's lingerie also changes between shots, giving different plays of light and dark in the sequence of pictures.

What comes through in all the pictures is the model's personality, engaging with the camera. This quality is heightened by considering the shots as a sequence, as they are shown here.

A shutter speed of 1/8 second is used to introduce the feeling of movement and give the images a slightly soft edge in contrast with the relatively harsh direct light. Use of an orange filter increases the contrast.

Plan View

client

use

model

assistant

make-up

camera lens

exposure

lighting

props and

background

film

art director

Kankan magazine, Slovakia

Natasha, Slovak Model Management

Editorial

Martin Fridner

Ivan Sloboda

35mm

105mm

Polapan

Tungsten

black paper

Martina Valentova

1/8 second at f/2.5

Bed with white sheets.

key points

- A red filter would heighten the contrast even further, but it can become difficult when working quickly to be sure that the focus is accurately set
- ► When using instant Polaroid film stocks, make sure that the processor is scrupulously clean, as it is easy to scratch the film

Photographer's comment

It really is a lot of fun if a woman reveals her character in front of the camera and interacts with it. This creates for me the erotic feeling of a series.

Low Key

photographer Marc Joye

Use

Portfolio

Model

Genevieve

Camera Lens 6x6cm 80mm

Film

Kodak Tmax 100

Exposure

1/60 second at f/16

Lighting

Electronic flash: 2 heads

Props and background

Plinth, dark red fabric

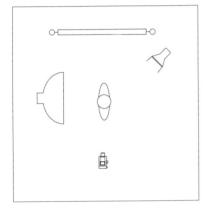

Plan View

6x6cm camera standard head with barn doors

A few high-key areas make for an overall low-key image. This

little in this case) in relation to how much of it is low-key.

may sound like a contradiction in terms, but the explanation is to

do with the proportion of the overall image that is high-key (very

key points

- "Keylight" is generally used to mean the dominant or more powerful light source. It is usually the first consideration when planning the setup and often dictates the nature of the supporting lighting
- Careful use of geometric form can give a powerful, balanced visual impact

There is absolutely no direct light on the background, which occupies a large amount of the frame, and this determines the feel of quiet greyness. The geometric form of the model is more important than close detail, and the strongly directional lighting emphasizes the graphic element of her pose, with the visual balance of relatively small areas of high-key shine on the extreme right of the model (her

back) and on her left (the front of the lower legs). The fulcrum is the V-shape formed by the thigh and abdomen, and the sense of balance is picked up by the fine rim of light on the left edge of the plinth, which is placed to control how much of each side is in view.

Just a fraction of the left side is visible, giving the fine line of light, while the right side is turned away to ensure that no edge light appears.

Photographer's comment

Here the model was moving and changing poses that were very powerful.

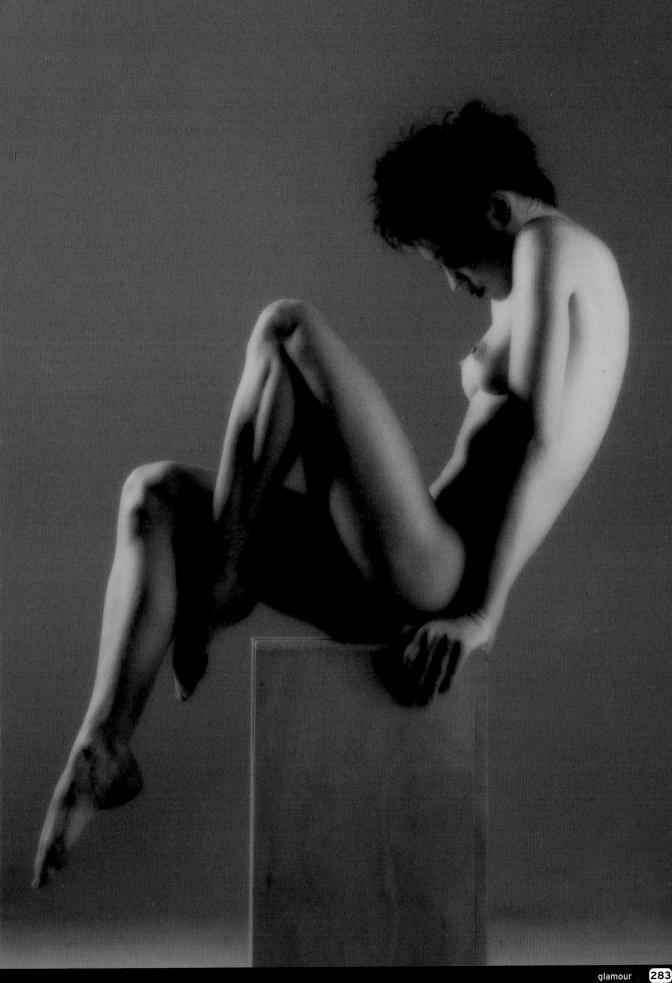

Gabriella

photographer Frank Wartenberg

client use Stern Magazine

model

Cover/Fashion Gabriella

assistant

Gabriella Bert

stylist

Gudrun, Uta

camera film Mamiya Fuji RDP 100

exposure

Not recorded

lighting props and background Ring flash Golden wall

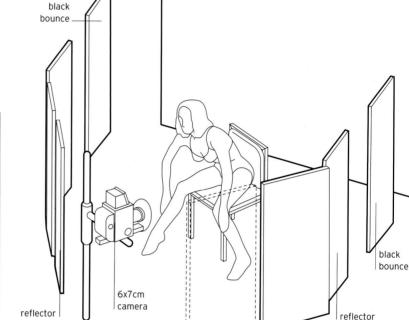

Although the only source of light is a single ring flash, this shot

is illuminated by almost all-round lighting, ensured by the use of

a bank of reflectors arranged in a semi-circle in front of the

model and a reflective golden wall behind her.

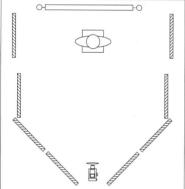

Plan View

key points

- Reflective props and accessories can add interesting glints of detail if lit appropriately
- Sometimes areas of both sharp and soft focus on the same main subject can enhance the image

The only break is that provided by two black panels, one to each side of the model, which have the effect of allowing some fall-off to occur on the side edges of the limbs and body. Even the chair is made from reflective metal, giving glowing metallic blue areas behind the model. The pose of the model means that her face is considerably closer to the flash than

the rest of her body, and the resulting difference in tone is immediately apparent, as the face is comparatively burnt out though sharp, while the body has a darker golden tone and is in softer focus.

The highlights on the bangles, shoe, chair seat and back and on the model's lips add balanced points of interest across the image.

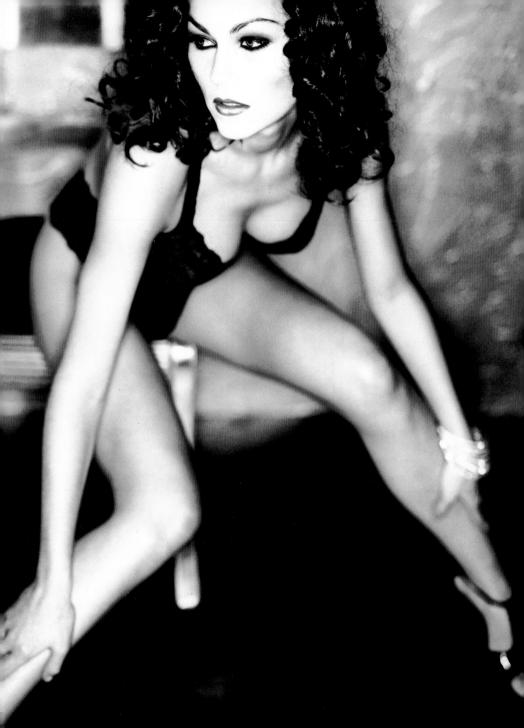

Feathers

photographer Marc Joye

use

Portfolio

model

Genevieve

camera

6x6cm 80mm

lens film

Tmax 100 and Fuji RDPII

exposure

1/60 second at f/16
Electronic flash: 4 heads

lighting props and background

Feathers

The incredibly large feathers that comprise this extraordinary head-dress are in fact small feathers laid on to a print of the shot of the model, and the whole assembly re-photographed. The trompe l'oeil is surprisingly convincing. Notice the gentle shadow behind the head feathers – the work of subtle manual retouching to complete the three-dimensional illusion.

Plan View

strobe head with flaps strobe head with flaps strobe head with flaps 6x6cm camera

key points

 Simple, physical techniques used in a sophisticated way can result in a shot that others might execute in a timeconsuming, expensive electronic way The background is illuminated much more brightly than the model. Two strobe heads aimed at the backdrop give a bright, even background. The position of the soft box to the side of the model does not give much strong, direct light on the front of the body,

and the strobe behind her on the opposite side gives backlighting that adds to the tendency towards silhouette. The pattern on the torso stands out by virtue of the colour, in contrast with the soft black and white base image and pastel feather shades.

Photographer's comment

After shooting the photos, I designed some black calligraphy on the model's body. After printing I reworked the calligraphy in red and added some pigeon feathers as a hat and to cover the pubic hair.

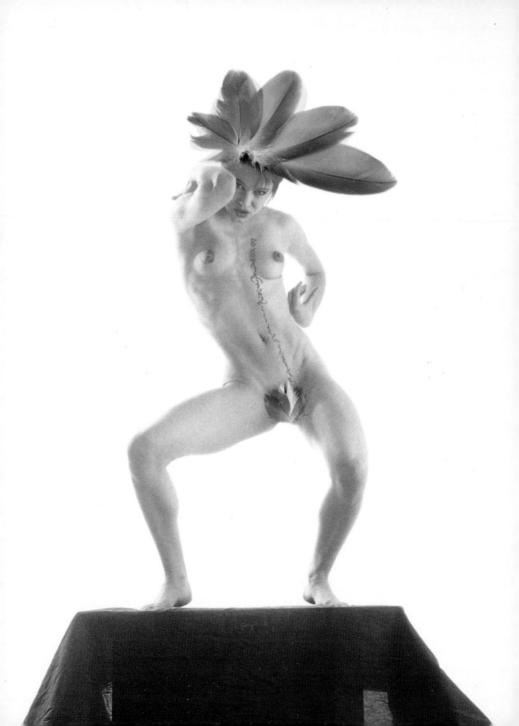

lady iguana

photographer Wolfgang Freithof

directly onto the model's skin.

client

Self-promotion

use model Select magazine

art directe

Michelle/Ford

art director hair/make-up Sophia Lee Ron Capozzoli

body paint

Claudine Renke

camera lens 35mm

film

105mm

exposure

Fuji Provia 100 1/60 second at f/4

lighting

Electronic flash: 3 heads

props and background

White seamless background

Plan View

standard head standard head standard head standard head

The corset was painted onto the model using a pre-cut mould

onto which liquid make-up was applied to stamp the design

key points

- Light shot direct through a silk umbrella gains good diffusion without entirely losing the "point source" look: notice the highlights on the knees merging into softer diffused lighting further along the limbs
- Black panels give a strong fall-off in the light to enhance outline separation

The model was standing between two 4x8ft black panels to ensure that the outside contours remain strong against the white background. Freithof shot 2½ stops overexposed to give what he describes as 'a painterly quality' to the picture. The main light is a standard head at a height of 12ft, directly over

the camera, shooting through a silk umbrella. The background is lit by two standard heads at 45 degrees, which are set $\frac{1}{2}$ stop over the keylights. This makes sure that the background is very bright and gives some separation between the background and the model's outline.

Photographer's comment

I collaborated with a cartoonist (Henrik Rehr) to add some extra visual effects.

I received many enquiries from this picture from diverse ad agencies and also from a German publisher.

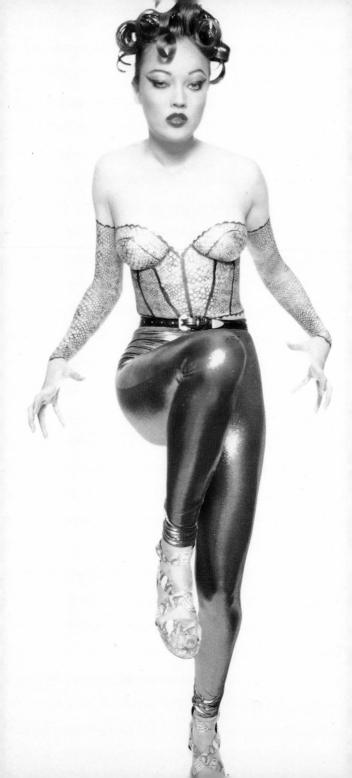

Elle

photographer Frank Wartenberg

This witty shot is brought off well by the careful attention to styling, graphic form, lines and tones and, of course, choice of lighting, to make the most of each area of texture. Every ripple in the jeans is clearly defined; you can count the vertebrae along the back; and every strand of hair is distinctly visible.

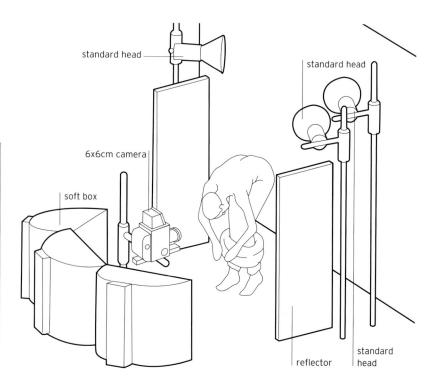

key points

- ► Agfa Scala is the perfect recording material when a low-contrast image is required
- ► A low-contrast stock can produce a higher-contrast image if a large contrast ratio is applied

The model is in the centre of a semicircle of light made up of three soft boxes to the front and completed by two silver reflectors, one at each side. Three standard heads evenly illuminate the white background. This is a lowcontrast image with a small lighting ratio (about 1:1.5): the key is not significantly brighter than the fill so there is a good tonal range.

The Plexiglas surface placed on the ground creates the opportunity for a reflection of the model to occur on the floor to add interest. From this viewpoint, the shot taken with the camera at about the same height as the model's head - only the reflection of the feet can be seen. If the camera had been higher up than this, more of her reflection would have been visible.

Fit for Fun

Editorial

Elle

Bert

Anette

360mm

on floor

Agfa Scala

Not recorded

Electronic flash: 6 heads

White backdrop, Plexiglas

Laurent, Uta

Mamiya RZ67

client

assistant

stylists

camera

exposure

lighting

props and

background

lens

film

art director

use model

Plan View

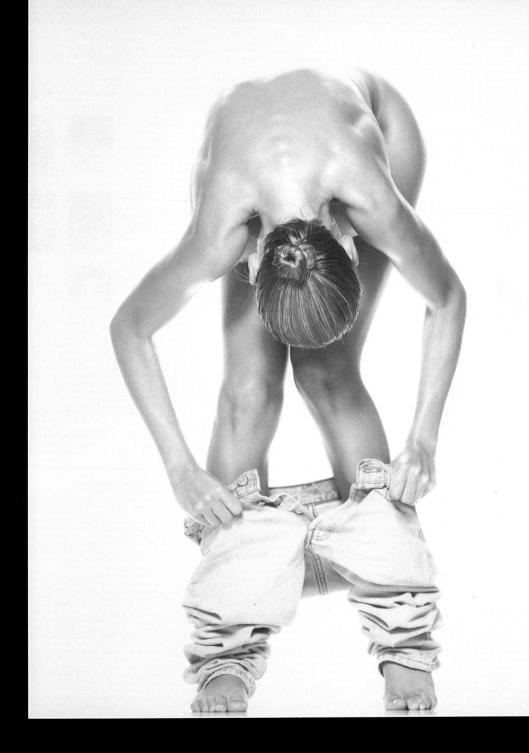

directory

photographer

Jörgen Ahlström

address

Norr Mälarstrand 12

112 20 Stockholm

Sweden

telephone

+46 (8) 650 5180

fax

+46 (8) 650 5182

agent

The Purdy Company

Ltd

(England)

7 Perseverance Works

38 Kingsland Road

London E2 8DD UK

telephone

+44 (0)20 7739 3585

fax

+44 (0)20 7739 4345 **pp.141, 159, 164-165,**

181

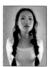

photographer

Peter Barry

address

15 Goodwood Court

Devonshire St London

W1W 5EF UK

telephone

+44 (0)20 7637 5303

Peter Barry's work is extremely varied – fashion, advertising, still life and food – so every

day is different, exciting

and stimulating.

Constantly learning and experimenting with new techniques, his two main passions are people and food. He has travelled all over the world and met

many fascinating people.

As a result, he feels that

photography is not so

much work as a way of

life.

p.109

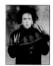

Johnny Boylan

photographer address

The Soap Factory
9 Park Hill London

+44 (0)20 7622 1214

SW4 9NS UK

telephone fax

+44 (0)20 7498 6445

mobile email

e +44 (0) 7831 838 829 johnnybfab@aol.com

www.contact-

www.contac

me.net/JohnnyBoylan

Photography becomes a way of life, an obsession.

Luckily for Johnny Boylan

it also provides a good

living. Every new

commission, whatever it is, is a challenge. That

challenge need not

necessarily be

photographic. The

sourcing of a location; a

model; finding an unusual

artefact; getting over the

logistical problems of

travelling to some

backwater in another

continent. Photography

can be make-believe and

fantasy, but most of all it

is an art form of

supplying your client.

There is no room for

error and it is

unforgivable to supply

something that is

unusable, whatever the

reason.

pp.51, 61, 81, 89, 111

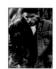

photographer

Maria Cristina Cassinelli

address Venezuela 1421

(1095) Buenos Aires

Argentina

telephone +58 (0)541 381 8805

refebrione

fax

fax

+58 (0)541 383 9323

agent Black Star

116 East 27th Street

New York

NY 10016

...

+1 (0)212 8890 2052

Endowed with a unique

creative style, Cristina

brings out the essence of

her subject, whether a still

life, a portrait or

a building immersed in a

landscape.

pp.63, 65

photographer

address

Simon Clemenger 1 Anchor House

Old Street

London EC1V 9JL UK

telephone 1

+44 (0)958 71 71 50

+44 (0)1635 28 13 44 telephone 2

pp.135, 157, 199

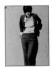

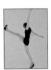

photographer

address

Corrado Dalcò via Sciascia 4-43100

Parma Italy

telephone

fax

+39 521 272 944

+39 521 778 8434

Corrado Dalcò was born in 1965 in Parma. He studied for five years at the P. Toschi Institute of Art in Parma, specializing in graphic design. He is a self-taught photographer, and worked as a freelance photographer abroad before founding his own photographic studio in 1991. He won an international competition in 1993 ("5ième Biennale") for young Italian photographers and his photos were published in the Photo Salon Catalogue. Corrado works mainly with agencies in Milan, concentrating on fashion. Some of his work has

been published in Italian

and international

magazines.

pp.117, 196-197, 200-201

photographer

address

Frank Drake Pelican Studios 17 Goldney Road Clifton Bristol, BS8 4RB UK

telephone/fax +44 (0) 117 914 0960

Frank Drake is self-taught; he decided on photography as a fine art after meeting Henri Cartier-Bresson in Paris in the 1970s. He worked with Peter Gabriel's Real World Records for six years, photographing musicians from around the world. He moved into fashion photography in 1996 after studying Art and Social Context at the University of the West of England.

p.93

photographer

David Dray

60 Milton Avenue Margate Kent

CT9 1TT UK

telephone

address

+44 (0) 1843 22 36 40

David Dray is a graphic artist working on the Isle of Thanet in Kent. He trained at the Canterbury College of Art, where he first started using cellulose thinners to produce montages from gravure printing. Later he applied the thinners technique to colour photocopies to achieve the results shown in this book. He uses this technique with his own photography or (as appropriate) with other photographers' work to maintain complete control

p.105

in design briefs.

photographer

Wolfgang Freithof W. Freithof Studio address

342 West 89th Street 3

New York NY USA 10024

telephone fax

+1 (212) 724 1790 +1 (212) 580 2498

New York-based Wolfgang Freithof is a freelance photographer with an

international clientele spanning a wide range of assignments from fashion,

advertising, editorial,

record covers to portraits,

as well as fine art gallery shows.

pp.145, 169, 184-185, 207, 209, 289

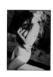

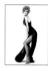

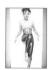

photographer address Juan Manual García

Carrera 11A #69-38

Bogotá

Colombia

telephone

+57 (1) 212 6005

+57 (1) 249 5843

fax +57 (1) 312 7661

Juan Manual García has been an avid photographer since childhood. As an adult he trained in photography in both Europe and the USA. Juan Manual García works in many different genres of photography. He tries to show an element of fantasy behind reality. He is passionate about photographing people and fashion. He has also specialised in still life photography utilising lighting methods that he devises himself. He has developed various industrial photography

projects and also works on

commission from some of the world's top companies including McCann Erickson Corp., Young & Rubican, Bates J. Walter Thompson and all other advertising agencies in Colombia. García is also involved in the magazine industry, and produces the covers for the most important magazines in Colombia. He also owns the largest photography studio in Colombia, which is equipped three sets and a digital photography station. García has won several awards in Colombia and Latin America for best food photographer. He has also won accolades for his fashion, product and landscape photography.

pp.219

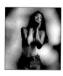

photographer telephone

+44 (0) 1474 814575

Colin Glanfield

Colin Glanfield is sadly no longer with us, but enquiries about his work can be put to his widow, Jenny, on the above number. Colin worked in virtually every branch of photography - from travel to automobiles, from medical photography to advertising - for several decades without ever losing enthusiasm. The

photograph in this book came from a project to document people with 'lived-in' faces, using an 8x10 camera.

p.41

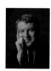

photographer address

er Peter Goodrum

2 Hillend Cottages Kewstoke Road Worle Avon BS22 9JY UK

telephone

+44 (0) 1934 516 178

Peter Goodrum turned his hobby of the 1980s into a career for the 1990s and beyond. As a book illustrator, he was hit hard by the recession: clients, art directors and advertising agencies vanished overnight, so in 1993 he decided to do a degree in photography at Cheltenham. He now looks upon this as the best thing ever to happen to him, both for exploring new ideas and techniques and for his personal development. He now specializes in photographing people - he particularly likes to photograph artists - and works for editorial. advertising and corporate clients as well as establishing a growing reputation as a photographic printer.

p.91

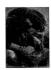

photographer

address

Michael Grecco Michael Grecco

Photography, Inc. 1701 Pierave

Santa Monica California

USA 90405

telephone

fax

+1 (310) 452 4461

+1 (310) 452 4462

Michael Grecco has an extensive background as an editorial and advertising portrait photographer. Along with his advertising work for Paramount, Fox, UPN, USA Network and Warner Bros., Michael does regular assignments for Entertainment Weekly, GQ, Movieline, Playboy, Time and many others. He has been in Photo Direct News three times. Michael has also been featured twice in American Photo. He has won numerous awards for his work including 1995, 1996 and 1997 Communication Arts and the American Photography annual. He also teaches at the prestigious Santa Fe Photographic Workshops.

pp.191, 267

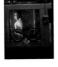

Roger Hicks photographer

5 Alfred Road Birchington Kent

CT7 9ND, UK

telephone fax

address

+44 (0) 1843 848 664 +44 (0) 1843 848 665

Roger is a wordsmith and photographer, both selftaught. He is the author of more than 50 books, as well as being a regular contributor to

photographic magazines. He has illustrated 'How-To' books, historical/travel books and of course photography books, and has written on a wide variety of subjects including airbrushing,

automotive subjects, the Tibetan cause and the American Civil War. He works with his Americanborn wife Frances E. Schultz on both self-

originated and commissioned projects, to provide packages of words and pictures suitable for both sides of the Atlantic.

p. 39

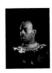

photographer address

Isak Hoffmeyer Ryesgade 3 2200 KBH N Denmark

agent address Charlotte Morgan 1st Floor 62 Frith Street London W1V 5TA UK

telephone

fax

+44 (0)20 7734 7511 +44 (0)20 7734 6114

Isak Hoffmeyer has been shooting for himself for the past few years and has worked in Denmark, England and Sweden.

pp.177, 192-193

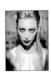

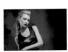

photographer

Kay Hurst K Studios address

> 9 Hampton Road Great Lever Bolton

Lancashire BL3 3DX UK

+44 (0) 1204 366 072 telephone

> Kay's work is concerned with the positive representations of women: women seen as assertive without being viewed as aggressive, women seen as

> natural without being viewed as uncultured, women seen as feminine without being viewed as passive. Her images have been exhibited in a number of leading galleries and have received major awards as well as being published as a range of

cards. Kay specializes in people, black and white and hand colouring. Her work is suitable for

editorial, advertising and

very personal greetings

fashion as well as being bought as

fine art.

fax

p. 55

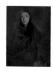

photographer

Marc Joye

address **BVBA** Photography Joye

Bursselbaan 262

1790 Affligem Belgium

telephone

fax

+32 (0) 53 66 29 45

+32 (0) 53 66 29 52

After studying film and TV techniques, Marc Joye moved over to advertising photography, where he found he had a great advantage in being able to organize shoots. He prepares his shoots like a movie, with story boards to get the sales story into the picture.

pp.19, 171, 282-283, 287

photographer

Ben Lagunas and

Alex Kuri

address

BLAK PRODUCTIONS Galeana 214 Suite 103

Toluca Mexico

C.P. 50000

telephone

+52 (72) 15 90 93

+52 (72) 17 06 57

+52 (72) 15 90 93

Ben and Alex studied in the USA and are now based in Mexico. Their photographic company, BLAK productions, provides full production services such as casting, scouting and models. They are master photography instructors at Kodak Educational Excellence Center. Their editorial work has appeared in international magazines, and they also work in fine art, with

exhibitions and work in galleries. Their commercial and fine art photo work can also be seen in the Art Director's Index (Rotovision); Greatest Advertising Photographers of Mexico (KODAK); and other publications. They work around the world with a client base that includes advertising agencies, record companies, direct clients.

pp.23, 69, 167, 241, 245, 252-253, 255

magazines, artists and

celebrities.

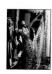

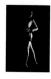

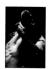

photographer Lewis Lang

address

83 Roberts Road

Englewood Cliffs

New Jersey 07632 USA

telephone

+1 (0) 201 567 9622

Lang began his career as a film maker, making commercials and documentaries for both broadcast and cable TV. A friend suggested that he use 35mm photography to teach himself about lighting and composition. He ended up loving photography and leaving film making. Since then he has been a freelance journalist, a fashion photographer and a fine art photographer, working on his own surrealistic images of people and still lifes.

pp.71, p.85, 95, 103

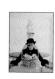

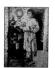

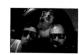

photographer

Peter Lagua

address

Marbacherstrasse 29 78048 Villingen

Germany

telephone

+49 (0) 7721 (0) 305 01

fax

+49 (0) 7721 305 55

Born in 1960, Peter Laqua studied portraiture and industrial photography for three years. Since 1990 he has had his own studio. A prizewinner in the 1994 Minolta Art Project, he has also had exhibitions on the theme of Pol-Art (fine art photography) and on the theme of 'Zwieback' in Stuttgart in 1992.

pp.73, p.107

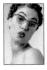

Wher Law

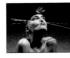

photographer

address

Wher Law Photography Workshop 412 Chai Wan Industrial City, Phase II, 70, Wing Tai Road Chai Wan Hong Kong

telephone

fax email URL

(852) 2516 6511 (852) 2516 6527 wher_law@hkipp.org www.hkipp.org

Wher Law, is a young renowned fashion and advertising photographer, who is crazy about alternative music and movies.

pp.152-153

André Maier photographer

address

104 Suffolk Street 12

New York NY USA 10002

telephone/fax (212) 254 3229

email URL

andre@andremaier.com www.andremaier.com

German photographer André Maier studied professional photography at the London College of Printing in England, and now lives and works in New York City. The diversity of his style ranging from photojournalism to fashion and conceptual portraiture - has earned him numerous exhibitions in Europe and New York. He now concentrates on expressing creative ideas and concepts through carefully planned makeup, original sets and computer retouching. His clients include record companies, magazines and ad agencies.

pp.123, 143, 160-161

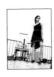

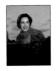

photographer

Jeff Manzetti

address

Studio Thérèse 13 rue Thérèse, Paris

75001, France

telephone 1

+33 (1) 42 96 24 22

telephone 2

+33 (1) 42 96 26 06

fax

+33 (1) 42 96 24 11

Jeff Manzetti's career took off rapidly, beginning with campaigns for international clients such as Swatch (worldwide), Renault, Lissac, Dior and L'Oreal, as well as many editorials for Elle magazine. Jeff's work has always focused on beauty and personalities. His work has appeared as covers and spreads in Figaro Madame, DS, Biba, and 20 ans. He has photographed celebrities such as Isabelle Adjani, Isabelle Huppert and Sandrine Bonnaire. His energy and humour extend to his work, as reflected in his advertising campaigns for Cinécinema and Momo's restaurant in London. He has also directed numerous videos and commercials in France, to great acclaim.

pp. 119, 127, 139, 179, 183

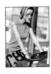

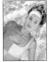

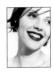

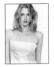

photographer Julia Martinez

address Viva Photography
Portman Cottage
2 Port Terrace
Cheltenham
GL50 2NB UK

telephone fax +44 (0) 1242 237914 +44 (0) 1242 252462

After completing her photography degree and being sponsored by Kodak, Julia launched her own photographic business, Viva Photography. She specializes in model portfolio shots, portraits and beauty photography commissions. She has also found that her career as a model has returned after shooting her own model portfolio. She now combines a career in front of and behind the lens, which makes life very confusing but always enlightening! She can be contacted for photographic commissions and model work at the number given.

pp.227, 261

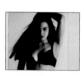

photographer Ron McMillan

address The Old Barn

Black Robins Farm Grants Lane

Edenbridge Kent TN8 6QP UK

telephone +44 (0) 1732 866111

fax

+44 (0) 1732 867223

Ron McMillan has been an advertising photographer for over twenty years. He has a custom-built studio, a 200-year-old converted barn on a farm site, on the Surrey/Kent borders. Ron's work covers food, still life, people and travel, and has taken him to numerous locations in Europe, the Middle East and the USA.

p.235

photographer Rudi Mühlbauer

address Kreilerstrasse 13A

81673 München

Germany

telephone +49 (0) 89 432 969

Born in 1965, Rudi has been photographing since early childhood. His areas of specialisation are: advertising, still life, landscapes and documentaries. He also does electronic imaging and retouching for advertising agencies.

pp. 21, 101

photographer

address Imago Ltda General Flores 83

> Santiago Chile

telephone fax

(+02) 251 0025 (+02) 235 6625

Patricia Novoa

Patricia Novoa was born in Santiago in 1957. An Art Graduate from PUCCh, specialising in printing, she has a degree in Professional Photography from the Escuela de Foto Arte in Chile. Since 1982 she has taught printing at the Escuela de Arte and is a photography professor at the PUCCh. She's exhibited at several print exhibitions both in Chile and abroad. In addition to teaching, she now works on her own photography and is a member of the Imago Ltd, a private company dedicated to design and photography.

p.231

photographer

Tim Orden

address

Tim Orden Photography

POB 1202 Kula

HI 96790 Hawaii

telephone fax

+1 (808) 876 0504

+1 (808) 876 0504

Tim says, "Clients ask me, 'Where is your studio?' I laugh and tell them that

it's the entirety of Hawaii.

When I lived in Seattle I

had a studio downtown

but found myself waiting for the weather to clear so I could shoot outdoors. Of course, the control of a studio was always

comfortable. No rushing because it might rain on

me at any moment. I could

fiddle with the

instruments to my heart's content. I consider the studio experience a great

learning chapter in my technical progress but it

wasn't till I committed myself to shooting in the

environment that things got really exciting. My

ideas come from

manifestations of

daydreams I've had about

how things could look. Often I spend seemingly

vacant moments (my wife complaining that I'm not

paying attention)

conjuring up the elements

that make up what I

consider a compelling image. Maui is my home,

Hawaii is my studio. It's

funny, just writing about this gets me excited to

create some new work."

pp.229, 259

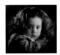

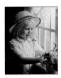

Dolors Porredon photographer

c/Girona 9 Granollers address

fax

Barcelona Spain

telephone +34 (0) 3 870 37 95

+34 (0) 3 879 67 97

Born in Granollers

(Barcelona) in 1949, Dolors

started her photography

career in 1972 as a selftaught photographer.

She has subsequently

worked on political and

humanitarian assignments centred on the human

figure in Africa and in Asia.

Currently, Dolors

collaborates with fashion companies and exhibits

portrait photography

focused on the subject of infancy and maternity. Her

work has been published in newspapers, photography

magazines, and on

television programmes. She has been exhibiting

her work since 1985 around Spain and also in

Paris, Edinburgh, Cologne

and Brussels. She

represented Spain in the World Photography

Convention in Ajaccio (Corsica) in 1990 organized

by the GNPP Association of French Photographers

pp.25, p.83

photographer Renata Ratajczyk

323 Rusholme Road address #1403 Toronto, Ontario

Canada M6H 2Z2

+1 (416) 538 1087 telephone

fax

+1 (416) 533 9569 renatara@ica.net

email URL

www.virtualcolony.

com/renatar

URL

www.lastplace.com/ EXHIBITS/CyberistHall/

Renata/catalog1.htm

Renata is photographer and digital artist. Her

work includes fashion,

fine art portraiture, as well as editorial, travel

and advertising

photography. She has a

painterly, imaginative, often surrealistic style

She often enhances her

work by a variety of

techniques including hand-colouring and digital

imaging. Her work has

been published in a

variety of magazines, on book covers, in calendars,

on greeting cards and has

been used for advertising.

Renata has her own stock library and is represented

by several stock agencies. Her studio is located in

Toronto, Canada, but she

also likes working on

location.

p.147

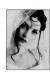

photographer address

Massimo Robecchi 44 Boulevard d'Italie MC 98000 Monaco Montecarlo

telephone/fax +33 93 50 18 27

Massimo Robecchi moved to Monaco after several years working in Italy. He specialises in pictures of people and still life. He is represented worldwide by Pictor International for stock photos.

p.57

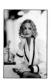

photographer Terry Ryan

telephone

address Terry Ryan Photography 193 Charles Street

> Leicester LE1 1LA, UK +44 (0) 116 254 46 61

fax +44 (0) 116 247 0933

> Terry Ryan is one of those photographers whose work is constantly seen by a discerning public without receiving the credit it deserves. His clients include The Boots Company Ltd. British

Midlands Airways, Britvic, Grattans, Pedigree Petfoods, the Regent Belt Company, Volkswagen and

Weetabix. The dominating factors in his work are an imaginative and original approach. His style has no bounds and he can turn his hand equally to indoor and outdoor settings. He is meticulous in composition, differential focus and precise cropping, but equally, he uses space generously where the layout permits a pictorial composition. His work shows the cohesion one would expect from a

exciting. pp.87, 224-225, 243

pictures are always

versatile artist: he is never

a jack-of-all-trades, and his

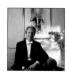

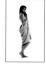

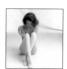

photographer

address

telephone

8. rue Pierre l'Homme 92400 Courberoie

Gérard de Saint-Maxent

France

+31 (1) 4788 4060

Gérard de Saint-Maxent has worked in advertising and publicity since 1970. He specialises in black and white photography.

pp.121, 233

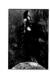

photographer

address

Kazuo Sakai Studio Chips Daiei Building, 3F

10-18 Kyomachi Bori 1

Nishiku, Osaka 550-0003 Japan

telephone 81 6 447 0719 fax 81 6 447 7509

> Born and raised in the Osaka area of Japan, Sakai has run the independent Studio Chips since 1985. He uses both traditional and digital technology to achieve the final result.

p.155

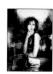

photographer Craig Scoffone

address Craig Scoffone Studios

> P.O. Box 8426 San Jose, California

USA 95155

telephone (408) 295 0519 (408) 975 0519 fax

email csoff@best.com

> Craig Scoffone has been producing top-level photographic images for San Francisco Bay Area clients for more than 15

years. Besides producing

fashion images, Craig also supplies Silicon Valleybased companies with product photography. Craig's on-line gallery is at www.best.com/atcscoff/cr aig.html.

p.129

photographer Alan Sheldon +44 (0) 20 87000 pager 0392243 code

> Alan Sheldon photographs people. For the last few years he has specialized more and more in celebrity shots, with a lot of emphasis on videos, CD, press and PR. His clients include Carlton, ES magazine, Virgin, Absolut Vodka, and Planet Hollywood. He shoots at parties, on location, and in the studio. In his personal work, he has been heavily influenced by Richard Avedon, though when he was an assistant he also worked with names like Annie Leibowitz.

pp.27, 29, 31, 33, 43, 45, 47, 49, 59, 97

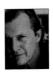

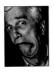

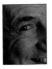

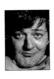

fax

photographer

address

telephone

fax

Des Kleinebst Photograph CC Cnr 10th Road and 4th Avenue Kew, Johannesburg South Africa Box 1921 Bramley Johannesburg 2018 +27 (0) 11 882 6005 +27 (0) 11 882 6072

Clive works from a large studio in Johannesburg. Most of the commercial work he does is automative, with the rest comprised of portraiture and still life. He studied at Natal Technikon for four years and received his National Higher Diploma, specializing in portraiture. His clients include Toyota, Mazda, Ford, Hyundai, Gilbeys and Allied Bank.

p.53

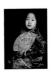

Holly Stewart photographer address Holly Stewart Photography Inc. 370 Fourth Street San Francisco CA 94107 USA telephone +1 (415) 777 1233

+1 (415) 777 2997

A lifelong fascination with objects - finding and photographing them - is at the heart of Holly Stewart's work. Her food photography and still life images reveal the simple vet extraordinary truths in the objects of the everyday world. Since opening Holly Stewart Photography Inc. in 1991 she has collaborated on both editorial and commercial projects, including print and film advertising, studio and location photography for a variety of magazines, including: Sunset, Coastal Living and Appellation Magazine; and three books: The Williams-Sonoma Wedding Planner (Weldon Owen, 1996), The Art of the Cookie (Chronicle, 1995) and Beef: New Menu Classics (Beef Industry Council, 1994). Her work has drawn

local and national attention and awards, including recognition in CA magazine, Graphis and the San Francisco Show.

pp.220-221, 248-249

photographer

Antonio Traza 8 St Paul's Avenue

London NW2 5SX, UK

mobile

address

telephone/fax +44 (0)20 8459 7374 +44 (0)468 077 044

> Antonio Traza specialises in photography for advertising, editorial and design groups. His images include work in portraiture, fashion and fine art.

pp.131, 133

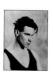

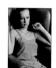

photographer Gordon Trice

address 774 E. North 13th Street

> Abilene Texas USA 79601

telephone

+1 (915) 670 0673

fax

+1 (915) 676 4672

email

gordon@bitstreet.com

Gordon Trice has worked in the editorial, advertising and corporate arena since 1968. His earliest experience was editorial. As a corporate staffer in aviation, he

learned about various print media and graphic arts. He has worked for newspapers, wire services, magazines and corporations worldwide. His current work focuses on product photography in studio and on location.

pp.148-149

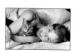

photographer

address Photography and Video

> Geliusstrasse 9 12203 Berlin Germany

Günther Uttendorfer

telephone fax

+49 (30) 834 1214 +49 (30) 834 1214

Günther says, "I moved to Berlin because this city gives me great inspiration. My style of photography nowadays shows my affinity with shooting movies. If I'm shooting women I always try to get one special side of their character on to the pictures."

pp.278-279

photographer

fax

Frank Wartenberg address Leverkusenstrasse 25

Hamburg, Germany

+49 (40) 850 83 31 telephone

+49 (40) 850 39 91

Frank began his career in photography alongside a law degree, when he was employed as a freelance photographer to do concert photos. He was one of the first photographers to take pictures of The Police, The Cure and Pink Floyd in Hamburg. He then moved into fashion photography. Since 1990 he has run his own studio and is active in international advertising and fashion markets. He specialises in lighting effects in his photography and also produces black and white portraits and erotic prints.

pp.35, 37, 75, 77, 79, 99, 125, 137, 173, 175, 188-189, 204-205, 211, 217, 237, 239, 247, 257, 263, 265, 268-269, 272-273, 275, 277, 285, 291

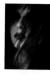

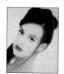

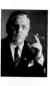

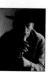

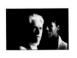

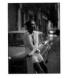

photographer address

Stu Williamson

Stu Williamson Photography

Rockingham Road

Market Harborough

Leicestershire LE16 7QE, UK

+44 (0) 1858 469544

www.stuwilliamson.com

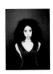

telephone

www

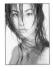

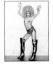

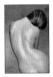

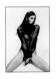

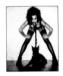

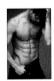

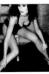

A former session drummer, Stu turned professional photographer in 1981. He has won most of the major photographic awards in the UK as well as lecturing worldwide for Ilford, Kodak, KJP (Bowens), Pentax, Contax, Lastolite, BIPP and the MPA. He became well known for his 'Hollywood' makeover style using the Lastolite Tri-Flector, which he invented, working in both monochrome and colour. He now works almost exclusively in monochrome, both commercially and in fine art photograpby - his clients value his unique way of seeing - and sells to European calendar companies via his London agents.

p.67

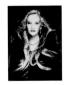

acknowledgments

First and foremost, many thanks to the photographers and their assistants who kindly shared their pictures, patiently supplied information and explained secrets, and generously responded with enthusiasm for the project. It would be invidious, not to say impossible, to single out individuals, since all have been helpful and professional, and a pleasure to work with.

We should like to thank the manufacturers who supplied the lighting equipment illustrated at the beginning of the book: Photon Beard, Strobex, and Linhof and Professional Sales (importers of Hensel flash) as well as the other manufacturers who support and sponsor many of the photographers in this and other books.